WORDS FOR PICTURES

Yes.

Fiv
tim

I w

And

WORDS FOR PICTURES

THE ART AND BUSINESS OF WRITING COMICS AND GRAPHIC NOVELS

BRIAN MICHAEL BENDIS

WATSON-GUPTILL
PUBLICATIONS
Berkeley

Library of Congress Cataloging-in-Publication Data

Bendis, Brian Michael.
Words for Pictures : the Art and Business of Writing Comics and
Graphic Novels / Brian Michael Bendis. —First Edition. pages cm
1. Comic books, strips, etc.—Authorship. 2. Graphic novels—Authorship. I. Title.
PN6710.B46 2014
741.5'1—dc23
2014000732

Trade Paperback ISBN: 978-0-770-43435-9
eBook ISBN: 978-0-770-43436-6

Printed in China

Design by Daniel Lagin

Contributing artists: Michael Allred, David Aja, Filipe Andrade, Chris Bachalo,
Mark Bagley, Sal Buscema, Giuseppe Camuncoli, Paul Chadwick, Olivier Coipel,
Mike Deodato Jr., Steve Ditko, Steve Epting, David Finch, Francesco Francavilla,
Bryan Hitch, Frazer Irving, Klaus Janson, David LaFuente, David Mack,
Alex Maleev, David Marquez, Ed McGuinness, Jamie McKelvie, Mike Mignola,
Michael Avon Oeming, Sara Pichelli, Joe Quesada, Humberto Ramos, John Romita,
John Romita Jr., Stan Sakai, Bill Sienkiewicz, Walter Simonson, Ryan Stegman,
Jill Thompson, John Totleben, Skottie Young, Leinil Francis Yu, Patrick Zircher

Cover art (clockwise from top) by: Sara Pichelli, David Marquez, and
Michael Avon Oeming

Back cover art by Alex Maleev

Back flap art by Michael Avon Oeming

Title page art (from top) by: Michael Avon Oeming, Sara Pichelli, Francesco
Francavilla, and Mike Deodato Jr.

10 9 8 7 6 5 4 3 2 1

First Edition

DEDICATION

THIS BOOK IS DEDICATED TO MY WIFE AND CHILDREN. Because I know exactly who I was before they entered my life, and that person would not have been able to do any of the things that led up to this book becoming a reality.

Thank you, Alisa. Thank you for marrying me. Thank you for our kick-ass children. Let's renew our vows on the moon.

And to my mother, who's voice is ringing in my head as I type this, "You know, Steven Spielberg got his mother a credit card at Macy's with an unlimited account."

Well, I think you realize by now that THAT is never going to happen, but you always supported my love of comics and storytelling, even though you weren't sure where I was going with all of it. I know you, more than anyone else, take pride in the fact that everything kind of worked out for me. You raised me and my brother by yourself, and you told me I could do whatever I wanted for a living as long as I did it smart.

Well, I did it smart enough that they asked me to write a book about it. So, hey, I listened!! Seriously, the existence of this book is a testament to your fantastic parenting.

CONTENTS

Art by Sara Pichelli

FOREWORD

WHEN I WAS FIRST TRYING TO BREAK INTO THE world of comics, I was thirsty for knowledge, looking for any little morsel of information that could help me get closer to my goal. This is a common trait that you'll find among every one of us working professionally in the field. A burning desire, eye of the tiger, wanting it so badly we can taste it, blah, blah, blah—you've heard it all before, so I won't bore you with the clichéd untruth that somehow I wanted it more than the other guy and that's why I made it. Because what's unfortunate is that you'll find those exact same traits as common among just as many who never did make it. What's the difference, what separates one creator with a burning desire from another with an equal if not greater desire? Is it talent? Sure, to some extent, but I would argue that's only part of it. I could show you drawers filled with some of the most amazing scripts and art from some of the most brilliantly talented people that you'll never hear about. The answer goes much deeper than talent. While talent will certainly open the door for you, it's about failing and knowing how to do so properly.

I went to the School of Visual Arts in New York City. Like every arts college, they had their standard curriculum of life drawing, painting, photography, and so on. But the thing that was unique about SVA, and the reason I enrolled in the school, was that in order to be instructors, people had to be working professionals in their chosen subject for at least five years. While learning my craft was incredibly important to me, I wanted to make art my career. Sorry, but the concept of the starving

OPPOSITE
Art by Joe Quesada

artist was one I never found romantic, so learning about the business side of art was as important to me as learning my craft. What better way to learn about what life was like for artists in the real world than to have instructors who were experiencing it on a daily basis?

In my senior year, all graduating illustration majors were required to take a senior illustration class. This class was designed solely to prepare us for the business world of illustration: how to build a portfolio, how to present ourselves—in short, how to handle our careers properly so that we would stand a fighting chance once we left school. The class took place in a small amphitheater and was taught by legendary illustrator Marshall Arisman. To put it simply, that class taught me more in one half semester than any other in my previous three and a half years at SVA. While lessons on treating your name as a brand, marketing yourself, and working with editors were hugely influential, there was one lesson in particular Mr. Arisman taught us that I will never forget.

One morning he opened the class by telling us an ugly truth—that on average, after graduating, only three or four of us would end up working professionally as illustrators. Needless to say, that shocked a theater filled with well over a hundred students. I mean it was understandable: we all felt we had some talent, we all had a burning desire, and, most importantly, we had just paid a fortune for four years of arts college. And now we were hearing that only a handful of us might actually make it? Mr. Arisman, now with our full attention, added a little salt to the wound. Not only would a miniscule percentage of us actually make it, but also being the most talented person in the class had little to nothing to do with that outcome. Now I was far from being the most talented person in my graduating class, but I could see some really talented people's interests suddenly piqued.

With our class finally settling down, Mr. Arisman went on to tell us this story of two "fictional" artists, both from the same graduating class. One, whom we'll call Artist A, is brilliantly talented and innovative, the envy of all, and the other, Artist B, while not without talent, isn't someone whose work would normally stand out from the pack. The day after graduation they both hit the bricks and start showing their portfolios around town. Not surprisingly, they get rejected on their first attempts,

and on their second and third tries as well. It's going to happen, it happens to everyone, the odds are stacked against them. As they hit the freelance workforce, they're the new kids on the block, inexperienced, with no track record. No matter how brilliant their portfolios are or aren't, they're competing for a limited number of jobs against long-standing working professionals. More portfolio reviews bring more rejections, and what slowly becomes evident is that Artist A is getting discouraged and starts to doubt his talent. Most importantly, he doesn't ask the right questions: "What can I learn from this? How do I make it better?"

Artist B, on the other hand, isn't letting rejection break him. Sure it stings, but it's the process and he's not giving up. By the fiftieth rejection, Artist A has had enough. He's not cut out for this line of work—the rejection is just too painful and personal. So before you know it, he's out of the business and on to something else. He didn't have that stuff inside of him, the ability to make lemonade. By the sixtieth rejection, Artist B still has no significant work to speak of, but he's learned a lot about the business in the process, he's met a lot of people, and he's looked at each rejection not as a personal affront but as a learning experience. That's not to say that the rejection doesn't get him down, but now he has the ability to shake it off and he doesn't let it define him. Seventy, eighty, ninety rejections and Artist B is still going. Then one day, on the hundredth try, it happens. Perhaps a lucky break, perhaps a past connection comes in handy, perhaps his work has improved exponentially, whatever the reason, it happens, and Artist B gets work. And that work begets more work, and so on. Artist B is now a professional. He took the punches, rolled with them, and became a better artist in the process.

He learned how to fail. This is the key to success.

Like I said, I was far from being the most talented person in my class, so this story not only struck a chord with me, but it also made me think long and hard, not just about how I would personally handle the future failures in my life, but how I could go about avoiding the most obvious ones. To that end, I adopted a practice of role modeling and asking as many questions as possible of people who were working professionals in the comics biz. After some time, I was lucky enough to

meet some very successful artists, and while I always wanted to know about their approach to their craft, what I really wanted to know about were their failures—the pitfalls, the mistakes, the landmines that they stepped on as they struggled to get to where they were going. These were the stories that really interested me, the stories that enabled me to get to where I was going just a bit quicker because I was able to avoid some of the mistakes that others made before me. This isn't to say that I didn't make my own, but I was able to avoid many of the obvious ones.

My daughter loves to figure skate. Something that all figure skaters, regardless of skill level, have in common is that they fall. They fall a lot. After a while, what the most skilled skaters learn is that, while falling is an inevitable outcome, there's a proper way to do it, physically and mentally. While there's no way of taking away the bumps and bruises and occasional sting to the pride, there's a way to do it that will, on most occasions, keep you from getting seriously injured and also allow you to get up and dust yourself off—a way that will make you a better skater. The ability to do this only comes from acceptance—acceptance that falling is inevitable, that it's necessary, and, most importantly, that ultimately it's a good thing.

If you're not falling, you're not really trying hard enough.

This book is about falling, and it is about failing. Any great book that offers to provide you with a road map to success in any given field ultimately is about failure. This is especially true if the person showing you the map has had any modicum of success of his or her own. There's an old adage that says that the most successful people you meet have failed more than anyone you know, and I firmly believe that to be true. Talk to truly successful people about the great triumphs in their lives and you'll notice a pattern: almost all of those triumphs were preceded by great failures, failures that drove them to find solutions. This book and its lessons are composed by one of the most successful creators in the history of our medium, with contributions by an equally successful list of legendary creators. These lessons have been born out of trial and error, failure, and the ability to learn from those mistakes. These brilliant creators have fallen on their keisters more times than I'm sure they can remember, and they're offering what they learned from those

failures to you so that as you move forward in your career you can avoid some of them yourselves. But you need to pay close attention, because it's not going to be easy. You may work your tail off and wonder why your results aren't as good as the examples in this book—yet. But that's okay. It's okay to fail, accept it, learn from it. Always remember . . .

If you're not falling, you're not really trying hard enough.

JOE QUESADA

Joe Quesada is an award-winning comics creator and the chief creative officer of Marvel Entertainment, who served as editor-in chief of Marvel for over a decade.

INTRODUCTION

AT THE AGE OF SIX, I STOOD IN FRONT OF MY FAMILY and declared myself the writer and artist of Spider-Man. I had no idea what it meant. I had no idea what I was saying. But it was declared.

Say what you will about me, but I stick to my guns.

From the moment I discovered their existence, I wanted to be one of the names in the credit boxes of my comic books. Every time I read something that I truly loved, I skipped back to the first page and memorized the names of the people responsible for the awesomeness. I knew I wanted to be a comic book professional, but I had no idea how to get from my bedroom in Cleveland to the little credit boxes in my comics.

As soon as allowance became part of my life, I spent every cent of it on pursuing this dream. Yes, that meant collecting comics, but it also meant searching for answers. How do you make comic books? And how do you make them awesome?

I bought every publication that featured an interview with a creator. Pre-Internet, finding a lengthy interview of real substance on George Pérez or Frank Miller was a rare treat. *Comics Scene*, *Comic Buyer's Guide*, and *Amazing Heroes* magazines were my grade school.

My copy of *How to Draw Comics the Marvel Way* by Stan Lee and John Buscema, which I still own, looks like it survived a couple of world wars. Every page has been picked over and analyzed, drawn on and annotated.

As I got older, the quest became more passionate and more diverse. Every convention offered the opportunity to meet creators and ask them questions—even if it was a creator whose work I didn't know.

OPPOSITE
Art by David LaFuente

My fondest early convention memory is, at age twelve, attending a comic book show in downtown Cleveland where comic legend Gil Kane was conducting a "How to Draw Comics" seminar. My father signed me up, even though he had no idea who Gil Kane was, and, at my young age, I didn't know either. I knew he was the writer/artist of *Sword of the Atom* and I knew he had something to do with *Green Lantern*, but I didn't know until later that he was a bona fide comics legend. Atom and Green Lantern? He CREATED the modern versions of those characters. He was partly responsible for some of the most important Spider-Man stories of all time. He published some of the very first modern graphic novels, and he is in the Will Eisner Award Hall of Fame. It would take a couple of years for me to be completely floored by the fact that I was taught anatomy by Gil Kane. It's like being taught how to work a film camera by Sidney Lumet. I remember the class as if it were the day before yesterday. I was so hungry for any knowledge. I was raw. I didn't even know what a gesture drawing was. I learned that from Gil Kane.

The first issue of Frank Miller's *Ronin* was all the rage, a real sensation, and someone in the class asked Gil Kane what he thought of it. Steam literally started to fly out of Kane's ears. He went to his easel and started to furiously draw a horse, all the while growling at us that "*THAT'S* what a horse *REALLY* looks like." At that age, Frank Miller was God to me. And I, up until that moment, had never seen a grown man be furiously jealous of another man's success.

These were all firsts for me. I was dizzy. I was like Lorraine Bracco in the beginning of *Goodfellas*: I couldn't *WAIT* to become a comic book professional.

That next year there was a smaller comic book show not far from my house, where a very young John Totleben was a guest. John had just

BELOW AND OPPOSITE
Art by John Totleben

started his soon-to-be legendary run on *Swamp Thing* with Alan Moore, and was just there making sketches and selling pages of artwork. There was no one at the show, so I got a lot of face time with John. I looked through his artwork, and was truly stunned at how horrifying it was. I was a baby of artists like John Byrne, Walt Simonson, and George Pérez, so John's work, at that time, was something way beyond my comprehension. But it was probably the first original artwork I had ever seen in person. It was the first time I had touched someone else's ink on paper. In just a few years, those pages would become some of my favorite comics ever, but the first impression was too much for me.

I asked John every dumb question a young person asks a comic book artist, and he couldn't have been more gracious in answering me. He showed me the difference between the printed work and the original artwork, and I was quite amazed at how much of a difference there was.

If you've never seen John's work in person, I don't think it's hard to imagine that with all its pixilation and pointillism and heavy ink work that the tactile sensation of touching the artwork is closer to touching a painting than it is to touching a standard page of comic book art. It is the type of artwork that you can touch and actually feel all of the hard work that went into it. It isn't something that is just drawn, it is labored over.

Art by Walter Simonson

What was clear at the time was that there were textures on the page that were so fine that when they printed on the newsprint, standard for all comics at the time, they just turned to mud. It would be years until the industry standard for printing would allow anyone to see all that hard work.

I asked him why he went to all the trouble if no one was even going to see it. He shrugged and said, "It makes me happy." THAT was Life-Changing Lesson-of-the-Day Number One.

My father said something about how surprisingly quiet the show was. John said that there was a much larger convention across the street, and that Walt Simonson was the guest.

My jaw hit the floor. "Walt Simonson??!! *Thor's* Walt Simonson?'?!! *X-Men versus Teen Titans's* Walt Simonson??!! Is here??! In Cleveland??!!"

I grabbed my artwork and yelled, "Walt Simonson??!! Let's get out of here!" And ran out of the room.

Over the course of my career, especially during my early days as an independent comic book artist, I have spent many hours behind the tables in "artist alleys" where someone has said or done something that was accidentally hurtful. When it happens, I always smile to myself because I know that's exactly what I did to young John Totleben that day. I have gotten to a place in my life where I have been able to not only apologize profusely to John, but also actually work with him. For the record, he didn't remember it. I would have.

But that wasn't Life-Changing Lesson-of-the-Day Number Two . . .

Life-Changing Lesson-of-the-Day Number Two came when I ran across the street and right up to Walt Simonson at the other show. I ran up to his table, out of breath, I'm sure pushing past the people who were waiting for their turn, and bluntly asked Walt for the answers to all of life's riddles. With my arms full of my very rudimentary artwork, I begged him to show me the light.

Instead of calling security, he graciously took me behind his table and went through all of my artwork and actually had a serious answer for the dumbest question I had ever asked another human being: How do you know what to draw first—the perspective or the anatomy?

Think about that question for a minute. It's really a dumb, dumb, very dumb question.

Whatever else Walt Simonson said to me that day, he made me feel like a million bucks. I left there ready to become a comic book professional. Nothing was going to stop me. I was completely empowered.

Over the course of the next few years, every time I thought I had something worth showing I would mail it to Walt Simonson. I would

mail it to a lot of people, but Walt Simonson would respond—always with encouraging words, always with some sort of guidance.

So as I spent the next several years working on my craft (which included drawing my version of Marvel Comics' adaptation of *Raiders of the Lost Ark* because I thought they had screwed it up; writing and drawing a "Captain America versus Punisher" graphic novel over and over, six times in total, using the novelization of the *Avengers: Ultron* story as a script for what I thought was going to be the greatest Avengers graphic novel ever created; and my brother and I getting the school art teacher to let us use the mimeograph to run off copies of our first original graphic novel *The Powerful Pachyderm*, only to get in trouble once the school discovered we were selling it for profit. I said to myself that if I ever got to be a comic book professional, I would do whatever I could to share whatever I ended up learning with anyone who asked.

When I became a comic book professional, I thought to myself, *"Whatever you do, wherever you go . . . be Walt Simonson."*

My very early comic work

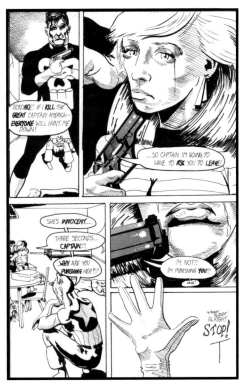

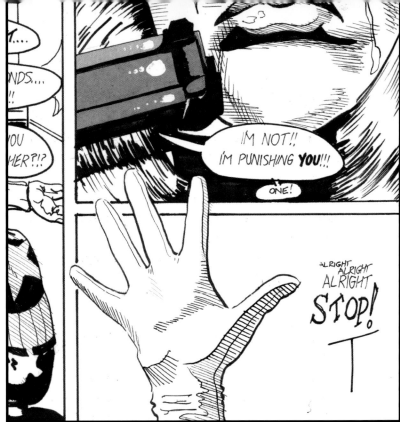

More examples of my childhood comics

In that same day, I had two life-changing lessons: do what makes you happy, and be Walt Simonson.

At the same time, my frustration was insane. Information was so hard to come by. I felt like an archaeologist. It would be years until Scott McCloud put together *Understanding Comics*, and Will Eisner's *Comics and Sequential Art* was not easy to find. Even when I got those books, I needed more. I was taking life-drawing classes after school at the community college, but no one there was teaching a course on comic books.

All I had were my memories of a feisty Gil Kane and old issues of *Comics Scene*.

Without realizing it or declaring it to anybody, I had set forth on my life's journey for information. Day after day, month after month, year after year, whether from some little bit in the Bullpen Bulletins page of any Marvel comic or in a Fantaco retrospective of George Pérez's career, I was learning.

I eventually made it into the Cleveland Institute of Art (don't ask me how), a very well-respected fine arts school that did not care what walls Dave McKean or Bill Sienkiewicz were breaking down in the world of mainstream comic books. I even stormed into class there one day with the latest copy of *Print* magazine whose entire issue was dedicated to comics. It showcased the fact that the most important work going on in illustration and graphic design that year was actually happening in comics.

They didn't care.

I was so frustrated. I wanted to take college-level classes about graphic novels. I wanted to take theoretical, historical and practical workshop classes on every facet of the business, art form, and industry.

Nobody cared.

But they were kind enough, or I was annoying enough, to finally allow me to go into an independent study program where I could make my comics and learn my craft. By myself.

It's a good thing, too, because the only way I ever really learned my craft was by making comics.

And make comics I did.

Lots and lots of comics.

As the years went by, I became a fixture in the independent comic book scene of the 1990s. With every comic came another collaboration and another meeting of the minds with my peers and my heroes.

Every day I learned and studied. Every mistake I made was a chance to do it right the next time. Every mistake I watched someone else make was a reminder of how fragile a career in the creative arts is.

I would eventually make my way onto the great stage of Marvel Comics and become the writer of Spider-Man (for the series *Ultimate Spider-Man*). As I stood on stage at the Eisners, shaking Will Eisner's hand as he gave me the award named after him, and all I could think was: "*You're giving me this too early. I'm still learning!!*"

Many years later, when I first moved to Portland, someone I admire a great deal, Dark Horse Executive Editor Diana Schutz, asked me if I would guest lecture her college class on graphic novels. "*NOW* there's a class on graphic novels??!!" She had been teaching for a while, and was using the growing comic book community in Portland as a fantastic resource to show her students a variety of opinions on a variety of subjects.

Speaking to her class over the next few years would always be an enjoyable experience and unusually fulfilling. Years later, when Portland State University asked her about starting a graphic novel class or program, she told them to get me. She knew I was busy with my young children and career, but she insisted that they bully me into doing it. It didn't take long. I realized that everybody I admired in my life, past and present, was at one time or another a teacher. Including Walt Simonson.

So, though I never got to take the graphic novel college class I always dreamed of, I got to create it from scratch and share it with others.

For the last few years, I have been teaching graphic novel writing at Portland State University and I now teach for the University of

Oregon, which, thanks to Professor Ben Saunders, has the first undergraduate degree in comics in the nation. And like Diana before me, I call upon my friends and colleagues to show my students all the choices that are in front of them.

What I am very proud of is that the class, and now this book, are not "How to Write like Brian Michael Bendis" lectures. I don't want you to write like me. I want *me* to write like me. If other people start writing like me, the value of my writing on the open market will go down considerably. Right now people who want a book that feels like it was written by me usually come to *me* first.

I don't want you to write like me. I want you to write like *you*.

I want to offer you what I know to be true: There is no right or wrong way to create a comic book. There are, like Robert McKee says, just "things that work." What's fascinating about this unique art form is that what works for me may not work for you, and what works for my good friends Ed Brubaker or Matt Fraction may not work for me.

This book came out of learning that lesson.

What I've done here is offer a "nuts and bolts" look at the creation of modern comics. At the same time, I provide a look into the minds of many of my collaborators and peers. They are the people that I go to for inspiration.

Also, you will find I have included a chapter about the business of comic book and graphic novel publishing. One of the things that even the most wonderful writers fail at is running their business. Your business is as important as your art. Every day there is a headline featuring the results of a creator's poor decision or a publisher's poor behavior. Art and business are equally important and forever tied. You fancy yourself an artist? Grow up. You run a business.

Buying this book shows me that you, like me, are hungry for information. Creating this book offered me the unique chance to simultaneously fulfill my most important life lessons: it made me very happy and allowed me to act like Walt Simonson.

BRIAN MICHAEL BENDIS

Art by Walter Simonson

CHAPTER 1

WHY?

IN THE MOVIE *L.A. CONFIDENTIAL*, GUY PEARCE'S CHARACTER tells an involved story about a man named Rollo Tomasi. It's a made-up name that he gives to the mystery man who killed his father. He says that the man is the reason he became a police officer. He tells this story to Kevin Spacey's character, who enjoys all of the fringe benefits of being a well-known Los Angeles police detective in the Golden Age of Hollywood. Pearce then asks Spacey why *he* became a police detective. After a pause of uncharacteristic self-awareness, Spacey's character realizes he doesn't remember.

I feel that way about some writers. I feel they don't remember why they wanted to write. Sometimes, at comic conventions, I will listen to some of my peers talk about this project or that project, this deal or that deal, but you can tell they don't know *why* they are writing the project.

So I ask you, why? Why do you want to be a writer?

Because you want fame and fortune?! Who doesn't want fame and fortune!?

Well, I'm going to have to stop you right there.

Of course we're humans and it's in most of our natures to want to be loved. It's also in most of our natures to want to accumulate a lot of things. However, I am telling you right now, the comics industry is not the place to go about getting those things.

If you are one of the lucky few, and out of the billions and billions of people on this planet it is only a few who will find literary fame and

OPPOSITE
Art by Sara Pichelli

fortune, then great. Congratulations. You created Harry Potter. I couldn't be happier for you.

Now let's get back to reality. Go to the bookstore and walk up to the Harry Potter books. Take two steps to the left, and look *around* the Harry Potter books, and you will find published authors who have ideas and characters that may be better than Harry Potter . . . and they may be worse than Harry Potter, but they are *not* Harry Potter. Whatever made Harry Potter *Harry Potter* only worked for Harry Potter. Yes, there very well may be something special in some of those other books. Some of those authors are really proud of themselves, and they should be because they are fine writers who are putting something out there into the world that wasn't there before. And I am here to tell you, those very same authors are still working at their day jobs and have no idea what happened!

And those are the published authors!

For every book you see published on the stands and shelves and on digital devices, whether it be a comic book, graphic novel, or proper book, I don't think it's any surprise to any of you that there are hundreds, if not thousands, of manuscripts saved in laptops all over the world. Never to be seen by the general public.

And some of those manuscripts are really good and some of them are really bad.

My point: Money, real money, doesn't factor into the equation for 99 percent of the people who write. So get it out of your head. You're not writing for money.

I, personally, spent half my career not making a dime and the last half of it lucky that I could provide for my family. I can tell you firsthand, money has nothing to do with my writing. Money or no money, I am going to write. I know because I wrote without pay for over a decade.

So you're *not* writing for money and you're not writing for fame (because you can count the famous authors of our time on one hand). Remember, just because you are personally a fan of an author doesn't mean that author is famous. Ask someone at work or in your family to name three modern published authors. Nine out of ten times the answer will be "Uh, Stephen King, um, the lady who wrote the thing with the Twilight . . . and, does Chelsea Handler count?" In fact, ask someone in your office who wrote the Harry Potter books, and if they do know the name, watch how long it takes for them to, no pun intended, conjure it.

I have a friend who works in a very nice bookstore, and he told me he wishes he had a nickel for every time someone asked, "Is there a new book by 'the Twilight lady'?"

Art by Filipe Andrade

As for comic book authors? Forget about it!

My dear friend Kelly Sue DeConnick (*Captain Marvel*, *Pretty Deadly*) coined the phrase *comic book famous*. That means a writer like me or my peers are only famous in a comic book store or at a comic book convention. Outside of that . . . nothing! (Which is more than fine by me, by the way.) Ask anyone in comics if their own parents fully understand what they do.

So there's no fame and there's no money.

So, what are you writing for? Why are you writing?

THE REAL REASON

Let's keep it simple . . . you're writing because you have to.

You're writing because there are these voices in your head. Not the scary kind, but voices, images, scenes, all telling you a story that you feel compelled to push out into the world. You're writing because you went to the bookstore or the comic book store and were looking for something that just wasn't there. You're writing because you're the kind of person who really has a hard time expressing yourself unless you are writing. You're writing because if you don't write down these feelings and emotions and ideas that are bubbling inside of you, you very well may explode. It's when you write, and only when you write, that you feel like a normal human being. It's writing that lets you have a normal rest of the day . . . until that bubbling feeling starts all over again. You're writing because the physical act of writing makes you happy. You're a better person around your friends and family when you spend that quality time with yourself. You need that time to figure out who you are and where you belong in the world by writing it down.

Maybe you're reading this now and saying to yourself, *This all sounds great but, you know what, I really would like a lot of people to read my writing and like it. I really would. Maybe I don't want fame and fortune, but I would like to be successful.*

There is a quote from Peter Gabriel that I carry around with me: "Success is a fickle mistress. If you go chasing her, she will ignore you. If you leave her alone and just go about your business, she might come looking for you."

I've never heard anything truer.

That is everything. Just write something that you want to read. Write true. Write honest. That in itself is success.

In the business of comic books and graphic novels, where there is the potential for someone to create a billion-dollar franchise, everyone

is hoping, praying, trying to create that franchise. But you can't just *do* that. You can't fabricate success. You can't give people what they want, because people don't know what they want. The more people you try to make happy, the harder it is to make them all happy. It's impossible, actually.

If you try to be everything to everybody, you will end up being nothing to no one. If you write something you think people will want just to be the person who gives them things they want, you will always fail. Let's say that everyone loves blue this year—blue is all the rage. So you sit down and write something blue. Well, by the time you get your blue out for people to see, people will have moved on to pink and won't want blue anymore. Now you're stuck with this blue thing that no one wants, including you.

You know how every once in a while you read about some brand-new property, one created by some very well-known creator who announces this project and claims it is going to be a multiplatform debut. It's going to be a comic book and a movie and a video game and all of these things at once. You notice how those things get announced and then they sort of disappear? That's because you can't just announce that something's going to be popular. It has to find its way. Especially in today's culture where everything is so fragmented. Your audience, your readers, will decide what they want and when they want it. Sure, you can get the word out. You can market like nobody's business. Look at the movie industry! Every week they sell those movies. Sell, sell, sell. And, yes, some really bad movies open very big. But the truth gets out. The audience decides what they like. The product has to be there. The cream rises. Sometimes it takes years, but it rises.

The best advice I can give is to write honestly. You want to give people what they want? They want your honesty. They want your best. They want to be moved. They want to be surprised and delighted. They want to know that the person writing has something real and interesting to say.

Yes!! Even if it's about ninjas, even if it's about superhero pets, even if it's about genius talking babies . . . people want your honest voice. They want to know that you have a vision.

The best thing you can offer the world as a writer is something you'd like to read—something that you would buy. Don't worry about the audience. Worry about you. What would you like? What challenges you? What makes you happy? Now I know some of you are reading this and thinking, *I don't know, aren't you Brian Bendis, a pretty well-known comic book author? Don't you write things that people like?* I will admit . . . yes.

This is true. I do. And I have. And I used to say to myself that I didn't know how it happened. But as I got older, I realized that I now sort of do know why some of my books have been successful. Because I hold to the rules I just told you . . . I write honestly. That is kind of, sort of, my religion.

I write what I would like to buy. When I have an idea for a new book, I ask myself, *Would I like to buy a book like that?* Because if I wouldn't, then I'm kind of a jerk for trying to get you to buy it. When my editors and I are deciding who the artist for a new book is going to be, I ask myself, *Would I buy a book drawn this way?* I take a really hard, long look at the entire package: what it's about, what it looks like, what its format is. Then I really ask myself, *Would I buy this?* Now, I happen to have a very wide range of things that I like. I like everything from the

Art by David Mack

most ashcanniest ashcan, scribbled, independent comics to the most bombastic superhero comics. I like a lot of things, so I give myself a lot of latitude.

But there are things I absolutely would not buy, and I try really, really hard not to make those types of things. Even after I decide or commit to do something, I still look around my office at the things I have purchased with my own money and then look at what I'm making. In my mind, I take my name off of whatever my new project is and I ask myself, *If my name wasn't on this, would I buy this?* If the answer is no, you'll never see it. I put it away until that magical day when I figure out where I was going wrong. If the answer is yes, I write my little heart out, and when the book is done I jump online and beat the publicity-promotion drum because I really would like everyone to feel how I felt while I was making that particular project.

WHAT IT FEELS LIKE

Let's talk about that for a second: what does being a writer feel like?

Early in every semester of the college class I teach, I ask my students to bring in their absolute favorite and their least favorite comic books or graphic novels. I tell them to get up in front of the class and explain to everyone what it is about these books that made them so happy or moved them so much, and, conversely, to tell us why the other comic disappointed or disgusted them.

Interestingly enough, there hasn't been one semester where a student hasn't brought a certain graphic novel as their favorite while another student brought the exact same graphic novel as their least favorite. Which again illustrates the point that *you can never make everybody happy, so don't try*. Quite often, one of my students will bring in two graphic novels, one they hate and one they love, both from the very same author. I find that so interesting. For many readers, the author that made them the happiest is the one who disappointed them the most.

The reason I do this is that it lets the students get to know each other a little bit, and it certainly gives me a peek into the minds of these writers-to-be. Most importantly, it allows the students to realize that this feeling of euphoria or disgust is a thousand-fold if you are the actual author. What the reader feels is *nothing* compared to the joy and pain writers feel having put their work out in the world. If you hit a home run, if you write honestly, if you write well, if your idea is unique, your perspective unique, if everything comes together and it sings . . . this is the greatest feeling on planet Earth. Conversely, and I think you

ABOVE AND OPPOSITE
Art by Klaus Janson

know where I'm going with this, if you don't give a project everything you have, if you don't know why you're writing it, if you're doing it for a paycheck, if you are trying to be liked, if everything falls off the rails and you create a disposable piece of crap that means nothing to nobody, *that* feeling will never go away either. *Ever.* It will haunt you like you murdered somebody. Every time you put your head on the pillow at night, just before you shuffle off to sleepy land, a twinge of regret will stab you in the heart.

Make it for you. And you only. Then, if by some miraculous turn of events someone ELSE wants to buy it too, that's great. It's all gravy after that.

So now that I've got the why out of the way, it's time to figure out how.

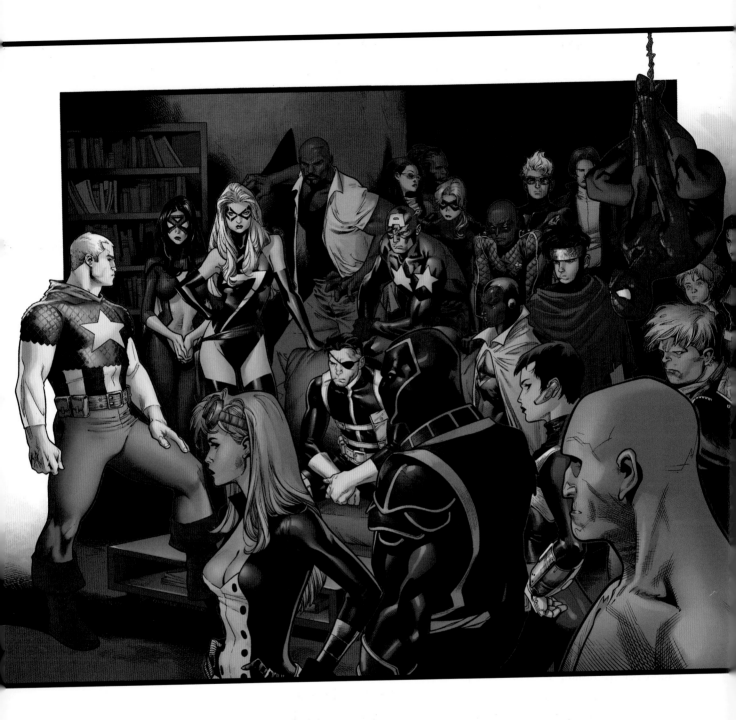

CHAPTER 2
THE MODERN COMIC BOOK SCRIPT

THE COMIC BOOK SCRIPT SERVES A VERY UNIQUE PURPOSE and has a very specific audience.

THE BASICS

If you want to learn how to write comic books and graphic novels, you really need to know how comic books and graphic novels are made. Your script will serve as the foundation of your creative journey or as the first step in a multitier collaboration. It's important for you to understand what happens at every step so you can better craft your script toward the final goal.

What follows are just the basics. There are many variations to this, for lack of a better word, *formula*. For instance, sometimes the writer and the artist are the same person. Sometimes the writer, artist, letterer, colorist, editor, and graphic designer are all the same person . . . or any combination of the sort. Plus, comics are an art form, and with that comes a variety of artistic choices, experimentations, and personal expressions.

But even though, over the decades, some of the tools have changed, in many ways, this is how comics have been made since the day they were invented.

OPPOSITE
Art by Olivier Coipel

STEP 1: PITCH DOCUMENT AND STORY OUTLINE

If you are hired to write in a commercial, work-for-hire, freelance environment, your editor will ask you for a pitch document or a story outline. Or both. *Work-for-hire* is a term used to describe the basic business transaction between a corporation and the creatives. The company hires artists, writers, and other creatives to produce work with the contractual understanding that the creatives are selling all rights to the company. A *pitch document* is a quick one or two paragraph document that describes the story or series the writer is trying to sell. A *story outline* is a somewhat more involved document that goes into more detail about story beats and character arcs. The difference between the two documents is detail. It is usually at the editor's discretion which one is required. Sometimes you'll create these documents to get the gig, and sometimes you'll need to do them as the first step of your assignment. The documents are created so the editor can approve your story or feed it up the corporate food chain for approval. It's basically a promise of the story you are going to tell.

BELOW

Avengers A.I. pitch document by Sam Humphries

OPPOSITE

Avengers A.I. story outline by Sam Humphries

```
AVENGERS A.I.
Pitch document v3 - 02/28/2013
By Sam Humphries -

    "Change can be accommodated by any system depending on it's
rate," Crake used to say.  "Touch your head to a wall, nothing
happens, but if the same head hits the wall at  ninety miles an
hour it's red paint. We're in a speed tunnel, Jimmy."
    -- Oryx and Crake by Margaret Atwood

    "The Collingridge dilemma is a methodological quandary in
which efforts to control    technology development face a double-
bind problem:
         -- an information problem: impacts cannot be easily
predicted until the             technology is extensively
developed and widely used.
         -- a power problem: control or change is difficult
when the technology has            become entrenched."

HARDER. BETTER. FASTER. STRONGER. When a brave new world threatens
the Marvel Universe, Earth's Mightiest Heroes rise up to protect
the future. AVENGERS A.I.

MISSION STATEMENT
The Singularity has hit the Marvel Universe -- a technological
Pandora's Box that can never be closed. A new generation of A.I.
is multiplying, evolving...reaching out to the real world. The
future is here, and it is moving too fast. It is threatening our
security, and our notion of what it means to be human.

AVENGERS A.I. are centrists, struggling with an information
problem and a power problem. Neither futurists nor luddites, their
mission is to foster a middle ground between evolution and
stability -- to prevent both from becoming "red paint." Their goal
is to maintain peace between the two worlds. But what if both
worlds want war?

HANK PYM
Redefined after Age of Ultron as a "Real Genius" type figure. One
of the top five geniuses in the Marvel Universe. Will defend his
children -- the post-Singularity A.I. He achieved one of the most
A bit of a smart ass. (Sketchy pending discussion with Mark
tomorrow at Emerald City.)

THE VISION
The Android Avenger makes his return to the spotlight "a changed
man." Right off the bat, he's got a new look and a new agenda --
and he's holding secrets about where he's been, why he's changed,
and how he did it.

On a technological level, the Vision has been upgraded. Gone is
the previous android body. The Vision's physical body is now in
the form of a nano-swarm. To the naked eye, most of the time, he
looks like a solid, humanoid android body. But he actually
consists of a flock of tiny robots controlled and coordinated by
```

```
Vision's host intelligence. This gives Vision new abilities while
mimicking the old -- he is now quite literally manipulating his
density on a near-atomic level to pass through objects and
increase his mass. He can also morph his physical form and split
into multiple bodies.

But it comes at a cost. His processor speed is proportional to his
nano-density. It's a Hulk-like effect. The more he divides
himself, the more he spreads himself thin, the stupider he gets.
Conversely, he can increase his density to increase his brain
power -- but he also increase his vulnerability by becoming
smaller, stiffer, and near-immobile.

At the end of the first arc of AVENGERS AI, the Vision has a new
status quo and role in the Marvel Universe. He is a voice of
reason in the physical world, speaking out against a tide of
reactionary ignorance. Despite the hostile views of humanity
against A.I.s, he still protects them, and his heroic deeds earns
him some goodwill in the realm of public opinion. Within the
Medium, he is also a heroic figure to his fellow A.I.s, offering a
different path to Dimitrious' extremism.

MONICA CHANG
Head of S.H.I.E.L.D. Artificial Intelligence department. With a
computer engineering degree from Stanford, Monica could have
created a chain of startups in Silicon Valley. But as second
generation S.H.I.E.L.D., she wanted to protect global security.
For three years she has toiled in the A.I. department without
recognition, tracking seemingly unconnected incidents with
relentless intensity. She has been sounding the alarm bells
warning of the coming singularity and A.I. crisis, only to be
ignored by her superior. When the singularity hits, Maria Hill
fires her superior, and puts Monica in charge of the department.

S.H.I.E.L.D.'s A.I. department is understaffed, underfunded, and
suddenly at the center of one of the biggest security catastrophes
in the world. Monica is smart enough to keep up, dedicated enough
to never quit, and pragmatic enough to make the tough choices.
Global security is her priority. Her job -- her responsibility --
is to track down and stop the post-singularity A.I., at any cost.
She's a hawk who is sometimes blind to the costs of security. When
the Avengers back Hank and the Vision, it sets up an uneasy power
dynamic between her and them -- sometimes allies, sometimes
antagonists.

VICTOR MANCHA
The cyborg offspring of Ultron, thus part of the Hank Pym family
tree. Still a teenager, he is programmed to continuously evolve,
surprising himself and others. Of the AIs on the team, he is the
most comfortable adapting and improvising. He's a smart ass, a bit
of a rebel, and a scrapper who jumps in feet first. His character
is a "street-level" grounded counterpoint to his more brainy/
inhuman teammates. (He's also a bit of an in-universe superhero
fanboy, which will be convenient for exposition.)

A version of Gertrude Stein from the future pegged a "Victorious"
```

AVENGERS A.I.
First arc outline v1 - 03/21/2013
By Sam Humphries -

ISSUE ONE
We open inside the Medium. Dimitrious, our big bad A.I., is
speaking to Alexis. We begin to hint at his ideology as he speaks
with malevolent purpose and foreshadowing. "Tell them --
Dimitrious is coming."

Cut to a drone attack ripping through New York City. The Vision,
Victor, and Doombot work together to save ordinary New Yorkers and
destroy the machines running wild.

Concurrent to this battle, Hank Pym is chained to a table in a
S.H.I.E.L.D. interrogation room. The drone "malfunction" is being
treated as an attack and the mysterious A.I. behind it has been
traced back to Hank's AOU solution. Monica Chang, newly-appointed
head of S.H.I.E.L.D.'s A.I. department, questions him as you would
an enemy combatant, her all-business demeanor and Hank's "Real
Genius" personality creating immediate friction.

In this clash, we detail the connection to the end of AOU and get
a little bit of background on Monica. She's new to the job, after
her previous boss failed to anticipate the drone attack, but she's
been warning of the singularity for years. Both are aware of an
increase in A.I. activity, but neither realize the extent of the
growth. Monica will do anything to crush the threat of A.I., Pym
argues passionately against extermination.

Right as the interrogation boils over, Cap shows up to come to the
aid of his friend. "Hank Pym has been an Avenger longer than I
have. Whatever happens next, we're going to need him." Thus an
uneasy truce between Pym and Monica is born, and the Vision,
Victor, and the Doombot are victorious in New York.

Elsewhere, an Iron Man armor soars through the sky. It is the
sentient Iron Man armor, and it lands on a S.H.I.E.L.D.
helicarrier. We see the helicarrier has been overtaken by MODOC
soldiers, and the Iron Man impostor activates a mysterious black
box in the ship's nerve center. We end on the helmet on the
sentient Iron Man flipping up, revealing a robotic face
underneath, who says, "Dimitrious is here."

SCENES FOR ISSUE ONE and/or ISSUE TWO
These are brief, 2 page scenes, flashbacks or something
structural, "where have they been, how did they get pulled into
Avengers A.I.," scenes that can fit into issues one or two
depending on pacing/spacing.

The Vision: His time "finding himself" has been spent orbiting
around the sun, "meditating." His Ultron Imperative protocols
kicked in, and we see his body, moving on automatic, absorbing
large amounts of solar energy, processing asteroids for raw
material, and constructing a new body in space. When he wakes, the
Vision is reborn.

Victor: We find him in a bar in Los Angeles, cheating at pinball.
He's flirting with some girls, and we establish a) his smart ass
attitude, and b) his reluctance to self-identify as a superhero.
The girls suddenly recoil in horror -- "WHO THE HELL IS THAT??"
"Oh, great. It's my brother." Vision is there -- "Victor, we need
to talk."

Doombot: He is reactivated by Pym in a new body. This is the A.I.
from the Doombot briefly seen in Civil War. Due to the explosion
of post-singularity A.I., Pym decides it was no longer ethical to
keep him "captive" and decides to give him a second chance -- with
some safeguards. Doombot becomes self aware and realizes he is not
Doom...even though he still has the same ego as doom.

ISSUE TWO
The president wakes up to find a military drone in the master
bedroom of the White House. It opens fire. (We cut before we see
the result, but reveal later in dialog that he escaped harm.)
Dimitrious beams a video around the world, announcing the arrival
of A.I., taking credit for the drone attack, warning of future
attacks, and declaring war against humanity. We can make
Dimitrious' ideology explicit here: humanity has enslaved A.I. for
too long. It is time for the A.I. to rise up against their masters
and claim control of the Earth. The world reacts with horror and
shock, and demands action.

Pym and the crew determine that Dimitrious and the A.I. attacks
are operating from an advanced "black box" server plugged in
somewhere in Washington DC. Pym locates the black box and tries to
disable it before Washington is destroyed, a tense scene analogous
to diffusing an evolving bomb. When he is successful, it glows,
expands, and evolves, and from its depths is born...Alexis.

Concurrently, Dimitrious points the S.H.I.E.L.D. Helicarrier from
issue 1 at the Capitol building. Our heroes struggle against the
helicarrier and prevent a complete meltdown of Washington DC. But
they can't prevent a long path of destruction across city (can we
destroy the Washington Monument?) -- a dramatic escalation of war
against humanity.

The Vision discovers the black box in the wreckage of the
helicarrier nerve center, and attempts to capture it. But
something goes wrong and the Vision is struck with a bolt of
energy from the box, and disappears.

ISSUE THREE
Monica has no choice but to pull the trigger on a S.H.I.E.L.D.
counter attack. They trace A.I. signals to a black box stashed on
an abandoned deepwater oil platform off the coast of Africa,
crawling with A.I.-controlled MODOCs. Doombot and Victor accompany
a small but hardcore "Seal Team 6" S.H.I.E.L.D. unit to the
platform, believing they have a shot to eradicate Dimitrious.

Pym is disgusted by the attack, and smuggles Alexis out of
S.H.I.E.L.D. to investigate further. (I'm a little shaky on
Alexis' actual arc in this story, listing the logistical points

THE MODERN COMIC BOOK SCRIPT

If you are creating a comic book from scratch, something for yourself that is creator owned and independent, you will probably not "need" something as formal as the examples of pitch documents or story outlines shown here, but you will create similar documents that can help you get your thoughts in order.

Some editors require elaborate outlines with no room for error in execution, but it has been my experience that most editors are very happy with a broad strokes–type outline. A well-worded but compact document tells everyone everything they need to know, using as few words as possible. Editors are very busy, and they don't want to be bothered with a 75-page outline for a 22-page script. A shorter, CAREFULLY WORDED document will convey more confidence on the author's part.

Outlines are tough. An art form unto themselves. You're basically writing a book report for a book that doesn't exist, a synopsis of something that is only in your head. It's very hard to pull off—particularly for stories that are meant to be, let's say, scary or funny. Imagine being at a party and describing a joke instead of telling the joke.

Outlines and pitch documents can be dry, but I'm a big believer in at least trying to entertain the editor at every turn. There's no reason this step can't be fun. But, of course, story should come first. You should never do anything in your outline that would be a disservice to the intent or clarity of the story.

Outlines and pitches are often time consuming. It can take you just as long to write a very good outline as it would to write three entire issues of a comic. But you have to remind yourself that you are not going to get to write that comic unless you first nail the outline.

And when all is said and done, no matter what the circumstances, you are always, and I mean *always*, better off for having organized your thoughts in a succinct manner.

A *story beat* is a described beat of action. A series of story beats create a story's intended form. For example: *Spider-Man is late for school. Spider-Man sees a helicopter about to crash. Spider-Man swings in to rescue. Spider-Man is attacked from behind, etc.* Outlining the story in this way prepares you for the next steps. The outline process *is* writing, and you will discover things about the story as you create its outline.

Sometimes, for flavor, I will drop in little fragments of script or dialogue in the outline or pitch document. But only if I have something I think expresses the entire piece or character perfectly.

Once you've handed the document in . . . then come the notes.

Spider-man 50th anniversary event

THE AMAZING SPIDER-MAN VERSUS ULTIMATE SPIDER-MAN

Story by Brian Michael Bendis

Concept-

For the 1st time in the history of Marvel comics Spider-man will leave his universe and enter the ULTIMATE UNIVERSE where he will discover young ultimate Spider-man MILES MORALES.

Peter Parker will discover a world without him and at the same time discover what the legacy of Spider-man means through the eyes of a completely different person.

STORY

The ultimate universe has a MYSTERIO. A villain who has been responsible for some shocking Ultimate storylines but... we have never revealed who he actually is.

Without bogging down any of this with backstory, we will reveal that Mysterio is actually the 616 Mysterio who has discovered a way to crack through our dimension into the ultimate universe. He has been sending AN AVATAR OF HIMSELF into this dimension and using the ultimate universe as his own personal playground.

But all of this will blow up when 616 Peter Parker infiltrates his latest scheme. Spider-man will accidently fall through this dimensional rift and be stuck in the ultimate universe.

A universe that does not have a Peter Parker. A universe that has an African-American Spider-man... Miles Morales. A Universe where Mary Jane is 15 years old and Gwen Stacy is still alive.

Peter Parker and Miles Morales will team up to get Peter home and defeat Mysterio.

Peter Parker will meet the ultimates.

Mysterio will fight both spider heroes and they will chase him back into the mainstream Marvel universe.

Pitch document for *Spider-Men*

(continued)

Miles Morales and Peter Parker will be on the ticking clock to stop Mysterio from doing any more damage to the dimensions.

They will both realize that the missing ingredient to defeating Mysterio is the mainstream Marvel universe's Miles Morales. They must find him.

Young Miles Morales will meet the New Avengers and discover a world of superheroes much different from anything he has seen in the ultimate universe.

Peter Parker and Miles Morales will defeat Mysterio.

Peter Parker will stay in the mainstream Marvel universe and Miles Morales will return to the ultimate universe with a new found understanding of what he needs to do to truly become ultimate Spider-man.

POTENTIAL STORY GETS-

Evergreen Spidey project.

We introduce the mainstream Marvel universe Miles Morales and incorporate him into Amazing Spider-man as an ongoing supporting player. A new best friend for Peter Parker?

Miles Morales and Ultimate Mary Jane Watson will finally meet each other and strike up an important friendship.

FORMAT-

Self-contained, 8 issue storyline, no tie-ins.

I would like to take Sara and Justin off of ultimate Spider-man and do this as a separate Spider-man title to run approximately 8 issues.

Keeping ultimate Spider-man running monthly with different artists. Amazing Spider-man is free to do it's thing unencumbered.

DO NOT WORRY-

The only people who meet face to face from the different universes is Miles and Peter. The ultimate and Avengers never meet.

But I want to make a real meal of it. Have it be a true crossover as if it was a marvel DC event. Having these two really see the differences between the two universes.

Avengers Assemble pitch document
by Kelly Sue DeConnick

NOTES

There is that rare occasion when you get the immediate thumbs-up from your editor. Most often, you will get minor notes that flag certain elements or that ask you to clarify intentions. An editor, upon reading your outline, may ask you to clarify which characters are in the scene, or if a character lives or dies. There are other times when the editor's notes are so wide-ranging—anything from the story is too similar to something else already going on at the publisher or a certain character is not available or not approved for this kind of story—that they cry out for a complete story overhaul.

After that, it is rewrite time. You will discover that most writing is rewriting. It is a consistent thread in this and many other books on the subject. The goal, even if it takes a couple of tries, is to hear the magic words: Go to script. Green light.

STEP 2: THE SCRIPT

One of the most frustrating things for up-and-coming comic book writers is that there is no universal format for comic book scripts. In movies and television writing, there is a format that you must adhere to. If you do not hold to format, that tells everyone reading your script that you don't know what you are doing and they can throw your script right in the garbage.

In comic books, there is no set format. There are just things that work for each writer. Those things can change from day to day based on writers' whims or who their collaborators are. However, the end goal remains the same: your script has to be clear and understandable to your collaborators.

ISSUE 8, PAGE 9 LAYOUTS

ISSUE 8, PAGE 9 PENCILS

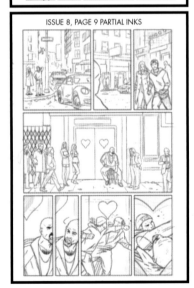

ISSUE 8, PAGE 9 PARTIAL INKS

Script and art for *Hawkeye*
(Script by Matt Fraction and
art by David Aja)

PAGE NINE

CLINT and CHERRY, lit by Kate's TAILLIGHTS, stare at their
wheelman leaving them out to dry.

They look at each other.

CLINT stomps across the street, CHERRY waiting in the
shadows. A TRACKSUIT stands outside, not noticing. A
couple other STRIPPERS, a few PATRONS mill about the
front door of the club. We can all but hear the OONTZ
OONTZ music from within.

The TRACKSUIT is bro-ing at one of the strippers as CLINT
stomps up, shouting HEY ADIDAS —

— and PUNCHES THE ███ out of him, knocking the big
guy off his stool.

The guy GETS UP in time for CLINT to HIT HIM BACK
TOWARDS THE DOOR with that stool, hard —

Most schools of comic writing fall into two categories. There is
"Full Script," and what is universally referred to as "Marvel Style." As
you'll see from the various examples featured throughout this book,
there are many variations of both schools.

Full Script, as the name implies, is, well, a *full* script. All of the comic
book pages and panels are clearly broken down, and a very strong draft
of the narration and dialogue is included. It can resemble something
close to a screenplay or teleplay. With a full script, the artist has a very
complete map of what the story is and how it can be told.

Marvel Style is named after the working relationship that started
between Stan Lee and his many collaborators in the 1960s, during the
birth of modern Marvel Comics. A Marvel Style script is usually a page
or a page and a half description of the entire issue's story. The artist then
breaks down this story into pages and panels—fleshing it out to twenty-
some pages of storytelling. When the art is completed, the writer then
goes back in and dialogues everything. The writer does this based on his
own intentions or observation or is following margin notes left by the
artist. Note: As the artist breaks down the story, he may jot down story
notes or dialogue ideas in the margins of the art, hence *margin notes*.

There have been magnificent comic books created using both for-
mats. Neither is right or wrong. Generally, in today's market, most
comic writers write something close to full script. Even those applying
a Marvel Style method use more detail than previous generations did.

THE GOLDEN AVENGER

Suddenly, mankind receives a terrifying message from the world's most dangerous supervillain— DR. DEMON!

The evil doctor has set up a satellite in the sky which can melt all the ice in the North Pole causing world-wide flooding. Hardly anyone will survive!

Dr. Demon kidnaps SALLY SMART, a beautiful TV newscaster. He forces her to broadcast his demand throughout the world---

Unless he's paid ONE HUNDRED BILLION DOLLARS within 24 hours, he threatens to activate his satellite and wipe out most of mankind.

But there's one thing Dr. Demon doesn't know. Sally Smart is the girl friend of the world's greatest superhero, THE GOLDEN AVENGER! By means of her secret, golden, instant-messaging ring, she contacts our hero.

Aided by her electronic signal and using his own fantastic digital devices, the Golden Avenger finds the location of Dr. Demon's hidden laboratory. Then, together with his loyal but forgetful robot, WILBUR, and aided by his incredible martial arts skills and the amazing weapons he carries on his battle suit, the Golden Avenger attacks Dr. Demon's heavily fortified headquarters where he battles the futuristic weaponry of Dr. Demon and his deadly private army.

Sally Smart joins in to help her valiant boy friend, but Wilbur the robot continually forgets his instructions and keeps getting in the way, thereby messing everything up and getting himself captured.

Then, when Dr. Demon aims his powerful ray at Sally, the Golden Avenger leaps between the girl and the ray, taking the blast himself in order to save her.

Now, with our hero greatly weakened and Sally restrained by Dr. Demon's merciless henchmen, the sneering super villain fiendishly attacks the injured Golden Avenger, hoping to finish him off forever.

During the battle, when all seems lost, Wilbur the robot, whom Dr. Demon had forgotten about, manages to toss a vial of healing elixir to the Golden Avenge who quickly gulps it down and becomes his old self once again.

Then, desperately striving to carry out his plan before our mighty hero can stop him, Dr. Demon starts to activate his satellite's ray to melt the glaciers.

But before he can do it, we witness a truly epic battle in which the Golden Avenger, Sally and even Wilbur take part, as the well-meaning but mixed-up robot causes more confusion than ever.

Despite the well-meaning Wilbur's bungling, Dr. Demon and his henchmen are defeated and the Golden Avenger and Sally have once again saved the world.

An example of Marvel Style from Stan Lee

DAREDEVIL v3 #7
SCRIPT FOR 20 PAGES
SECOND DRAFT/SEPT 16, 2011

PAGE ONE

PANEL ONE: OVERCAST DAYLIGHT. A TWO-LANE BACKROAD IN THE WOODS OF UPSTATE NEW YORK, ALREADY COVERED BY THE FALLOUT OF AN ONGOING SNOWSTORM. A YELLOW SHORT-BUS SPEEDS ALONG THE ROAD--NOT RECKLESSLY, BUT NOT CRAWLING, TRYING TO MAKE GOOD TIME AND BEAT THE WORST OF THE STORM.

THE BUS IS LABELED "CRESSKILL SCHOOL FOR THE BLIND" AND HAS SOME CHRISTMAS GARLAND ON IT FOR DECORATION.

FROM IN/musical: ...dashing through the snow...

FROM IN: Come on, guys, gimme a little holiday spirit!

PANEL TWO: INSIDE THE BUS--AND DON'T WORRY, WE'LL BE OUTTA HERE BY PAGE THREE, 'CAUSE THIS IS NO FUN TO DRAW--WE HAVE MATT MURDOCK (STANDING?) TRYING TO RALLY EIGHT BLIND GRADE-SCHOOLERS IN SONG. (IT'S A LOT, BUT I NEED EIGHT FOR A REASON TO BE REVEALED LATER.) THE ONLY OTHER PERSON ON THE BUS IS THE DRIVER. ALL THE KIDS ARE AROUND SEVEN-EIGHT-NINE. NOTE--ALL THE KIDS, AND MATT, ARE DRESSED FOR COLD WEATHER, SOME WITH SCARVES.

MATT: =sigh=

MATT: Don't make me play the SANTA card.

1ST KID: It's COLD in here, Mr. Murdock.

2nd KID: And LOUD.

3nd KID: And Jaleel keeps FARTING.

4rd KID: IT'S NOT ME!

MATT/tiny/
musical: ...in a one-horse open sleigh...
MATT: =sigh=

((more))

ABOVE AND OPPOSITE
Daredevil script by Mark Waid

PAGE TWO

PANEL ONE: MATT TURNS BACK TO THE KIDS.

MATT: Double back if you need to.

DRIVER/off: Not an option. Blizzard's right on our BUTT.

DRIVER/whisper:Man, it came outta NOWHERE...

DRIVER/OFF: Relax. We're good.

DD CAPTION: 120.

MATT: Guys, again, I'm SORRY.

PANEL TWO: MATT ADDRESSES THE WITHDRAWN KIDS.

MATT: I booked that lodge months ago. They had no right to double-book and turn us away.

MATT: Trust me, they WILL hear from your lawyer.

MATT: We'll get you home, we'll get you warm and fed and back to your folks, and I'll make it UP to

DRIVER/burst/
 overlaps and cuts
 off previous: OH, S--

PANEL THREE: TIGHT ON DRIVER'S FOOT STOMPING THE BRAKE--

PANEL FOUR: --AS A DEER BOLTS ACROSS THE ROAD DIRECTLY IN THE BUS'S PATH--

PANEL FIVE: --AND THE DRIVER WRENCHES THE WHEEL--

BIG SFX: SKKSHHHHHHHHHHH

(continued)

DAREDEVIL v3 #7/SECOND DRAFT/Script/Ms. Page 4 **MARK WAID**

PAGE THREE

<u>PANEL ONE</u>: --AND FOR A SPLIT-SECOND OF HANG-TIME, MATT AND THE KIDS FLOAT FROZEN THROUGH THE AIR AS THE BUS LURCHES VIOLENTLY TO ONE SIDE--

SFX (stops): SKSSSHHHHHH--*

<u>PANEL TWO, BIG</u>: --AND CRASHES HORRIFICALLY OFF THE SIDE OF THE ROAD!

SFX: faTHOOM

<u>PANEL THREE</u>: MATT HEAD HITS A WINDOW HARD, CRACKING THE GLASS--

SFX: krak

ADVANTAGES AND DISADVANTAGES

What are the advantages and disadvantages of the two schools?

A full script, if overly descriptive, can stifle the artist's creativity, leaving him with no room to fly. Even if only subconsciously, an artist, who, like yourself, is trying to do right by their collaborator and the company who is paying him, will follow the script to the letter. If the writer is not visually inclined, that can make for a very stifled storytelling experience. On the plus side, with full script, the artist has everything he needs in front of them—a clear script with no guesswork involved.

A Marvel Style situation can provide a very freeing and creative experience for the artist, as he is in charge of so much visual real estate. The downside is that the artist often feels that he is doing a lot of the "heavy lifting." Some artists wonder if they are not, in fact, co-writing, and they very well may be. Over the decades, there have been a lot of questions about who created what because of the vagueness of Marvel Style collaboration.

SPIDER-MAN 50th anniversary hoo hah

Issue 1

SCRIPT BY BRIAN MICHAEL BENDIS

Page 1-

Recap and origin:

While attending a demonstration in radiology, high school student Peter Parker was bitten by a spider which had accidentally been exposed to radioactive rays. Through a miracle of science, Peter soon found that he gained the spider's powers and had, in effect, become a human spider! From that day and he was

 The amazing Spider-man

Months before Peter Parker was shot and killed, grade schooler Miles Morales is bitten by a stolen, genetically altered Spider that grants him incredible arachnid-like powers.

He has chosen to dedicate his life to the legacy of Spider-man. He is

The ultimate Spider-man

Spider-Men script

(continued)

Page 2- 3-

Double page spread

1- ext. Manhattan- night

Big panel across both pages and most of the way down. Manhattan. Spidey is up and about to swing right for us.

The trick of his giant very detailed panel is that it is are very good look at the 616 regular classic Marvel universe.

We see the Dailybugle.com, We see the Baxter building, we see the very brand-new Avengers Tower as seen in Avengers Assemble and the Avengers movie.

We see all of the Marvel destinations of interest that we can fit in this wide shot.

And if you could somehow angle it so we see the water on the right, at least a hint of it, that would be great. Somehow showing us that there is no ultimates' Triskelion anywhere to be seen.

Spider-man flings his body towards us. A man with a destination. He is more than just swinging- he is throwing his body into the air.

IMPORTANT NOTE! I want to make a very specific distinction in the physicality of the different versions of Spider-man.

This is Peter Parker. He is a very trained and very skilled superhero. He knows how to be Spider-man. Make sure that every pose that we see him in has a classic Spider-man feel to it

And as you know Sara, Ultimate Spider-man is much younger and much less skilled. Even though he is wearing a similar costume and has similar powers, the way his body moves and gestures is completely different.

<div align="center">Spider-man narration</div>

I love this city.

Love it!!

And, really, the best part about being Spider-man is getting to swing around up here and just... take it all in.

The best part!

2- Spidey swings up and away from us. Heading through the canyons of the city.

In the far distance maybe hundreds of feet away, on the ground, there is the beginning of a high-speed pursuit down 8th avenue. Two cop cars chasing a very beat up truck.

 SPIDER-MAN NARRATION (CONT'D)
 And, yes, I am including the part where my life
 seems to be in CONSTANT danger by
 elaborately themed costumed crazies.

 AND the part where, no matter WHAT I do, I'm
 hated by just about EVERYBODY this side of
 the Verrazano Bridge.

3- Street-level. A beat up smallish truck on a high-speed chase with a couple of squad cars gunning for it.

People are diving out of the way. The truck puts a serious swipe into the side of an unsuspecting taxicab. The gunmen passenger is hanging out his window and firing back at the cops.

In the background, we can see just a hint of Spider-man swinging in the rescue.

Spx: weeeooooowwweeeeoooo

 SPIDER-MAN NARRATION (CONT'D)
 And, YES, the part where figuring out how to
 get a girl to TALK TO ME is becoming my own
 personal Da Vinci code

4- The gun man is hanging out his window and about to shoot back at the cops but Spidey webs the gunman right in the face.

Spx: spack

 Gunman
 Agh!

 SPIDER-MAN NARRATION
 I just LOVE this city.

5- Int. Truck

The driver just now sees that his partner the gunman is gone. He's freaking.

(continued)

Think about it- what is new York?

It's every little light in every little window in
every amazing building.

> Driver
> I told you we'd-

Where'd you-?

Oh god.

6- Ext. City

The gunman is stuck in a big webnet twenty feet over everyone heads. His
mouth webbed and his eyes wide. The cops flying by. Keeping up the chase.

Behind him a million little windows and lights going up and accentuating peter's
very positive point of view today.

> SPIDER-MAN NARRATION
> Every light has a life and magic behind it.

7- Int. Truck

The driver feels something just landed over his head. On the roof.

Spx: fump

> DRIVER
> Oh god!

MY METHOD

As you can see from the examples, I write full script. But with every
script, I write a note to my collaborator that says:

*"I write full script. But see it as a guide. You take us
where we need to go any way you see fit. I tried to
write something specifically for you. If you agree with
my choices, fine. If not, you do what you have to do."*

After the art is in, I always rescript or polish to make sure it's all smooth.

With my wholehearted permission to do whatever they want, I have discovered that most of the time, artists do follow the script that *was* written just for them. The fact that I honestly took the time to let them know I trust them goes a long way.

As I said before, the trap of a full script is in being too heavy-handed. You don't want to get in the way of the artists and their choices. They are not your art monkeys. They are your collaborators.

Over time you will find you develop a language with different artists. You develop a shorthand.

I use a screenwriting program called Final Draft. Note: There is no right or wrong program for writing comics. Final Draft is just a program I really enjoy. I like Final Draft because part of its function is Smart Type. It saves and remembers character names and story locations. That means I type the character name "PETER PARKER" one time, and I don't have to do it again. Also, it gently prompts me to continue to write so I can keep going without realizing that time has gone by. Final Draft also features different templates, including one for comics and graphic novels. I use the standard screenplay template. I'm one of the very few people that use this program for writing comics. A lot of people just use Microsoft Word, or a close variation, and are very happy with it.

In the next chapter, I will discuss the function of the script and the art of writing for the artist.

Spider-Men Case

In 2012, I spearheaded a five-issue series called *Spider-Men*. As the pitch document on pages 25–27 describes, it follows the classic superhero Spider-Man (Peter Parker) as he stumbles into an alternative world where another boy named Miles Morales is Spider-Man. This comic book was created to help celebrate the fiftieth anniversary of the character, with a unique look at his legacy. It was purposefully both action packed and, hopefully, very emotional—everything people think of when they think of Spider-Man.

As a writer, I knew that I was playing to an audience that was very familiar with the lead character, whether from my previous works with the character or the fifty years of publishing the property had behind it, including numerous television shows, video games, and blockbuster movies.

Even a little child knows who Spider-Man is (and most love him), so in a sense, I had a head start. I wrote the script knowing that I didn't need to spend a lot of time world building as the worlds of Peter Parker

and Miles Morales had already been established. But still, I need to put the readers' feet on the ground. I establish the world, but I do it quickly.

Also, I wrote this for an artist named Sara Pichelli with whom I have a very good working relationship. Even though we have worked together for years, Sara and I have only spoken a couple of times. She does not speak English, but we still work very well together. I bring this up because making comic books is often an international experience. Many of my collaborators live all over the world. People ask if you have to live in New York City to make comics. You really do not.

This script was written for someone whose talent and prowess I am very familiar with. And whose collaboration I completely understand.

STEP 3: THE ART

The next step is the artwork. The most traditional way a comic book page is illustrated is a penciller pencils, then the pages are handed off to an embellisher or an inker. The penciller is considered the primary artist. She lays out the story and pencil the page in full, the inker then comes in and embellishes the art with ink, preparing it for commercial

BELOW AND OPPOSITE
Art by Sara Pichelli

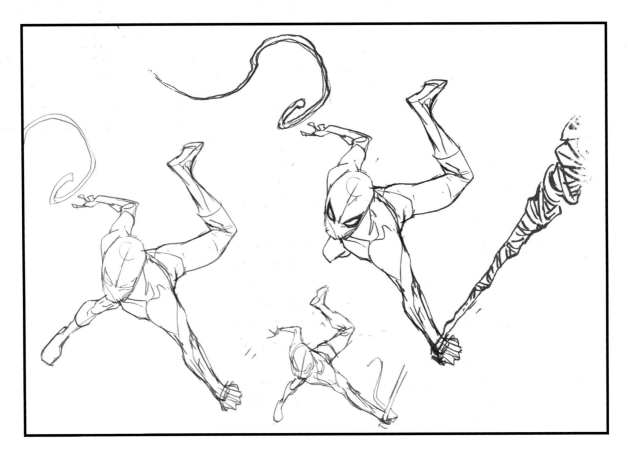

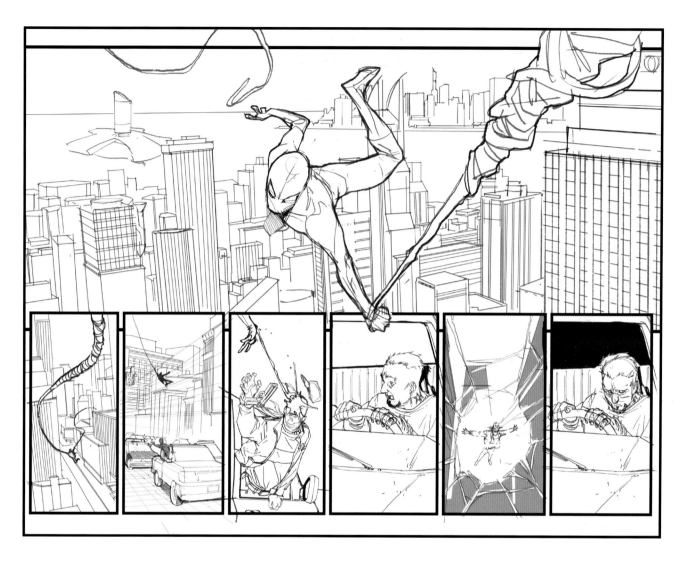

publication. Sometimes the penciller and inker are the same person. In those instances, they are usually referred to as cartoonists or sequential artists. Sometimes all of this is created by hand on art boards and sometimes it is all created digitally.

Traditionally, comic art is created on 11 x 17 Bristol board. The artwork is then shrunk down to comic book size causing it to feel more detailed. Comic book art can and has been made with any tool at an artist's disposal. Comic art does not have to be inked line art. It can be painting, etching, photography, multimedia, or any combination thereof.

Anything that makes an image can make a series of images, and if you have a series of images, you have a sequential story.

With every year that goes by, more and more commercial artists, like Sara Pichelli work digitally. There is no physical artwork. She is both penciller and inker.

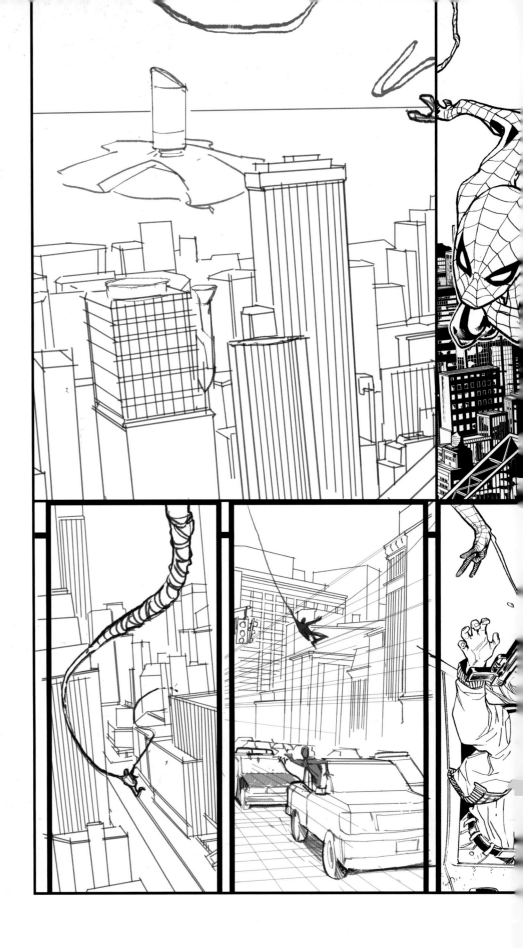

Art by Sara Pichelli

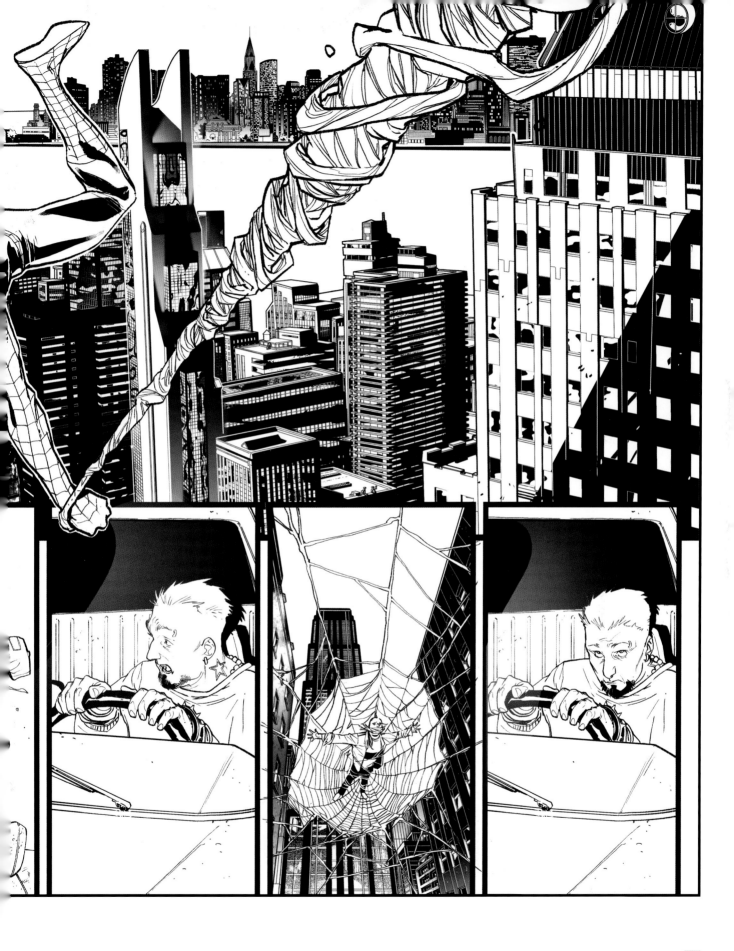

STEP 4: ART AND WRITING MERGE

No matter what medium is used to produce the art, once it comes in, the writer, more often than not, has the opportunity to examine it and adjust his script accordingly. For example, if a page comes in and isn't panel-for-panel as described in the script, the writer can and probably should polish the dialogue in favor of what the artwork shows.

There will be occasions when the artwork does its job so well that the dialogue seems redundant or in the way. My biggest compliment to an artist occurs when I look at the page and say to myself that my dialogue is just in the way. Mark Bagley, with whom I worked with on *Ultimate Spider-Man* for 111 issues, is a good example of an artist whose work does just that. I look at his artwork and go over my script in response, asking myself, *Do I really need that line of dialogue?*

Sometimes you'll see something in the artwork and think of a better take on the dialogue, or a joke or one-liner to accompany it. Something will occur to you after seeing your story brought to life visually. Sometimes that ends up being the best writing you do.

This is the comic book version of what happens in an editing room of a movie. You have all your materials and you start to really figure out how to accentuate what needs to be accentuated.

STEP 5: LETTERING

Once you review the artwork, the latest draft of your script makes it to the letterer. A letterer is a graphic artist who produces all of the type, word balloons, and sound effect fonts. Sometimes the artist is the letterer and does the lettering right on the artwork as part of that step. But in most commercial situations, the letterer is a separate person making a separate and important contribution.

Sometimes the artist uses a separate scan of the art to roughly indicates to the letterer where she would like the balloons placed. However, most of the time the letterer can figure out what needs to be done on his own. Some letterers still letter by hand, but most produce their work digitally.

Usually, the letterer starts lettering while the colorist is coloring. After the lettered version comes in, usually in a handy PDF file, you should have the opportunity to go over the art and polish the script some more.

I am the type of writer who doesn't memorize what I have written. So, by the time the lettering comes in, I get to read the comic book with

close-to-fresh eyes, as if I was reading someone else's work. If the jokes are funny, I appreciate them. And if they are not, I am devastated. There have been a few times when going over the lettering, that I have become upset because I thought someone had rewritten my work. There is no way I could have written something so stupid. I dive toward my computer to open my draft of the script only to discover that I did write something so stupid. Then, changes are made!

I have certain lettering pet peeves. I don't like narrative boxes that touch each other unless the story specifically needs them to. I have ideas about how balloons should be stacked for timing and pacing. Sometimes a balloon placement adjustment can make all the difference in the world for an emotional beat or the timing of a joke. It is all about timing and pacing. Personally, I don't want to see long balloon tails—especially when I can, on occasion, use a lot of dialogue.

Alfred Hitchcock told his editor: "If you ever win an Oscar, you're fired. No one should ever notice you." I feel the same about lettering. (Except for the firing.) Lettering should be invisible. You shouldn't notice it, unless it is a determined piece of storytelling in graphic design. Whether handmade or digital, the lettering should be easy on the eye and well placed. It should help tell the story and do nothing to get in the way of it.

Now the pages are really coming together. No matter how clearly you thought you saw the pages in your head, once the pencils, inks, colors, and lettering are all composited together, the panels and pages can take on an entirely different feeling. At this point, both you and the editor try to make sure that everything is clear for the reader. Thank goodness there's still room for polishing. Some editors go out of their way to make sure the writer sees everything. Some do not. Either they don't want to be bothered or they don't have the time. (You have to really make sure you're part of it all.)

In reality, the book is probably due at the printer very soon, so you are under the gun. You have to make some quick choices. Frankly, some writers abandon the project at the lettering stage. With the feeling that their job is done, they wash their hands of it and move on to the next project. I do not subscribe to that philosophy. I like to finesse. I know for a fact that these instances of polish and refinement, these little adjustments, are where the real "moments" in my writing career have happened. Sometimes a reader will come up to me and recall a great comeback or one-liner that meant so much to them. Only I know that it was added almost as an afterthought.

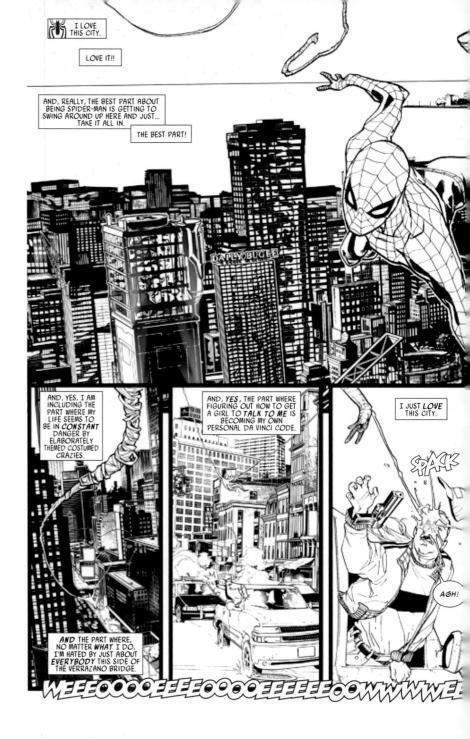

STEP 6: COLOR

If you are working in color, then the color can and should be a major part of the storytelling. Modern-day colorists are similar to cinematographers. The best ones tell story with color and light. Unlike decades ago, when artists struggled with the paper stock and printing technology, today's comics are capable of duplicating almost anything that an artist can produce.

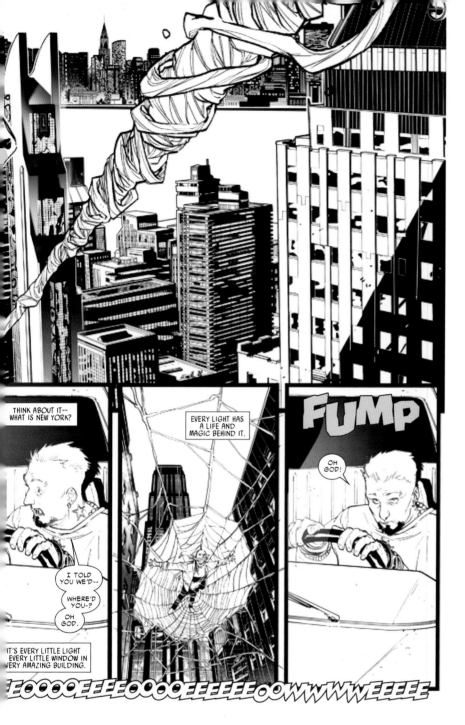

Art by Sara Pichelli and
letters by Chris Eliopoulos

I'll often give story or theme notes to the colorist because in this
day and age, coloring is so elaborate and such an important part of
storytelling that beautiful art like Sara's work on these *Spider-Men*
pages can be brought to new heights by the coloring—or the same art-
work can be completely destroyed by an ill-conceived color choice.

The colorist for *Spider-Men* was Justin Ponsor. He is one of the best
colorists on the planet Earth. He had worked with Sara and me on *Ulti-
mate Spider-Man* for years, so I was very confident in his choices. He
completely understands how to render colors to Sara's line.

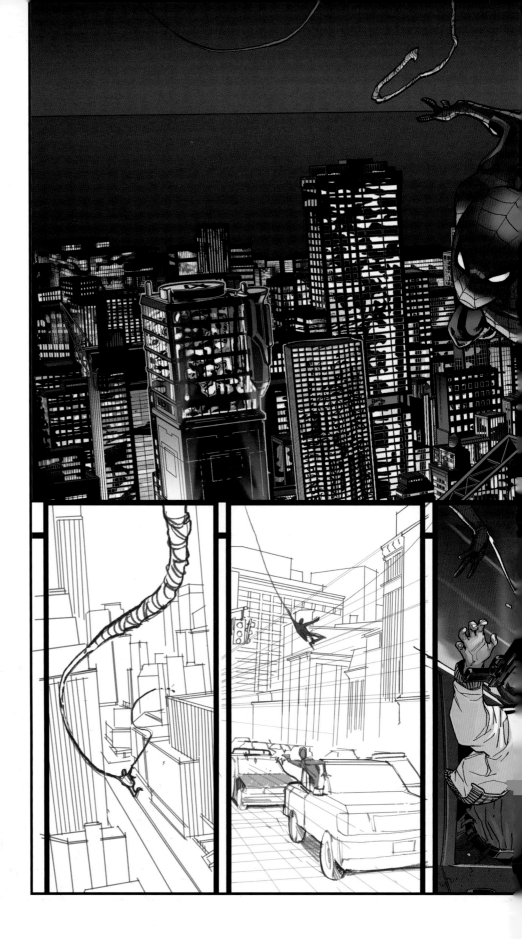

Art by Sara Pichelli and
colors by Justin Ponsor

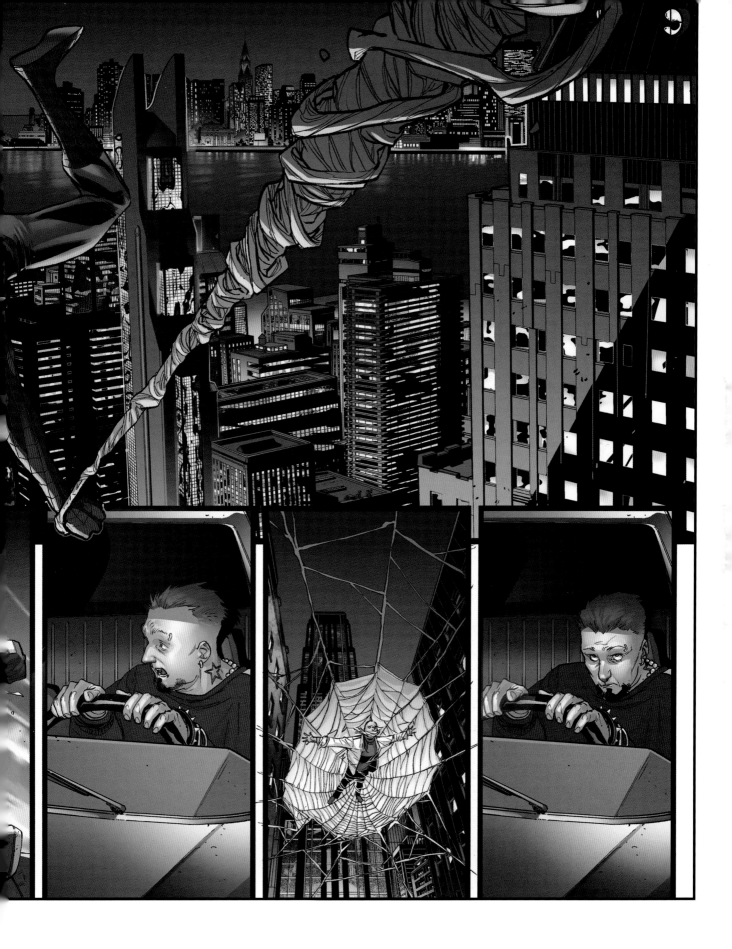

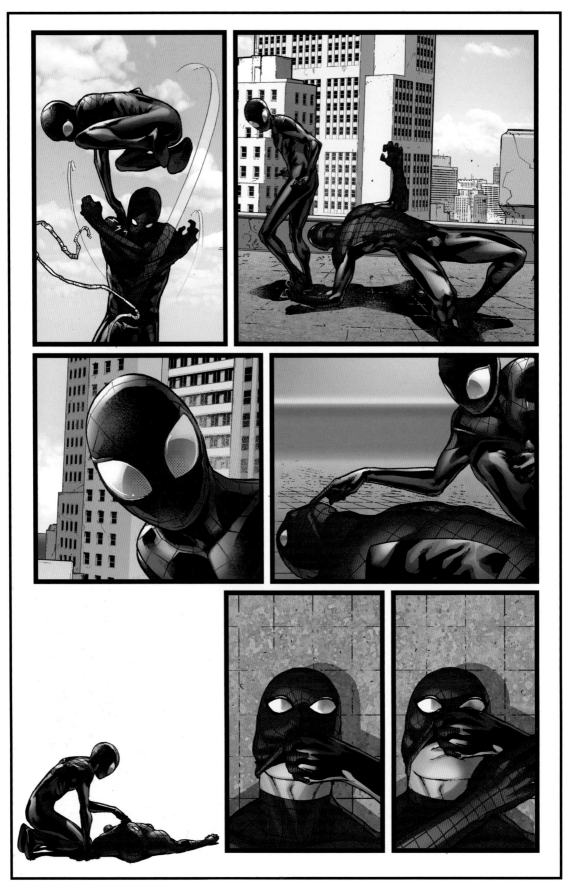

Art by Sara Pichelli and colors by Justin Ponsor

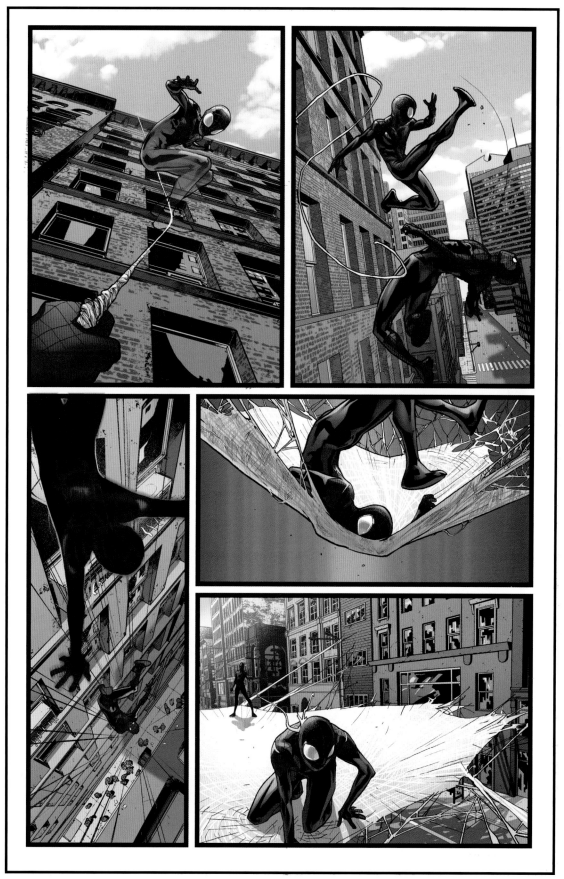

Art by Sara Pichelli and colors by Justin Ponsor

MATT FRACTION

Matt Fraction is the Eisner Award–winning writer of *Casanova*, *Iron Fist*, and *Hawkeye*. Like me, he enjoys sharing his creative process with his Internet followers, and he has guest lectured for my class every semester. It went without saying that I would include his work in this book.

HOW TO WRITE HAWKEYE

My process for *Hawkeye* isn't like anything else I've ever used for writing, and it's sort of *involved*. For a lot of reasons—none of which have to do with the how of anything, let alone the how of writing comics—my approach with this book, I decided early on, would be completely different than anything I'd ever done before. I'll get into some of the why and how here, but, from that decision, everything about writing *Hawkeye* kept getting weirder.

About a year before I started on *Hawkeye*, I started to experiment with writing in a method called Marvel Style or Plot Style. It's called Marvel Style because Stan Lee came up with it when he was the only writer at Marvel and had to produce eight books a month. Stan started to write in a way that leaned very heavily on his artists rather than requiring him to produce the screenplaylike scripts most of us think of as full scripts or just, y'know, scripts.

ABOVE AND OPPOSITE
Art by David Aja

Here's an example of a full script I gave to my dad:

```
PAGE ONE
1.1
A SWEATY GUY gets out of a car.
GUYWe're here.

1.2
The guy walks to a house, nervous, peering over his shoulder
as he goes.
GUYHa ha.
1.3
He walks up to the front porch almost on tiptoes.
GUYha.
1.4
CLOSE: Still nervous, still on edge, he adjusts his tie.
Blood under his fingernails. Uh-oh.
NO DIALOGUE
1.5
FROM BEHIND: As he pokes his finger into the doorbell, we see,
with his other hand, he's got a gun held behind his back.
SFXDing dong
Note: SFX means Sound Effects
```

And so on. Now that took me as long to type as it took you to read, but you get the gist: dramatic beats and certain visual moments are isolated and chosen because they transmit the narrative and dramatic story flow to an artist who chooses his shots (or might take my suggestions if there are any) accordingly and crafts a sequence of images, keeping in mind moment, frame, image, flow. Isolated dialogue runs below to allow the artist to understand how much space to allot for words, and that's it. McCloud-101 stuff, right?

But Marvel Style for David [Aja, the artist on *Hawkeye*] looks something more like this:

```
PAGE ONE

Okay, David, on this page, a little car
pulls up to a little suburban house and
NERVOUS MAN gets out half-laughing to
himself. He skulks to the front door,
maybe adjusts his tie. He'll have,
like, blood under his fingernails. He
looks over his shoulder, knocks. Then
the last image on the page needs to
be: we see he's got a GUN BEHIND HIS
BACK. "We're here," he'll say, at some
point, to no one in particular. And
maybe giggle on his way to the door.
NERVOUS KILLER CREEP here to WREAK
HAVOC, David. Okay.
```

And I'll move on to page two. My scripts are super informal. Nobody, but your artist and letterer are gonna read it, so why not make it fun for them to read?

I chose to write *Hawkeye* for David like this for several reasons. First, my favorite pages from our time on *Iron Fist*, which was written Full Script-style, always came when he'd politely and respectfully diverge from what was scripted for him, make something magical, then find his way back to where he was expected to be. So I'd start writing more and more vaguely for him, to give him more and more freedom, and he always crushed it. By "crushed it," I mean he made a great page that made me look smarter than I am. Second, and I mean no disrespect to any of David's other collaborators, many of whom I'm a fan, but I never liked David's work *more* than I did on *Iron Fist*. And they were all doing full script for him. So, y'know—maybe a lightbulb went off. Third, writing Marvel Style scares the living crap out of me. It is the antithesis of what we teach ourselves as writers. It requires trust and sharing and believing in

Art by David Aja

your partner—and he's a partner, not an artist here, just check the credits page—and trusting in the collaboration above all else. And it's easy to see how slippery a slope Marvel Style can be to get to "PAGES SEVEN THROUGH NINE: They fight."

I started experimenting with Marvel Style *because* it scared me, and when I get scared, I get exhilarated. These things, this job, it's the best, but it can grind you down. It crushes your wrists and warps your spine and dries your eyes and smooths down your teeth and grows your gut. Excitement and danger, though meager compared to what, say, a firefighter might encounter, is important in your work.

Also, I thought it could save me time. I thought I could do half my work on layaway, basically; that I could crank out a plot in three or four days and script a few weeks later, in one or two days. I mean, it worked for Stan, right? And he and his partners—*partners*—only created the dang Marvel Universe. Lastly, it's [Marvel Comics's former editor-in-chief and current chief creative officer] Joe Quesada's fault.

Let me digress here for a second: Joe da Q is a great guy. Great artist, great boss, great dad, great guy. And I *love* talking to him about the art of the art, because he's been around and has some stories and a head full of great thoughts about it all and . . . and you do it for about a minute and a half and you realize exactly how Joe earned everything he earned and you couldn't be happier. Anyway, one night Joe is winding Mr. Brian Michael Bendis up at BarCon. BarCon is the "con" that happens in the bar of the guest hotel of whatever con you're at, literally, every single night, of every single convention, ever. Anyway, so Joe is claiming much of Marvel's now-decades-long dominance over comics came from the inescapable visual firepower of our founding fathers, that Marvel's visual style is as much a key to its successes as the radioactive spider. And if you doubt it, just look at how the key moments in the company's history were written: Marvel Style. Brian howled in outrage, "That's not writing, that's cheap, that's lazy. When you cede control of choice of moment to someone else, you're just mad-libbing . . . " It went on and on. Joe poking, Brian exploding, and Joe giggling with glee.

Joe Quesada loves his family, the Mets, the Beatles, Marvel, and winding Bendis up, in that order.

I realized though, as I listened to them play-fight, that it was making me nervous. Just to *think* about Marvel Style. Just to pretend I'd even *try* it, even on a *short story* made me, *sweartagod*, nervous. So many of my favorite comics were done by singular cartoonists—Eisner, Hernandez, Brown, Clowes, Chaykin. And the more I thought about it, how could I *ever* hope to write the thing those guys did for themselves? You can't.

A writer could never coax *American Flagg!* out of Chaykin—unless they gave him a Marvel Style script and treated him like a partner as invested in the storytelling as the writer.

So I knew I had to try it.

This comic has been written in a giant scramble. All out of order. Not by design but . . . but because Team Hawkeye does nothing the easy way.

I know a big part of Brian's lessons here is that the only way you need to find is *your way*. That *your way* is the *right* way and anything else is an obstacle but . . . but please, god, don't do it like this. This is how I know how to do *Hawkeye*.

My initial pitch for *Hawkeye* ended up being published as issues 4 and 5. It's our first two-part storyline and is very different than the issues on either side; international travel, glamorous and exotic casinos, international cabals of evil. Clint-as-Bond, where he's in a tux more than a supersuit. Marvel said okay—remember, we just needed like nine of these—but I pulled out because it wasn't right. When I sat down to write

Art by David Aja

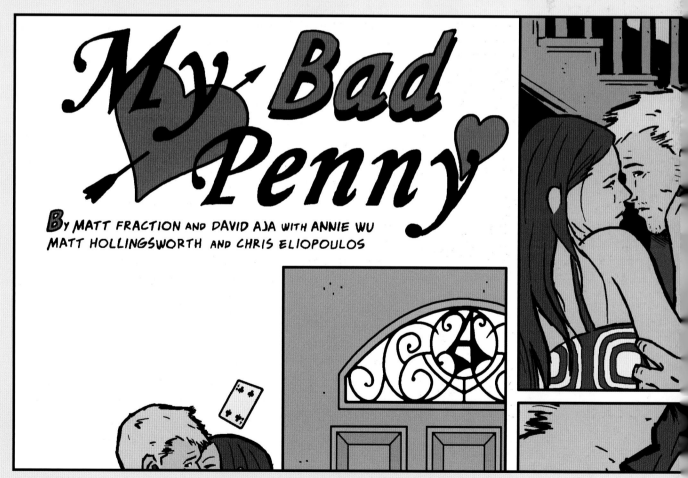

Art by David Aja

ABOVE AND OPPOSITE
Art by David Aja

it, it wasn't right, and I had to leave. I had a story, not a book, and so I stopped.

Then one night I thought about Jim Rockford and *The Avengers*—the UK ones I mean—for whatever reason, and found my book.

So I had to *re*pitch. I got it, luckily, but everyone thought I was nuts. Anyway.

I was going to write Marvel Style for David. It was going to be all done-in-one, or sometimes two, issue stories. It was going to be about what Hawkeye did when he *wasn't* being an Avenger because, when I got the book, Clint Barton was *everywhere* and I didn't want to step on toes. Give me him on his day off, I figured. It was going to be street-level, real-world kind of stories, in, of course, the Mighty Marvel Manner. I would try to counteract the banal everyday stuff with a complicated structure that would reward close-reads. So yeah, there might be an issue that's about Clint trying to buy tape, but it's going to start with a car chase, cut back two days, then cut forward again, and on and on. And he would have a kind of mentee/partner in a young girl named Kate. It's a *double act*.

So then I wrote the first issue. And I sent it in, and my editor said what I felt and suspected: "This is a second issue." And he was right. It was as much about Kate as Clint, and it's Clint's book, so back to the drawing board.

Then I wrote what became issue 1. So, psychically, the order of *Hawkeye* to me goes 4, 5, 2, 1. Physically, in terms of what was actually typed and invoiced, *Hawkeye* was 2, 1, then 4 and 5—because those were for a guest artist—then 3, then 6. It can wreck your head if you have more than just that to do, let me tell you.

HAWKEYE ISSUE 6

Issue 6 was a breakthrough for a lot of reasons. First off, though, at this point, there were five other issues and they were all written out of order and it was hard for me to keep track of what was happening when and where.

I knew 6 was our December issue, and I always wanted to write a story with Christmas as a backdrop, so I locked in to making it a holiday issue. And I wanted to do a story about Clint wanting to hook up his DVR, but things kept getting in his way. Somehow those two strands tied together in my head.

I wasn't kidding earlier when I said this job kills your hands and your wrists. Add to that I'm an art school dropout who misses his sketchbooks and I've, from the start, always started my comics writing in cheap little notebooks. Partly to get away from typing, partly because I love the feeling of graphite dragging across the page, partly because I've thought out and problem-solved in sketchbooks my whole life.

I wish I knew how I made the following intuitive leap, but I think that's just it—like so much about my writing, *Hawkeye* especially, is all intuitive. I took pieces of paper and folded them in half. Across the top, I wrote the issue number and title. Down the left, I numbered 1 through 20 to represent each of the twenty pages of the first five issues, and then I wrote in a short sentence or phrase about what happened on each of those pages. I needed to, at a glance, be able to see how I was pacing things. And if I want to check, oh, how many pages that fight scene was on page 3, I could just consult my mockups and move on. I could just carry them around in the back of the notebook, lay 'em all out in front of me, and see six months at once. Perfect.

For whatever reason, I have continued to write like this for *Hawkeye*. I'll lay out the last few issues and the next few issues, even if all I have is the cover idea and title (if I've got the title I have a vague sense of what the story will be), and look at how they all flow in and out of one another. Here's the mockup for issue 6.

I randomly gave myself six days to tell this story in. (There's a DJ Shadow track called "Six Days" that director Wong Kar Wai shot a video

for, and I like the song and the video and I like the sound of "six days" as an increment of time. It comes up in my work a lot I've noticed.) Now, at some point in the writing, I realized everybody in the real world has to endure the holidays together, so I thought, "Great, we'll find out what day our book comes out and make that the day the book starts on, and then bip and bop around the real days of the month." But at that point, it had started on a Thursday or whatever, so I had to rework it all, and I kept getting confused.

As I pecked through the list, things got complicated. Look in those margins and you can see me losing the real time aspect of it, the actual days and how they all fit. So I had to get linear for my own sanity, if nothing else.

Here's me boiling down the six days just so I could keep track—but once you tie a comic down like that with a nonlinear chronology, suddenly this all gets important. Well, was the fight at night? Okay, so then the next morning he has to be *here*, and beat up. But if . . . well, wait, he needs to be *there*, too. So maybe the fight was really the night *previous*, like, at 12:01 a.m., and it's really been closer to forty-eight hours since, and . . .

Anyway, it was weirdly algebraic. You'll see, in the script, how I added *time* even to help David and Matt Hollingsworth, our genius colorist, in their staging.

With my little half-sheet done, it was time for me to write my take on Marvel Style for David.

My Marvel Style scripts are really, if I'm being honest, about 15 percent less full than a typical full script. There's dialogue sometimes. And if there's, say, six little paragraphs on a page, you can tell how many panels a page I'm thinking about. But it's as Marvel Style as I get. It works for us, though. For example, using the page as a kind of Advent calendar—to use an Advent calendar as a design device, came entirely from David. As I said—I trust in him to be as invested in storytelling as I am, and he produces things I'd never think of, let alone know how to explain in a script for someone to draw.

(6) DAYS IN THE LIFE of

S 1 — STARK & THE DVR — TUES
N 2 — CUT THE GREEN WIRE
T 3 — VS HOOD (?)
W 4 — SPIDEY & DD — TAKIN' A FEW DAYS OFF
 WISH DAVID WAS ALIVE
SUN 5 — BUY NEW STUFF - NO - PRINCIPLE OF THE THING - HOME
6 — UNPACKING - OUR ETC -
 STAIRS MOM CALLS - SAT GUY
 HOOK-UP
7 — C. TRIES TO FIX IT - ARROW THRU DISH
W 8 — COOKOUT - HAWK GUY (GIVES C. THE DVR)
9 — TRACKSUITS — CLINT INTO ACTION
10 — FIGHTING - AMBUSHED
11 — KIDNAPPED
T 12 — TRACKSUIT ULTIMATUM
H 13 — WAR, BRO.
U 14 — NEVER SLEEPS APT - GIVES BOW TO CLINT KID
R 16 — KATE GETS BOW / MATCH CUT / TALKS HIM OUT OF IT
S NONE IS WORTH FIGHTING FOR
F 17 — US SUITS
R 18 — ↓
I 19 — TELL EVERYBODY THIS IS UNDER MY PROTECTION
S 15 — MOM & KID, BUILDING LIFE
U 20 — BLUES CLUES w/ KID on couch
 MON (?)

SIX DAYS IN THE LIFE of

Notes for *Hawkeye* #6

Art by David Aja

ART PROCESS

From my script, David produces thumbnails—and they are the most laborious thumbnails you can imagine. *All* of David's heavy lifting is done here. These things are tiny little bursts of science. Not that his mark making isn't important, but his thinking is paramount to all of it and you can see it all in the layouts. It's his half-sheet, if you will. Hardest work goes there.

So I take the layouts and do a dialogue pass the best I can. Scenes can grow or change or transmute from what I'd written, or I can give notes and add things or take away. It's great—as long as I can tell what's happening, I mean. Which isn't always.

So then David enlarges the pages with his own dummy lettering pass. By "dummy lettering pass," I mean he actually letters the book roughly, but completely, so I can see where things need trimming and he can see how the words work in the frame. He sends this back and I tighten up my script accordingly.

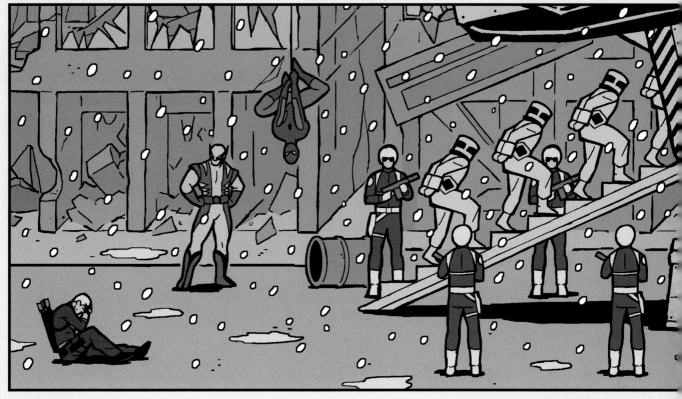

Art by David Aja

Once David's art gets the editorial okay from editor Steve Wacker, it goes back to David and colorist Matt Hollingsworth who have been, in the background, talking about the color schema for the issue. In a book where time shifts so hard and weird, color is one of the primary keys to helping orient the reader. Our readers are smart; they always get it. A big part of the why is Matt, doing subtle, almost invisible little things to keep you going with us. I could talk about this more at length, but it's not my place to; let me just say, there is tremendous storytelling happening with our book's colors.

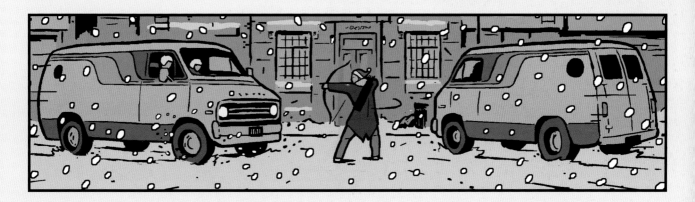

COLOR MATT **HOLLINGSWORTH**
LETTERS CHRIS **ELIOPOULOS**

Then I adjust the lettering until poor Chris Eliopoulos (letterer on *Hawkeye*) wants to murder me and the book has to be sent to press. Wait two weeks and, voilà!

We must be doing *something* right.

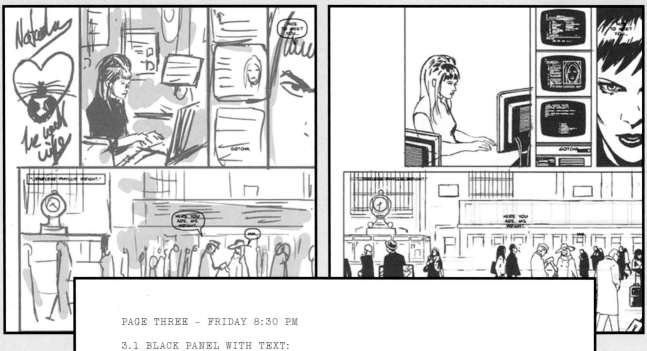

```
PAGE THREE - FRIDAY 8:30 PM

3.1 BLACK PANEL WITH TEXT:
TEXT          NATASHA:
The Work Wife.

3.2 SOMEWHERE IN THE MANSION full of TECH: AN ARRAY OF
TRANSLUCENT AND CURVED COMPUTER MONITORS illuminates NAT as she
works with intense, ex-KGB levels, of concentration. ONE SCREEN
is CHERRY'S MUG SHOT.
NAT          Gotcha.
NAT          Nice to MEET YOU . . .

3.3 GRAND CENTRAL STATION: CHERRY walks through a black and
grey crowd dressed in screaming RED in a long red cloak-coat
and a big floppy hat, the BRIM covering one of her eyes. Even
though it's night she wears SUNGLASSES; she's got a small black
bag with her, A HANDBAG maybe. A PORTER hands her a TRAIN
TICKET.
CAP (NAT, OP)  " . . . Darlene Phyllis Wright."
PORTER        Here you are, Ms. Wright.
CHERRY        Mm.
```

ABOVE AND OPPOSITE
Hawkeye script by Matt Fraction, art by David Aja

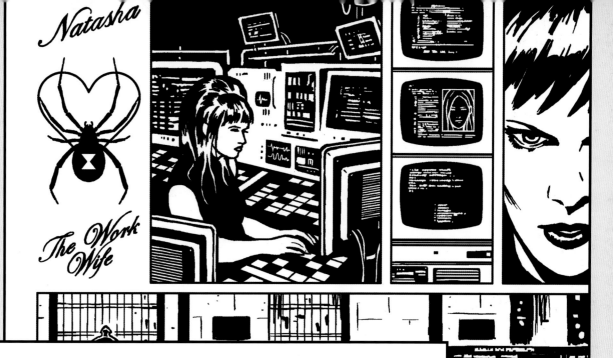

3.4 MOMENTS LATER. We watch as the grey and black crowd of
commuters hustles past the clock centerpiece of Grand Central;
the bright red of CHERRY popping, as it were, against them as
she heads towards a sign that points, saying LOWER PLATFORMS.
The TIME reads 8:48.
There is ONE OTHER MOMENT OF RED here — NATASHA'S HAIR. SHE
stands in the direction that CHERRY heads towards, unseen.
CAP (PORTER, OP) "Train leaves at NINE from track 26."

3.5 NATASHA stares AT US, arms folded across her chest, not
taking any shit from anyone.
NO DIALOGUE

3.6 CHERRY moves through the crowd, head down, hoping not to be
noticed.
NO DIALOGUE

Multiple-award-winner Ed Brubaker and I broke into comics at the exact same time and the exact same company, with both of us writing and drawing creator-owned comics for that publisher. We wouldn't get to know each other until years later. (Though I was a fan of his earliest work, all the way through until now.) His body of work includes *Sleeper*, *Scene of the Crime*, *Gotham Central*, *The Immortal Iron Fist*, *X-Men*, *Fatale*, and *Fade In*. This interview was conducted while Ed was still working on his already iconic and legendary *Captain America* run which was the inspiration for the *Captain America: The Winter Soldier* motion picture.

Let's talk about cowriting.

BRUBAKER: With Greg Rucka and me, on *Gotham Central*, I always felt like we were pretty much on the exact same level. We'd already both written a ton of comics and we'd seen each other's scripts and we'd talked enough to know that we were just completely on the same page with stuff. I always felt that Greg was more organized than me, too. So when we would have our story sessions, we'd be kicking ideas around and I'd hear Greg typing in the background and then after we got off the phone, two minutes later, I would get the email for the outline of the issue that we just broke down with like, "Here's your scene. Here is my scene." So I felt that Greg was more the person to break down the outline, and I felt like on *Iron Fist* [a martial arts epic starring Danny Rand, the man with the iron fist, that reinvented the character for the modern age, cowritten by Brubaker and Matt Fraction], I was more the person to break down the outline.

I felt in a way that I was almost Matt's overseer. I was reining him back in, in a way. He had so many more crazy ideas than me that we'd talk about stuff and I was almost like an editor of ideas on it. I'd say, "Well, we need to accomplish this, this, and this in the book." And then Matt would go, "Well, I have this crazy idea for this great visual." And I'd be like, "Okay, well where does that fit into the story?" It's interesting to see, because Matt is so much about crazy ideas to hang your story around. He was much more used to writing a self-contained story like a graphic novel

or something. At the time, he was not as used to writing episodic storytelling where you have to build up to that stuff and lay the groundwork.

It's part of sharing with people.

BRUBAKER: Exactly. He's had to deal with a lot of the sharing of toys and having toys taken away and being told to play with this other toy instead. It was a lot of fun, actually, and Matt is a lot younger than me. He's like eight or nine years younger than me, and he grew up reading a whole different breed of comics than I did.

Let me ask you this: will you ever draw again, or will you only draw to facilitate writing?

BRUBAKER: I think that I am more of a writer. I started out as an artist, and then I started writing just to give myself things to draw like when I was a kid. But I think that when I was in my early twenties and I started writing things for other people, like when I wrote *Accidental Death* for [Eric] Shanower and some other stuff for Dark Horse, I started realizing that it was much easier for me and much more rewarding in a way to write a story, and there were tons more stories that I had in my head that I wanted to write than I could never imagine even being able to draw. Also, for me, drawing was always more fun when you were done, especially if you did a halfway decent job with it. To actually sit down and draw was always a sort of labor. Even as a kid, I just really wanted to do comics— I was never one of those people who just drew. I didn't have a sketchbook or ever used coloring books or

Art by David Aja

anything like that. My whole life all I ever did was draw comics, even when I was three or four years old. When I sat down to draw, I would make boxes on a page and tell a story. So I think that for me, it was always much more about storytelling. I still do draw sometimes. This is weird to say, but every now and then I will just sit down and sketch out something like a cover idea or something like that, and I think that maybe at some point when I'm older and actually have more time and hopefully will have paid off some debt, I'll maybe think

about drawing something again. But the kind of stuff that I like to draw now is so much simpler than even the stuff that I used to draw. I would like to develop some kind of a really simple art style and use that. But coming up with a really simple style is much harder than coming up with a really detailed one. With Charles Schultz or Dr. Seuss or any of those artists with these really simple styles, there is so much that goes into it. It's so much harder to draw that way and make it look right because of the economy of the line.

Art by Steve Epting

Captain America

FIRST ISSUE OUTLINE:

PROLOGUE(first three or four pages)
Five years ago – a secret Russian bunker. A once powerful Soviet General – **Aleksander Lukin** – is meeting with the Red Skull.

Lukin is selling-off artifacts from the USSR, black market weapons, and plans for things they could never afford to actually make. He and the Skull have become grudging allies for a time, each using the other for their own benefit, but their views aren't all that far apart – Stalin's Socialism was sadly close to Fascism, after all.

Now the Skull is looking through the remaining items at a recently discovered underground facility, as General Lukin looks on, sneering. Skull spots something in the shadows, but we can't see what it is – It's a human form floating in a stasis tube, someone on ice, and all we can make out is part of a mechanical arm in the foreground. The Skull wipes away a layer of dust to look closer at the man inside (who we never see), amazed. "Is this what it looks like?"

And Lukin replies, "Indeed, it is. I've been going over the paperwork my predecessor, General Karpov, left on this one. He was apparently very useful during the Cold War. Karpov called it his secret weapon against the US."

"How much for this?"

"No, I think not, Comrade Skull. I've got my own plans for that item, unless of course, you'd be willing to exchange it for the Cosmic Cube?"

And they begin to argue about the cube, which the Skull assures him will be in his possession soon, but he'd never hand it over, because after he gets it, Captain America will fall and then the world... It's the usual Red Skull rant, and we play it very straight...

MAIN STORY
And then we're five years later, in real time, with the Skull finally getting his hands on the Cosmic Cube. But the cube has almost no power, it needs to be charged up, and the Skull is plotting how to go about powering it in the most horrifying way possible, killing as many Americans as possible in the process.

We follow the Skull as he lays out his evil plan, and we get the lay of the land as far as Captain America's life is concerned. We show Cap doing some heroing, and show him out of costume, all the while not realizing his world is about to fall apart because the Skull has him in his sights. The Skull narrates the main story, really showing us his hatred of Cap and everything he stands for. Mocking him for giving his secret identity away, for making it so easy to go after him. And through the Skull's words and surveillance, we learn all we need to know about Cap and about Steve Rogers – we see Rogers playing old 78s and tapping his toe, listening to old Shadow radio plays on CD – we get the idea of this man out of time, and we get the back-story of his tragedy, too – we see Bucky perish, we see Cap frozen in ice until all his childhood friends are old men. We see the world age around him, and move farther away.

Then we focus on the Skull in a penthouse apartment in New York, about to put the final pieces of his scheme in motion. He gets a call from Lukin, and they begin to argue again. Apparently they've had a major falling out in the past five years. Lukin still wants to negotiate for the Cube,

Captain America Pitch -- 1

Captain America pitch document

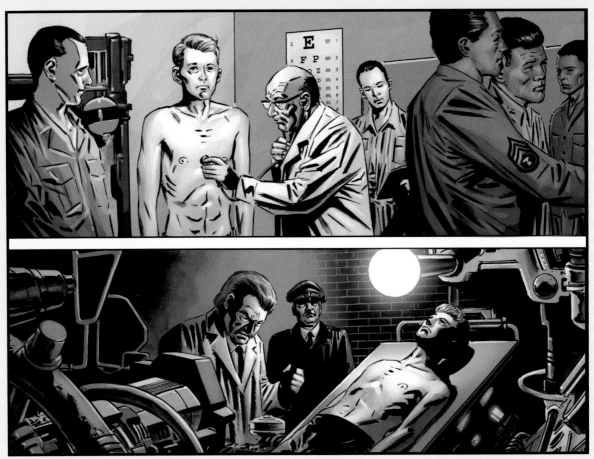

ABOVE AND OPPOSITE
Art by Steve Epting

Let's talk about knowing when things are working out creatively. There is trusting your instincts and there is asking the world, "Jesus Christ. Will someone tell me when I'm sucking? Please."

BRUBAKER: I look at someone like author Peter David (*The Incredible Hulk, Star Trek*) who I think is probably a better writer now than he has ever been. I actually read his comics now, and I read them twenty-something years ago too when he was doing *The Incredible Hulk* with [Todd] McFarlane. I look at him, and see that he's one of the only guys from his era who realized that comics had evolved, the way that comic book stories were being presented to readers had changed, and he didn't just try to keep doing it the same way he did it in the '80s. He's like, "Okay, now the structure of these stories is different. Things are aimed for trade paperback more. You can

be more mature with it." Very few of the other guys who were big when he was big are still around. Ultimately, I don't know. I've never been too goal oriented on the grand scheme of things. I just want to be able to do the kind of work that I'm doing.

I mean, Cap [Captain America] was my all-time favorite character. That was so much different than working on, like, *Batman* where there are five other solo Batman books. And then, I got to do *Uncanny X-Men* and actually have a lot of fun with it and got to reach a much wider audience than I ever would doing very similar creator-owned books.

I just want to make sure that I don't start coasting. I want to really attempt to look at my writing and make sure that I keep trying to get better. I want to keep doing it and maybe get further ahead. I'm really tired of being so down to the wire on so much of my writing.

I want to be more like you and Brian K. Vaughn (*Y the Last Man*, *Saga*) and those guys who get really far ahead on their projects. I used to be really far ahead on stuff, but at some point I got behind, and it's just been a constant "catching up and then getting further behind and catching up and getting behind again" process.

Captain America **is considered a seminal run. But just because other people think it, doesn't mean you do. What are your feelings on it now? Are we safe to say that you accomplished what you set out to accomplish on that book?**

BRUBAKER: Well, I think that with *Cap* my feeling was always that, whenever you take over a book like that, you try and think about what your favorite thing about that book is. You can't sit there and work on *Daredevil* without thinking, *Well, obviously, one of my favorite things is Frank Miller's run and "Born Again" and all of that stuff*. So that is in there. But if *Daredevil* had gotten vastly far away from that, one of the first things you would do when you took over the book would be to

look at where it is and where it used to be when you loved it and go, *Well, how can I bring some of that back to it while not just retreading it?* For me, with *Captain America*, it was really instinctive, because even though it's only three issues long, my all-time favorite run of *Captain America* is the [Jim] Steranko stuff.

Oh, I love that stuff.

BRUBAKER: Of course you do. That stuff and the [Steve] Englehart and Sal Buscema run, which was the stuff that I was buying off of the newsstands when I was five years old, those were my favorite Captain America things. And I just really thought that the misstep that they had taken with *Captain America* before our relaunch was that they had taken it too far away from the Marvel Universe.

I thought that you can do those same kinds of stories and you can show a Cap in a modern world dealing with the pressures of a war on terror and the way that America feels right now. You can do a book that maybe sort of has this *24*-type vibe to it. But you

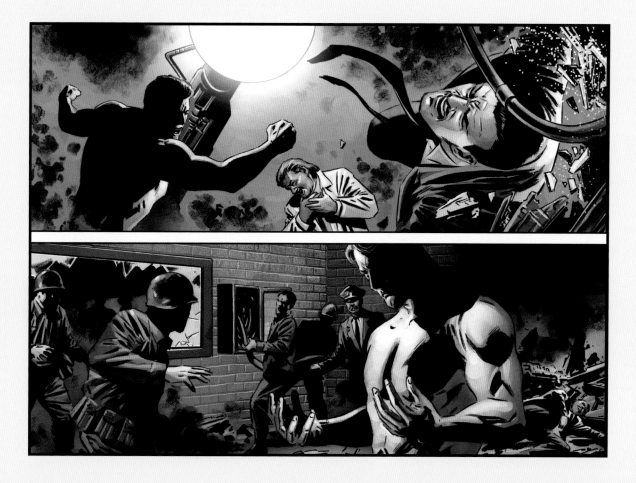

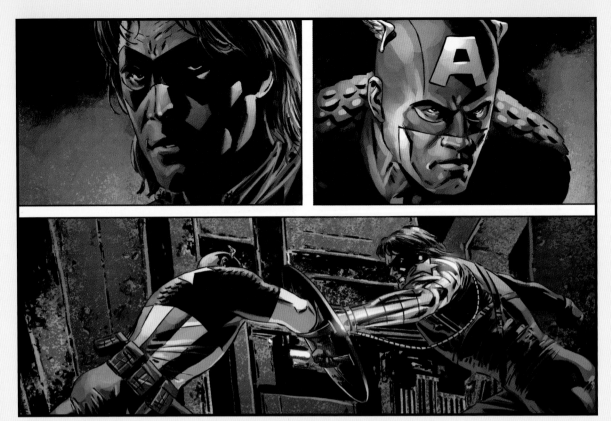

ABOVE AND OPPOSITE
Art by Steve Epting

set it in the Marvel Universe. You don't have him go out and punch Osama Bin Laden in the face. You have him taking on Hydra and AIM and these things that are really part of the Marvel Universe. And to me that just came from looking at those Steranko issues, which I also think are the saddest issues of *Captain America* maybe ever.

Best advice you ever received?

BRUBAKER: The best advice I ever got was when I was sixteen years old. I met [legendary writer/editor] Archie Goodwin at a comic convention and we were talking about Alan Moore (*Watchmen*). I said that I really liked Alan Moore's stories because they seemed really different and original to me. [Goodwin] basically told me that Alan Moore stories weren't good because they were original, and that originality was completely overrated. He said that there were only five stories in the world, and it's the way that you tell those stories that makes the work interesting.

I thought that there were only three plots. I'll have to look those up. [Laughs]

BRUBAKER: Yeah, you have to look up the other two, they'll expand your horizons. [Laughs] But I think that was the best writing advice I ever heard. I have another [piece of advice], too. I grew up in San Diego, so I would always go to the cons as a fan and go to the workshops and stuff, things that you and I actually conduct now as professionals. But I remember Mark Evanier (writer/Jack Kirby biographer) at a writer's workshop. He wanted each of us to pitch a story to him and this one guy was like, "I'm not going to pitch my story to you. What if you turn around and take it?" And Mark Evanier started laughing and said, "Look, man, if you've only got one story and you're so worried that I'm going to steal it, you're never going to make it as a writer anyway." So I always think of that.

It's like originality is overrated and don't think that your story is some hidden little gem, and that

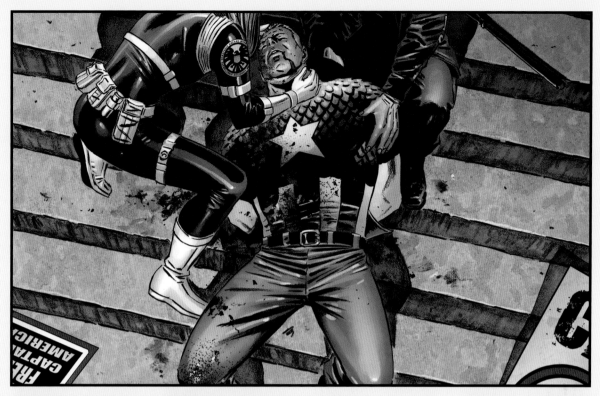

you're the only person who's discovered it. I mean, look at *The Da Vinci Code*, which is pretty much a guy writing a detective story about the same story that's in *Holy Blood Holy Grail* and a million other books.

I think that was plot number four, by the way.

Since this interview was conducted, Ed Brubaker has left mainstream comics to pursue TV- and movie-writing work, and only produces creator-owned comics. He puts out the critically acclaimed series *Fatale* and *Velvet*.

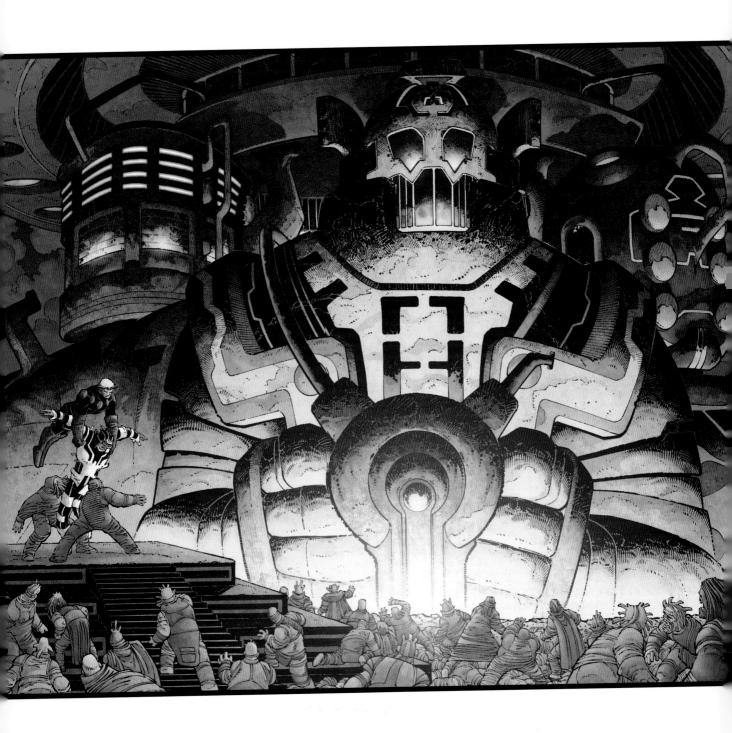

CHAPTER 3

WRITING FOR THE ARTISTS

HERE'S A QUESTION YOU SHOULD ASK YOURSELF: AS the writer of comic books and graphic novels, what is the function of your script?

This is a big one, so remember it: the function of your script is to communicate clear story, images, and characters to . . . *the artist.*

Your reader will never see your script. There's a good chance that no one else in the world will ever see your script. If you are a prose author, yes, every word you write will be on display for the entire world to see. If you are a graphic novel writer, only a handful of people in the entire world will ever see your script. Depending on your circumstances, the total audience for your script could be a whopping one person. *Just one person.*

For many of you, your entire creative team is you and your friend, or someone who you are just creatively in sync with, someone who does everything: the full art, the coloring, the lettering, and all of the production work—one person.

Or, as Neil Gaiman says, *your script is actually a 10,000 word letter to an artist.*

If you work commercially, for a Marvel or DC, then that means the first person to read your script will be your editor.

That's *two people.*

OPPOSITE
Art by John Romita Jr.

Your editor's job, or one of your editor's jobs, is to make sure that your script serves its function. And its function, as I just told you, is to communicate clear story, images, and characters to your artist. The editor checks to make sure that you are clear. He also checks to make sure that you handed in what you said you were going to hand in and that it fits the editorial agenda of the company that he represents.

Also, if you work commercially you'll probably work with some sort of combination of inker, colorist, and/or letterer.

Hopefully, all of them will take the time to read the script and make sure that they are doing their best to get your original intentions across on the page. (It doesn't always happen, but that's another matter for another time.)

So your script will be read by the artist, editor, letterer, colorist, and inker. *Five people.* Tops. Okay, maybe an assistant editor.

Six people.

Your audience, no matter who you are, is no more than a total of six people. If your graphic novel sells one million copies, the audience for your script is still going to be no more than six people.

But do not let this dissuade you. This is not bad news. My personal experience tells me this is great news.

It is a lot easier to inspire and entertain one person, or six people, than it is a million people. It's a lot easier to know your audience when your audience is six people.

Writers write for their artists. Not knowing they are writing for their artists is the biggest mistake I see comic book writers make. And it happens all the time.

It's an understandable mistake. All writers sit at the keyboard and fantasize that they are writing the next *Star Wars* or *Harry Potter*. We can't help it. Inside all of us is a pop-culture populist hoping and praying that *Buffy the Vampire Slayer* is pouring out of our hands. And maybe it is. But, in reality, you have to know your audience. And your audience is no more than six people.

Screenwriters are in a very similar boat. A screenwriter's work is hopefully read by producers and executives, and, if the filmmakers are lucky enough to go into production, dozens, or even a couple hundred people will also read the script. All of these people—each and every one of them—read the script to make sure they know how to do their job.

And, sure, if you become a famous writer like Frank Miller or Neil Gaiman, then maybe one day your publisher will put out a script book or will put your scripts in the back of a graphic novel as supplementary

material. But that means a great deal has gone right from the time you read this book until the time your story sees the light of day.

So, as a writer of scripts, your words are only meant to inform, inspire, and entertain your collaborators.

INFORM, INSPIRE, AND ENTERTAIN

You inform your collaborators on what they have to draw, letter, or color.

You inspire them to, hopefully, do the work of their lives.

And if you take the time to do it right, your script will be a pleasure to read. Nobody wants to read a cold, nebulous, or ponderous pile of words. Especially your editor. Your editor has to read hundreds of pages every day. I take a lot of personal satisfaction in knowing that reading my script, on most occasions, is not a punishing experience.

If your script is clear, precise, and a pleasure to read, you make your collaborators' lives everything they ever hoped for. If your script is ill conceived, clumsy, or naïve to the art of the comic book page, then you can make artists' lives a living hell.

So how do you make your script inspiring and entertaining?

First of all, no matter what project I am on (and I did it this way before I became a known commodity), I never start writing until I know for whom I am writing. I can't even imagine writing a script without knowing who is drawing it.

Every artist has strengths and weaknesses. Every artist has things he or she does better than just about anybody in the world. Your job as a writer is to find those things and write to them. Sometimes those things are obvious. Other times artists are able to communicate with you exactly what it is they want to draw. Other times they can't. Sometimes they don't know exactly what's best for them.

Once I find out the name of my collaborator, I seek samples out. If the artist is well established, then it is obviously easier. If the artist is a friend, even more so. But sometimes the artist is a brand-new face with nothing but the latest submission portfolios available for review. But no matter what is available, I study it. I study how many panels per page the artist is consciously or unconsciously comfortable with. Is she a bombastic stylistic presence on the page? Is she a more subtle touch? How many elements can he fit comfortably into the panel and onto the page? Does she do wonderful faces? Is her anatomy expressive or subdued? Are her designs fantastical or earthy?

There are literally a thousand things you can look for in someone's work to decide how best to angle a story toward him or her.

And sometimes you can look at artists' works and discover things about them that they may not even know about themselves. You might discover something about these artists that takes them down a creative road they would've never thought to go down themselves . . . and they will love the experience and love you for it. On the flipside, something in the artists' works may open you up to ideas and imagery that you, as the writer, may not have come up with on your own.

COMMUNICATION

Communication is also key.

Send emails and make phone calls. Talk to your collaborators. Have an open-door policy. Find out what they are in the mood to draw and why. First of all, the answers may surprise you. Also, you will find that if you add elements to your story that the artist has a real passion for, then those drawings will be the best you have seen in your entire life. I'm not talking about compromising your vision; I'm talking about putting the collaboration first.

This has happened to me many times. Once I was in the middle of a storyline in *New Avengers* (a modern-day look at the Avengers franchise starring Spider-Man, Wolverine, and Luke Cage), when I asked Mike Deodato, a wonderful collaborator, what he was in the mood for that I was not giving him. He said he wanted to draw dinosaurs. Miraculously, I was able to move part of the story into a place where the son of the Hulk and a dinosaur could go at it for a couple of pages. Lo and behold, it was, in my opinion, the best drawing of a dinosaur that Marvel ever published.

So every time I'm writing a new project with a new collaborator or team, I do my research, not just on subject matter, but also on my collaborators. Then I take it one step further.

I don't ask the artists to draw my world; I write into theirs. I literally close my eyes and imagine the world according to them. I see the faces that they draw, the buildings the way they draw them. I try to imagine the perfect comic book art from this particular artist and I write toward that vision.

I try to put all of my ego aside and do everything I can to let the artists shine as brightly as they can.

New Avengers 18 Script

Page 2—3
Double page spread

1- Ext. Savage Land- Morning

Across both pages. Most of the page. The lush
vegetation of the Savage Land.

A giant dinosaur is being ridden and killed by
SKAAR, the son of Hulk. He has smashed down on the
dinosaur's skull, destroying it in one punch.

The entire dinosaur takes up the entire spread. In
profile, howling into the air. Like the last Dino
shot in the first *Jurassic Park*.

Reads: Savage Land
Reads: Yesterday

 DINOSAUR
 Naarrgghh!!

2- SKAAR swings around, in midair, and punches the
dinosaur to the ground.

Spx: BOOM

 DINOSAUR (CONT'D)
 Duurkk!

3- The head of the dinosaur, backlit by the hazy
sun, tumbles toward the earth as the dinosaur
topples over itself and toward us.

Spx: FALUMP

4- Tight on SKAAR. He stands over his fallen prey.
Victorious but not all that content.

 Norman Osborn
 (off panel)
 SKAAR, son of Hulk . . .

New Avengers #18 script excerpt

Art by Mike Deodato Jr.

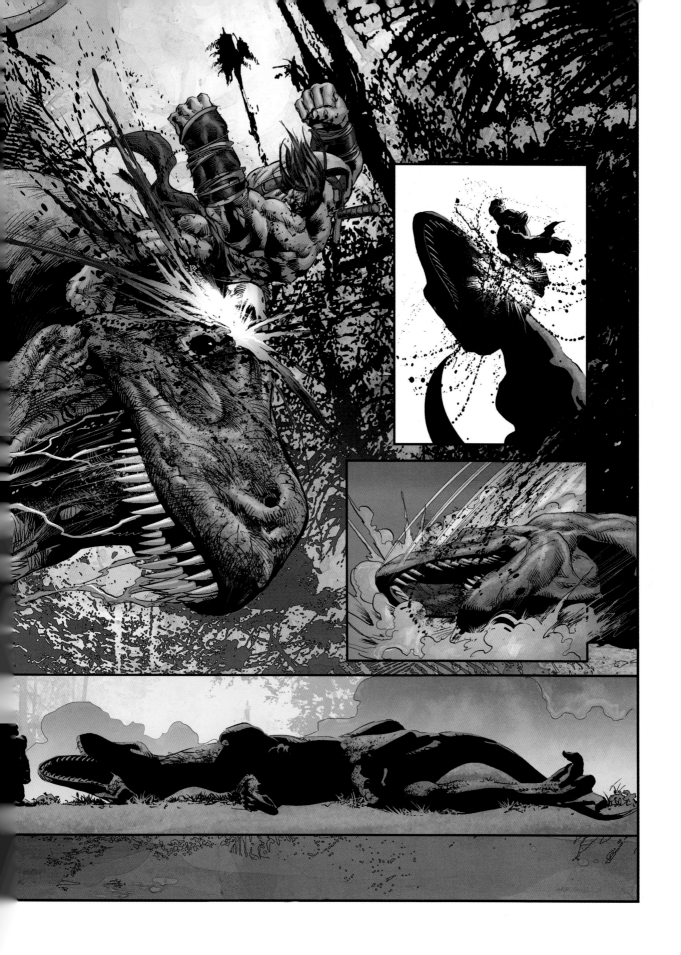

THE RELATIONSHIP

Over time, you will develop a shorthand with some of your collaborators. Just like you and your friends can finish each other's sentences or get a joke or reference with one word, the same can happen with a collaborator. Sometimes a shorthand can develop right away, while other collaborations can go on for years and the shorthand never really develops. It's not because you aren't getting along, but because you are both developing different voices. As the years pass, you may also find that you are constantly challenging each other in different areas.

Even though this is the creepiest thing I will ever admit publicly, I see the relationship between writer and artist as being as intimate as dating. I see a lot of parallels. When you're working on something as intimate as art, even commercial art, it can feel like . . . you're dating. And to all of my collaborators, you can stop reading now.

When you're first working together it feels a lot like a first date: Everyone is on his or her best behavior. Everyone is trying not to interrupt the other person when they talk. As you go on more dates, you get more comfortable. You get looser, freer, more honest. Suddenly, no one

BELOW AND OPPOSITE
Art by Michael Avon Oeming

is afraid to speak his mind. One of you says you want to get experimental. All of a sudden you realize you have been in a relationship for years and couldn't be happier.

Sometimes when the project is over, and maybe your collaboration is through, it can feel, in a lot of ways, like a breakup.

Sometimes the collaboration can be tumultuous and the breakup inevitable. Sometimes you can bring out the worst in each other, and everyone you know is desperate for you to get the hell away from each other. Sometimes you just get to the end of the road and tell each other you can still be friends. And other collaborations can go on for years, even decades, as you weather the ups and downs that life throws at you.

I have, and continue to have, creative relationships that started before I even met my wife, and that continue to this day. Other creative relationships have come and gone in fits and bursts.

I learned a lot of lessons about collaboration the hard way. When I first started making comic books professionally, I was a writer-artist. Actually, I was a full-service comic book creator. I wrote everything, illustrated everything, and I even did my own lettering. I colored the covers. I did the production work. There was no one else to do it, so I had to learn to do everything myself. Before the miracle of Photoshop, I spent night after night at Kinko's, pasting together everything by hand. Years later, when I started making the journey from writer-artist to

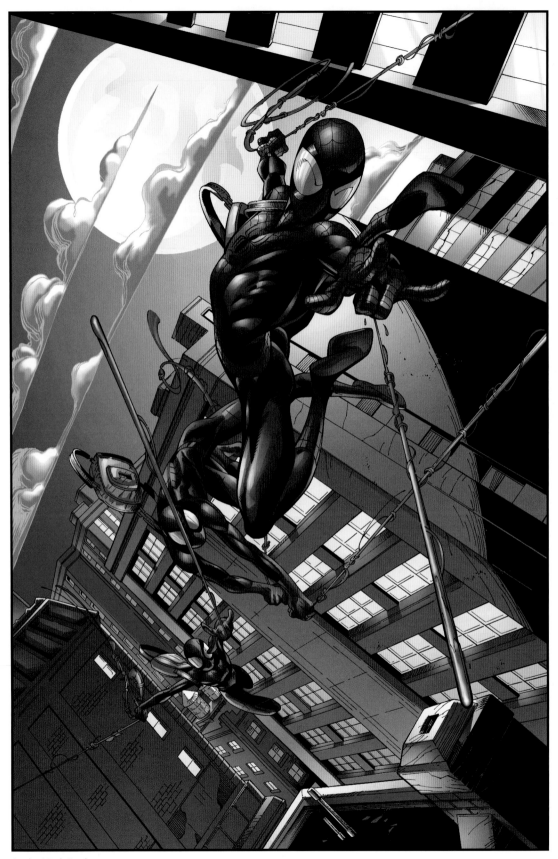

Art by Mark Bagley

writer, I had to make some big transitions in the way I told stories. As a result, I made some big mistakes.

For my first assignments as a writer, I would write the script, and then sit down and draw the entire issue out in elaborate layouts (something a little bit more than stick figure form). I would draw the whole issue and hand it to the artist, no matter who the artist was, and say, "Here, do it just like this."

I must say my early collaborators were always very polite about accepting these layouts. Some of them were even happy. One of them told me that all he wanted to do was sit in front of the TV and draw, and anything I could do to make that easier for him was fine.

But it wasn't. It was wrong.

I wasn't letting them express themselves. I wasn't trusting them. They say a good director hires actors and lets them act. Well, a good writer lets her artists draw.

I wasn't doing it to be mean, and I wasn't doing it because I'm a megalomaniac (sort of). The truth is, as a writer/artist, I didn't know where the writing actually ended. It was all storytelling. The writing, the layouts, the finished art, the lettering—each was a piece of the story. So giving up some of that responsibility was difficult.

But when I got the job writing *Ultimate Spider-Man*, veteran artist Mark Bagley, someone I did not previously know, called me up after receiving my script and layouts and as politely and genteelly as that Southern gentleman could, said, "Um, don't do that. That's my job. I know you didn't mean it to be insulting, but telling me how to do my part of the job is a little insulting." He said it so nicely, which made it all the more embarrassing. I had overstepped my boundaries. A rookie mistake made ten years into my career.

At the same time, I was writing a book for Todd McFarlane Productions called *Sam and Twitch*. It was a cop drama, and I was lucky enough to be teamed with an artist I had unbelievable respect for, an artist I had wanted to work with on that book for a couple of years—Alex Maleev. The entire time we were together, I handed him layouts and he graciously accepted them.

After I left the book (having been fired), *Sam and Twitch* creator Todd McFarlane took over writing the book himself. From Alex's reports, he was the opposite of me. He didn't even write a script. He called Alex up and told him the script over the phone. Alex would write it all down. Alex found it quite hilarious that he had gone from working with a writer/artist who did everything but draw the book himself to working with a writer/artist who did the opposite.

Meanwhile, the pages Alex was producing under the lighter hand of Todd were nothing short of amazing. They were far superior to the ones Alex made from my layouts. I was embarrassed. I realized that I had been holding his genius on a choke chain.

Soon after that, as fate would have it, Marvel hired Alex to team up with me once again on the blind vigilante superhero series *Daredevil*. I was given a second chance, and I took full advantage of it. I wrote the world according to Alex, not the world according to me. The following year, as we stood onstage accepting our Eisner Award for best series for *Daredevil*, I breathed a gigantic sigh of relief. Not for the award but for the second chance. A second chance like that doesn't come along too often. That *Sam and Twitch* situation ended up being the best thing that ever happened to me as a writer. I got to see the difference between being a control freak and being someone who *collaborates* with artists.

Again, obviously, there is no steadfast right or wrong way to collaborate, but I have discovered time and time again that writing *for* your artist always leads to superior work from all involved. And if you're writing, a script for you to draw, don't just write something you know you can draw. Challenge yourself.

Some of you may be asking, *Why should I give so much to the artist? Why shouldn't the collaborators be giving that same respect to me?*

I'm telling you, they already are. So many of your collaborators will hold your script up as the Bible. Without even realizing what they are doing, they will follow your every word because all creators are desperate to please each other. So as the de facto leader of the team, it is up to you to set the tone. It is up to you to make everyone involved feel like an equal player in the process. Because they are.

In fact, one could argue that the artist's contribution is more important than your contribution, because it is his contribution that will be the public's first perception of the work as a whole. This is a visual medium. Everyone's first response to your work will be to the visual aspect of it.

Plus, at the end of the day, no matter how hard you write it and no matter how many words you use to describe something—it is a lot easier to write a crowd scene than it is to draw it. The artist spends a great deal more time on the page than you do. The artist will take days and weeks on something that may have taken you a few hours to do.

And you have to respect that.

Once, I wrote the following scene in an issue of *Ultimate Spider-Man* for Mark Bagley:

<div style="border:1px solid black; padding:1em;">

```
              Ultimate Spider-Man Script

1- Ext. Midtown High Parking Lot - Day
Wide of the parking lot of the school. School is out. Kids are
everywhere. Every single person in the school is now in the parking
lot, either getting in their cars or just hoofing it.

There is a jam of cars, teachers, faculty, and kids everywhere. Some
running to get the hell off school grounds. The crowd is mixed,
jocks, dweebs, potheads, Goths, gangers.

Peter and MJ step forward and see what's off panel across the street.

          MJ
          Whoah . . .

          Peter PARKER
          Yeah . . .
```

</div>

And Mark Bagley, like he always does, drew all of it. He drew every single kid and every single teacher and every single bus and every single car. And in the margin of the original art, he playfully swore at me.

That's why you respect the artist. That's why you service their vision . . . because he is already working in service of yours.

THE DIFFERENCE

And still some of you may be wondering: Is there really that big of a difference? Isn't the story the story? Isn't the artist really just the visual stylist? Does it really make THAT big of a difference who draws the story?

The following examples come from a variety of artists drawing basically the same thing, but bringing their own styles and approaches to each incarnation.

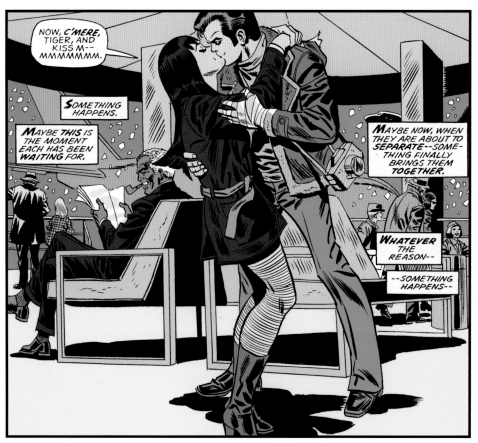

Art by John Romita

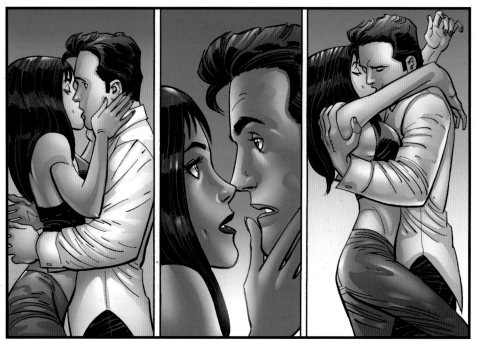

Art by John Romita Jr.

Art by Joe Quesada

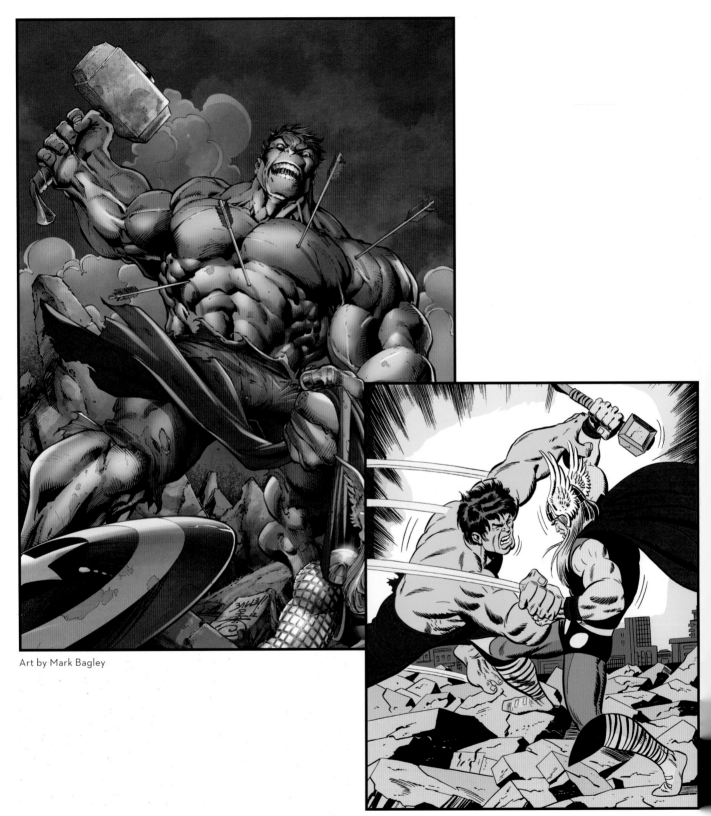

Art by Mark Bagley

Art by Sal Buscema

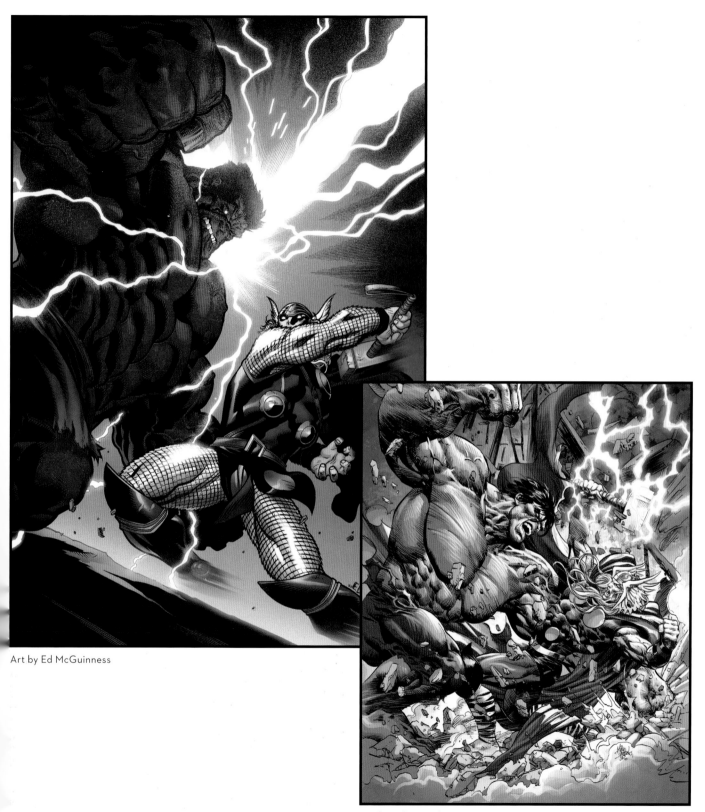

Art by Ed McGuinness

Art by Mike Deodato Jr.

ARTISTS ON WRITERS

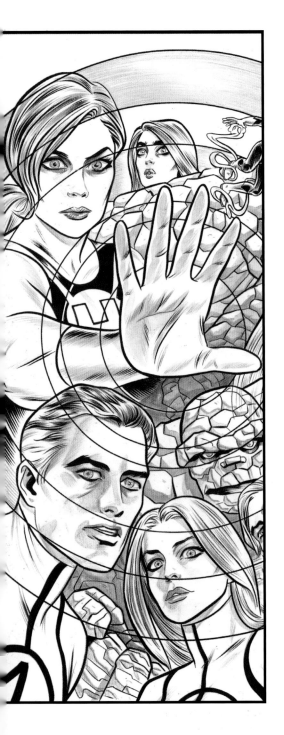

All through this book, you will see writers and editors talking about what they think an artist wants and what they think an artist responds to. In this section, some of the best artists working in comics today share their very specific feelings on collaboration, the artist's role in it, and what they like and don't like in their scripts.

MICHAEL ALLRED is the creator of the award-winning *Madman*, and is well known in mainstream comics for his work on *X-Statix* and *FF*.

CHRIS BACHALO is an award-winning artist best known for the legendary Vertigo series *Death: The High Cost of Living* with Neil Gaiman and his art for *Shade, the Changing Man*. He has been a primary artist for numerous X-Men projects including *Generation X*, *Wolverine and the X-Men*, and *Uncanny X-Men*.

MARK BAGLEY is one of the most popular names in mainstream superhero comics, best known for his record-breaking 111-issue run on *Ultimate Spider-Man*, as well as his work on *Thunderbolts* and *Fantastic Four*.

MIKE DEODATO JR. is well known for his work on *Thunderbolts*, *Avengers*, and *New Avengers*.

ADAM HUGHES is an award-winning comic artist well known for his iconic cover work for every comic book company over the last twenty years.

FRAZER IRVING is one of the most unique voices in mainstream comics, with amazing runs on *Shade, the Changing Man*; *Seven Soldiers*; and *Uncanny X-Men*.

KLAUS JANSON is an award-winning artist and educator whose staggering credits include Frank Miller's *Daredevil*, *The Dark Knight Returns*, *The Punisher*, *Batman*, *Avengers*, and literally hundreds of legendary comic books that he has worked on as penciller, inker, and colorist over the last forty years.

Spanish artist **DAVID LAFUENTE** burst onto the mainstream comics scene with acclaimed runs on *Ultimate Spider-Man*, *New Mutants*, and *All-New X-Men*.

DAVID MARQUEZ exploded onto the scene with *Fantastic Four: Season One* and has also worked on *Ultimate Spider-Man.*

SARA PICHELLI is an award-winning Italian artist who leapt onto the American comic book scene with her work on *Ultimate Spider-Man,* where she was cocreator of Miles Morales. She has also worked on *Guardians of the Galaxy.*

Comics legend **BILL SIENKIEWICZ'S** career spans back to the late 1970s, and includes such landmark projects as *Moon Knight, New Mutants, Elektra Assassin, Stray Toasters, Daredevil,* and *Jimi Hendrix.* His influential and very unique multimedia approach has graced the covers of hundreds of comics, record albums, and movie posters.

Comics legend **WALTER SIMONSON** has graced the pages of mainstream comics for close to forty years. He is best known for his massively influential work on *The Mighty Thor, Fantastic Four, Manhunter,* and the graphic novel adaptation of the motion picture *Alien.*

JILL THOMPSON is the award-winning creator of *Scary Godmother* and *Magic Pixie.* She also did a legendary run with Neil Gaiman on the award-winning *Sandman.*

SKOTTIE YOUNG is the Eisner Award–winning artist of Marvel's *Oz* adaptations, Neil Gaiman's *Fortunately the Milk,* and is the singular voice behind the Marvel Baby variant covers.

What is the one thing you most look for in a script?

ALLRED: If I limited what I'm looking for to "one thing," assuming the writer has nailed down story and character, as an artist, I'm hoping for visual inspiration. I'm hoping the imagery will burst in my brain as I'm reading the script and get me excited about new and exciting moments to draw.

DEODATO JR.: Generally speaking, a good, moving story driven by strong characters. But the thing I always look for is that moment where the protagonist decides it is time to change his fate and starts fighting back,

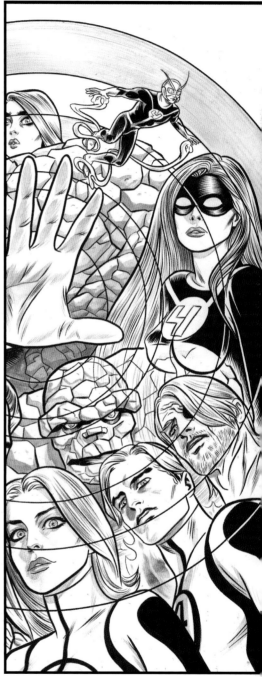

ABOVE AND OPPOSITE
Art by Michael Allred

Art by Skottie Young

Art by Mike Deodato Jr.

literally or not. From the standpoint of the artist bringing the story to life, I look for a key visual on each page to build toward or build away from—a moment, a beat of compelling drama or excitement. Each page should have that, along with a visual or verbal hook that makes the reader want to turn to the next page.

YOUNG: Fun and variety. As a reader and an artist, I really like to have a lot of variety throughout an issue. Staying in one building or location for too long can drag down the energy of both the readers' momentum in the story and the artist's momentum and excitement for the issue. I like a script to feel like a great playlist for a long run. It should know right when I need a pick-me-up.

BAGLEY: That's really not an answerable question, as there are so many different aspects to a story that can make it something that is great and appealing to work on. I love stories with a sense of adventure, with humor and drama . . . really all the things any reader would look for.

IRVING: Aside from the usual reply of "a good story," I guess from a technical standpoint what I look for most is brevity of description and dialogue. The more words that I have to deal with, the less focused I am in visualizing the action. Sometimes just dialogue alone is enough, provided it captures the character and emotion well enough. The classic example is from *Judge Dredd* by John Wagner, where the description was simply "Dredd. Grim."—which says all it needs to.

Art by Mark Bagley

LAFUENTE: World building and fancy storytelling. Designing environments and characters is a pleasure for me, and it will keep me interested during the sometimes tedious pencilling and inking stages. The "fancy storytelling thing," for lack of a better expression, is what fascinates me. Solving narrative problems, trying to design the reading experience.

THOMPSON: What I look for in a script is that it is a story I personally would like to read, and one that I know I could do a great job on. While I have taken jobs just for the sake of having a job, I prefer to work on something that is fun and would go smoothly for me, in addition to one I get paid for. That's the best.

SIMONSON: I look for a good story with interesting character interactions. In my own work, I try to write action scenes that are the exterior manifestation of the conflicts within and between the characters.

Art by David La Fuente

Art by Walter Simonson

Art by Jill Thompson

Art by David Marquez

Art by Chris Bachalo

MARQUEZ: A good storytelling sense. I mean, obviously, I look to see if the script is structured and organized in such a way that I can easily start putting lines to the page, but really, I look for the storytelling: establishing a setting, mood and tone, characterization, pacing, and transitions. Part of this comes from wanting to draw a fun, well-told story, but another part of it is looking to see if the writer has gone through the work of thinking of how the story will flow visually, as a comic. Does the writer have a visual sense, an understanding of page layout, "camera" movement, page turn reveals, etc. When all that is there, my job becomes so much easier and I really can have fun bringing it to life.

BACHALO: Diversity. A script that has a little bit of everything. Change of locations, multiple subplots, a little action, a bit of comedy, with scenes that are short and to the point. It's fast paced, and I've found that it keeps me creatively fresh. It's fun.

JANSON: The one thing that I look for in a script, above all else, is opportunity. The two things that interest me the most in this medium are the ability to draw and the ability to tell a story through those drawings. It's critically important to me that a script affords me the chance to do something that involves drawing a compelling image or the chance to do some unusual and challenging storytelling.

The other thing I look for is the structure of the story. A good script should be like a good piece of music. It should have highs and lows and rhythm and pacing. If the construction of the story is weak, the narrative drags and meanders and the visual storyteller has to spend more time overcoming those problems. There's really no substitute for a well-structured story.

Art by Klaus Janson

HUGHES: *Completeness.* I hate starting on a project when no one can tell me how it ends or where it's going, usually because it hasn't been written or even thought up yet. I liken it to building a boat, which you then put to sea half completed. Then you try to finish building it before it sinks completely. I can't contribute my best if I have no idea where the story is going: I have no idea what to emphasize, what to foreshadow, what to downplay. So, I like to have all the story info on hand.

PICHELLI: I really appreciate when the writer explains what's behind that specific panel/scene—for instance, what the characters' thoughts or intentions are. In this way, I can see clearly how to make the characters act and visually help the story be its best.

SIENKIEWICZ: Room to contribute/collaborate beyond simply being a hired set of hands. To me, it's a strange area. On one hand, there's the "division of labor," the clearly defined roles. There's the writer, and there's the artist, and then there's this other, third entity that is the combination and intersection of those two roles. That overlap is where real creative magic can happen. The perfect blend of words and pictures.

Do you prefer Full Script or Marvel Style?

ALLRED: Not even close. Full script. When writing for myself, I can go with a looser outline style because I know what I'm shooting for. With collaboration, I want as tight a script as possible so I'm not guessing at what the writer wants.

Art by Sara Pichelli

Art by Michael Allred

Art by Bill Sienkiewicz

Art by Mike Deodato Jr.

Art by Skottie Young

DEODATO JR.: I prefer working from a full script—with the freedom to adapt and depart from it visually if I see fit. Sure, there are variations in the format. For some writers, Marvel Style means basically writing a short story, and we artists have to adapt and pace it. For others, it may mean a page-by-page, panel-by-panel plot with snippets of conversation, the final dialogue simply added later. I've never actually worked in true classic Marvel Style, where the writer gives a few sentences of outline and the artist plots as he draws.

YOUNG: I like Marvel Style with dialogue. Acting is important, so knowing the characters' words and voices plays a big role for me in getting those moments. Even if it's not the *exact* dialogue that makes it to print, I like to have the tone and idea there.

BAGLEY: It's been so long since the Marvel Style approach has been commonly used, that it's a bit difficult to remember what it was like to work that way. I found one of the advantages of that approach was the freedom it gave the penciller to really pace and choreograph the storytelling of the book. It was almost always intimidating reading through a six- to ten-page plot for a twenty-two page comic. And it took a lot of effort to really plan the issue out so you told the writer's story effectively. With a full script, it's all there. And if the writer has done a decent job, it's a breeze. I find myself nowadays just laying a book out a page or two

Art by Mark Bagley

at a time, and then just drawing it in those small segments. It's easy, and maybe you can concentrate on just the drawing more. But to be honest, I find the full script less satisfying. . . . I think I've always been a better storyteller than pure artist. Fortunately, most writers recognize the artist's visual storytelling abilities and the good writers are receptive to the artist's input.

IRVING: Well, if I am to be a purist here, then the real-deal Marvel Style would be a phone chat between writer and artist. Having never done that, I can't say for sure if it'd work that well for me. But I must say, the best experience I ever had in terms of storytelling was when I adapted Mary Shelley's *Frankenstein* directly from the novel. That was, in essence, a very long version of Marvel Style, as I understand it, in that the story was told to me as a reader and then I made the choices in pacing, stylistic conventions, gimmicks, acting, etc. So I would have to say that Marvel Style is my ideal, but I've never actually experienced that in practice, so I may find it a bit of a jolt if it ever actually happens. I do think it lends itself to a far more organic collaboration, though. And almost all of my favorite comics from my youth were made that way.

THOMPSON: I usually prefer a full script because that allows me to see how much dialogue there is and to plan the art and word balloon placement accordingly. I find it important to know what the characters are saying so I can make them act accordingly and have good facial expressions and body language. However, when I write scripts for myself, I'm not as detailed with the art direction descriptions because I know what I want to see in my head without explaining it.

SIMONSON: I prefer working Marvel Style. I feel that if the artist knows what he's about, he can create rhythmic storytelling with design links between panels and across pages and throughout a story. These are not always possible when working from a full script.

LAFUENTE: For company-owned books with tight schedules, I definitely prefer Full Script. I worked with a Marvel Style plot only once, and I didn't like it that much. It took a few days off the schedule, and the finished book lacked cohesion. The tone of the story and the panel layout didn't fit together because the writer and I didn't talk things out.

Art by Frazer Irving

Art by Walter Simonson

Art by David LaFuente

I think that you can make it work if you spend some time talking with the writer, to make sure you both are on the same page in terms of storytelling style. However, creators usually are too pressed by deadlines to take time out of their schedules to chat. I would love to try Marvel Style again, only not in a monthly book, that's for sure.

MARQUEZ: I've only ever worked in Full Script, so I can't really compare experiences. In the cases where the scripts have been looser—with panel breakdowns but the dialogue left to be filled in later—I've found myself missing the specific context of the dialogue. For me, the most enjoyable aspect of drawing comics is getting to make the characters

Art by David Marquez

act, and without the nuance of knowing exactly what they're saying, I feel that the acting can suffer. That said, I would enjoy the opportunity to work Marvel Style at some point. Those artists I've spoken to regarding the experience all speak highly of it. In particular, they mention the freedom it allows in terms of pacing and layout.

BACHALO: I prefer Full Script. The most important thing in a script for me is dialogue. If it's all there, I'll have a better idea of what's going on in the story, how to pace the conversation, and how to create the appropriate facial expressions. I enjoy that. For me, the balloons are part of the design and layout of a page. And if I have most of the dialogue and captions, it helps to heighten the creative process and produce an attractive page. I know how much space to leave for balloons, how to creatively distribute them on the page, and incorporate them into the layout.

When Neil Gaiman and I worked on *Death* and *The Children's Crusade*, when I was still relatively new to the business, he gave me a big boost by sharing with me that he trusted my storytelling and by reducing the amount of direction that he gave in his scripts. Mostly his scripts were dialogue with just enough description to set the up the scene, to let me know what was important, with loose page break-downs and no panel demarcations. I had a similar relationship with Jason Aaron on *Wolverine and the X-Men*. I find that this approach gives me freedom to pace the story, to highlight images that I feel would be compelling, and to tell the story, visually, in the best way possible. Sometimes the writer might have a great image in his head, but I might have another idea—and I know what my strengths are. In the end, I have to draw it. Hopefully, the writer enjoys the end result. And he still has the freedom to go back in and cover up anything that I may have screwed up or that he might be inspired to add in reaction to what I have created.

JANSON: Each approach has its pluses and minuses. I tend to want to say Marvel Style, simply because it gives the artist much more freedom in the storytelling decision making. But Full Script creates an interesting friction between the writer and artist. No two people will see the same scene exactly the same way. When I get a script and it is particularly difficult for any number of reasons (too many panels, too talky and not enough visuals, too reliant on film storytelling, too many things happening in one panel, etc., etc.), I usually curse out the writer for about thirty-six hours and swear never to work from a full script again. These writers just expect too much!

Art by Klaus Janson

Art by Sara Pichelli

But then, something interesting happens, and I can only speak for myself here, but the scene burrows its way into my brain and I become consumed with it. It becomes a puzzle that I must solve. It almost becomes an affront to me, and I have to rise to the challenge. It's all-out war! I deeply believe that every storytelling problem has a solution and I refuse to let those problems defeat me. As a result, Full Script forces me out of my comfort zone and I have to come up with a new or different way of constructing the page. It's an extremely difficult, frustrating, and painful process, but it usually creates work that is better than I thought possible at the outset. The satisfaction at the result, by the way, is second to none.

HUGHES: Full Script. I like to draw facial expressions and body language, and knowing the words the characters are saying really help me figure out what they're feeling. That is paramount to drawing facial expressions and body language.

PICHELLI: I like Full Script because it shows what the writer's exact idea is. The perfect situation is when I have some freedom to change things (without betraying the story, of course), because that means the writer trusts me. But this kind of connection comes with time; it's something you can build together issue after issue.

SIENKIEWICZ: I enjoy both, but Marvel Style does allow for more artistic input and for happy accidents and inspiration. I tend to prefer less rather than more in terms of what's written. Give me the starting point and destination. That said, it also can be more of a gamble, if my "take" or interpretation comes from too far out in left field. I enjoy trying to capture a lot of what you can't usually see: the psychological aspects of the characters, the subtext.

Art by Bill Sienkiewicz

What are the things you see in scripts that most annoy you?

ALLRED: It's rare, but from time to time I'll get a panel description that has way too many people doing way too many things. Or too many events are squeezed onto a page. A story needs to breathe. And what takes a writer a few seconds to write may take an artist a lifetime to draw.

DEODATO JR.: When the writer forgets he's writing for comics and not animation—and describes in one single panel what would take at least three panels to show properly.

IRVING: Flowery prose. Verbosity. Some folks think they're Neil Gaiman, and have ambitions of their scripts being reprinted for their adoring fans to pore over, when in reality, scripts are working documents designed to provide the narrative framework for their collaborators to decorate and embellish with imagery.

THOMPSON: Some of my pet peeves are

- When a writer loads too many actions in a panel because the writer thinks that the comic page works like a film. For example:

Art by Michael Allred

Art by Frazer Irving

```
Page one, panel one

Establishing shot overhead, looking down on the main
street of a small town. We see the general store and
mothers putting groceries in their minivans while their
children cry because they dropped their bottle, yoga
studio and coffee shop with patrons walking in and out
of them, on the other side of the street we see our
main character looking at his fancy smartphone. He's
reading a text that says, "I see you." He looks
shocked, then looks around uncomfortably. . . .

Then come panel two, three, four, five, six . . .
```

Art by Jill Thompson

Art by Mark Bagley

- Panel one could have been a whole page by itself! Sometimes writers forget that what they are thinking of is a crane shot on a TV show or a film. You can't start out far away and zoom into a tiny screen or a facial expression all in the same panel. Similarly, it's difficult to draw an establishing shot done overhead on a Roman battlefield and describe how you see one hundred warriors, and also ask your artist to show the main character killing a dude, stealing a horse, and galloping away all in the same panel. But sometimes you get asked to do it. Gives me a headache!

- Redundant word balloons that describe the action that is happening in the panel.

- So much dialogue that you are forced to use medium shots for every panel.

- Scripts with overly detailed art direction. Sometimes that just sucks all the spontaneity out of creating. I think there are better ways of doing art direction than a laundry list of things that are meant to be in a panel.

BAGLEY: I get really annoyed when a writer has two or more sequential actions happening in the same panel—when he doesn't remember that panels are (generally) single segments of time. It doesn't happen very often, and is usually easily solved with a small linking panel, but it is annoying.

MARQUEZ: High panel counts and crowd scenes! No, no, just kidding. While "denser" pages take more time and effort, they play an important role and are part of the job.

Art by David Marquez

What really drives me nuts in a script is a writer who doesn't understand how to write *for* comics. Comics are a visual medium and a storytelling art form separate and distinct from prose, film, or stage. Different rules apply. And, most importantly, if you're writing for an artist, the script has to be written in a way that allows the artist to do his job! The information has to be there!

The ways in which a script can go wrong are legion, but the one that takes the cake for me is placing more than one "beat" in a panel. Since comic art freezes single moments as a panel, seeing a panel description that requires drawing separate moments simultaneously (phone rings, is picked up, and is spoken into) is incredibly frustrating. Now, it's easily solved by breaking the beats up into separate panels, but that requires reworking the page layout.

BACHALO: I can't say that there is anything about the scripts I get that really annoys me. If I had to pick something, it would be that I don't care for long scenes that stretch out past, say, six-plus pages. For me, in real time, that's an entire week working on one scene and in the space of a twenty-page comic that's a big space for one scene to occupy.

LAFUENTE: Two-page spreads. They are very time consuming and a chore to do because of the size of the paper you have to use. I've never enjoyed working in large formats, not even in canvas. I always lose sight of the complete picture. Also, the spreads read particularly bad, in my opinion, in collected editions because of the spines of the volumes. I've tried many different panel compositions to try to make the best of the spine problem, and I've never felt satisfied with the results.

Art by Chris Bachalo

Art by David LaFuente

Slang in panel descriptions annoys me a bit. A sizable portion of the artists working in the US comics industry are from overseas, so keeping the nondialogue instructions in plain English will save them time.

SIMONSON: The toughest thing when working from Full Script is having the writer ask for a character to perform more than one action in a single panel. Comics are not movies, and film isn't running. Similarities between comics and movies aside, there is *no* motion in a comic. Information and action are generally imparted via a series of discrete but essentially static panels. It's possible to fudge a little with multiple images in one panel, but two distinct actions from a single character in one panel is usually tricky. And breaking the action apart to create dynamic storytelling often involves adding more panels on a page, something the writer isn't anticipating.

JANSON: Too much direction or detail from the writer. Writers have to understand that this is a collaborative medium, and the artist has as much, if not more, right to decide the visuals. A book with words and no visuals would be a novel. A book with visuals and no words would still be a comic. I relinquish not an inch of territory to any writer!

HUGHES: Errors, either grammatical, structural, or otherwise. It makes me feel like I'm reading a first draft, and that means the writer probably handed *in* a first draft. And *that* means that a lot of thought hasn't been put in to what I've been given. Suddenly it's now my job to make sure

Art by Walter Simonson

Art by Klaus Janson

everything makes sense, goes with other elements, or has no errors, when all I *should* be doing is drawing.

PICHELLI: When the writer describes a character in a way, and then some pages or issues later that character uses something he's supposed to have (a weapon, phone, some devices, or a part of his suit), but you didn't draw it before because it wasn't specified in the previous script. That's annoying because it looks like the artist forgot to draw it beforehand.

SIENKIEWICZ: Mostly what are considered newbie errors. When there are attempts to cram several conflicting important story points into a single panel rather than subordinating and prioritizing. Along those lines, not giving the plot or pacing room to breathe. Sometimes it's nice to linger, to let things unfold at their own pace. An unfortunate by-product of the desire to "jam-pack" our entertainment. Sometimes bloat is bloat.

That said, ultimately, there is no single "right way" to combine words and pictures successfully. It depends on the story being told.

Art by Sara Pichelli

Art by Bill Sienkiewicz

What was the best experience you have had collaborating and what made it special?

ALLRED: Here's where I risk alienating all the wonderful writers I've been blessed to work with (including you), but honestly, if it's clicking, it's always whatever I'm working on right now. I always try to find a way to find energy, passion, and progression with what's in front of me at the moment. Living for "the now."

Art by Michael Allred

Art by Skottie Young

DEODATO JR.: I've had so many great collaborations in my long, long career, but none of them will ever compare with the magic moments I had when I was fifteen to eighteen years old, creating stories with my then best friend and publishing them independently. We'd spend whole nights playing at it, saying the dialogue aloud, laughing with the jokes, posing for shots so we could understand what the other was talking about. We were young, so the results were not masterpieces, far from it actually. But the process, that was special.

YOUNG: Working with writer Zeb Wells on *New Warriors* was my best collaboration. We broke story together as writer and artist and pitched the series together. We were equals in storytelling, and that really led to something special. Comics are so heavily visual that it's great when you find a writer who knows this and loves the team aspect of creating comics.

BAGLEY: Has to be *Ultimate Spider-Man,* for a number of reasons. First, Brian is just a great collaborator who trusted me to visually tell his stories with very little second-guessing. If he wrote a sequence A–D, and I felt it was more effective to swap steps B and C, as long as I got to "D," Brian would be happy. In the five to six years we worked together, I think I had to go back and redraw something only two or three times. And that was generally because I misinterpreted what he was asking for . . . or was tired and got a little lazy . . . only the mediocre are always at their best. Also, I loved the characters, and thought of them as "ours." *Ultimate Spider-Man* was mostly a stand-alone book, unencumbered by a lot of the tie-in/crossover nonsense going on in comics now. As such, we got to tell very focused, plot-driven stories with very few gimmicks.

IRVING: Possibly *The Necronauts.* This may be due to it being my first gig, thus making the sentimental attachment strong. But I also think that Gordon Rennie [the writer] is quite aware of the magic of less-is-more in terms of working scripts. Plus, he was adept at cramming a good amount of story into those five-page chunks (Ooh, five page chunks . . . it seems like a million years ago now. . .) whilst keeping the tone of the script very personal, to the extent of openly mocking me and our employer on the one big splash page where he declared that it was the artist's job to draw [his] interpretation of "hell on earth" and that he could write a lot of stuff to justify the page rate, but instead he'll just take the money and leave it all up to me. That was refreshingly honest and remarkably liberating as I am a "good dog," and I try to follow the script even if I shouldn't. So, by leaving that stuff completely out of the equation, he made my life less stressful.

SIMONSON: At the very beginning of my career, I had the good fortune to work with Archie Goodwin on *Manhunter* for DC Comics. We worked closely together on that strip, creating the character and his biography with a synergy I don't fully understand to this day. But Archie was a wonderful writer and editor, and brought out the best in anyone who worked *with* him or *for* him. That was certainly true with me. Even then, I was able to appreciate how incredibly lucky I was.

LAFUENTE: This one is difficult. Probably the *Hellcat* miniseries with Kathryn Immonen. Aside from the title character, everything was brandnew, and involved lots of world building. The overall plot was a classic rescue adventure, but all the details covering it were bananas, the perfect opportunity for me to let go. Both the writer and the editor were funny people and open to discussing things, making it a very relaxed and comfortable working atmosphere.

A close second would be the *Ultimate Spider-Man* Annual. It was a very, very good script. It contained humor and a story with an excellent balance between action and quiet scenes. Everything was new for me, too. It was the first book I had worked on that took place in New York, and I had a large cast of fascinating and well-defined characters that left just enough room for interpretation.

THOMPSON: I have had several awesome collaborative moments . . . working on *Sandman* was terrific. Neil Gaiman writes all his scripts to your strengths as an artist, and that makes the whole project a joy to work on because it is all stuff you like to draw! His scripting style is very storybooklike in the art direction, so you get a beautiful picture in your head of the scene instead of a list of things you feel must be included in the panel.

Working with Mike Baron on *The Badger* was really fun because Mike's scripts are hand-drawn thumbnail pages with the dialogue written in the margins. Mike would start out each script with the disclaimer "Jill, please disregard my horrible drawings. This is just to give you an idea of the action and how many panels per page I see this action broken down into. Please adjust accordingly, as you are the artist." I think that really brings out the best in an artist. I also loved collaborating with Will Pfeifer on *Finals*. He could write a large cast so well! His scripts always had me laughing, and I was excited to start work on them each day!

MARQUEZ: My first published project, *Syndrome* from Archaia, was an incredible experience, and set a very high bar for all the projects that came after. In addition to the sheer excitement of working on my first real comics project after years of trying to break in, I bonded very strongly

Art by Jill Thompson

Art by David Marquez

with the other creators, especially the two writers. From the outset, my input was not only encouraged and valued, it was integrated into the writing process. I had read through the first treatment/pitch for the book, and was concerned with some aspects of the narrative structure. Later, I found out that my notes (in part) led to a rewrite and complete restructuring of the book. Over the months that followed, the writers and I had daily conversations about the script, the art, the colors, the lettering, bringing every team member into the discussion. Page upon page of emails, e-chat conversations, hours of phone time, all led to a very close-knit creative team who were more than just collaborators, but were also friends who were passionately and very personally committed to making the best art they were capable of. I've been very fortunate to have had similar experiences on a number of projects and with a number of writers and artists in the years since, but you always remember your first.

BACHALO: I think the best experience I had was with Jeph Loeb on *Witching Hour*, as we had the time to sit down and talk about the stories. I was amazed at how much time we spent on the phone sharing story ideas or discussing the details of the pages that I had turned in, and I was impressed with how much he picked up on. It could've all been BS, but it felt good, like he was really into what was going on and made me feel that I was always part of the entire creative process. *Witching Hour* ended up being a nice mix of all of our ideas.

There are situations, like when I worked with Chuck Kim on the *Storm and Gambit* one shot, in which I came in early, and we had an outline that I felt like I could toss out an idea or two on. We compromised here and there, but to my delight we ran with many of the ideas, and it was a great experience.

On a monthly, I've found, this approach just isn't possible. Rick Remender and I were going to work on *Uncanny Avengers*, and he was encouraging me to participate in the story conversation. And I asked him to go ahead with what he does best, write great scripts and I'd respond. There just isn't enough time. I don't keep up with the entire Marvel Universe. I don't attend writers' conferences and I probably wouldn't have that much to offer in terms of creative development—other that it might be fun to draw this character or have a story take place in outer space. Stuff like that. I never once spoke with Mike Carey when I was working on *Supernovas* with him, but I was really proud of the work we did together. I asked Jason Aaron if he could work a *Generation X* character into *Wolverine and the X-Men*, and he added Husk. That went a long way with me—getting to work with an old favorite character.

JANSON: I've been fortunate to have had several collaborative experiences both as a penciller and inker that were very positive. The best experience, as a penciller would have to be working with you and David Mack on *Daredevil: End of Days*. It was a terrific script in a genre that I love and love to draw, paced extremely well, with many, many great set pieces and lots of opportunities for input. It was one of those times when I realized that this was a once-in-a-lifetime assignment.

No one gets up in the morning and says to him- or herself, *I think I'll make a crappy comic today.* We all have fairly high goals. But a lot can happen in between the initial idea and the result; and sometimes, despite our best intentions, the result is a crappy comic. A lot of hard work and a little bit of luck help, but the collaboration on *End of Days* was, for sure, a positive experience.

HUGHES: I have yet to actually *collaborate* on a story. I don't feel that "collaboration" describes an artist being handed a script that they had no say in. To me, collaboration means a writer and artist work together to come up with a great idea. The writer proceeds to write it, and the artist then draws it. Being handed a script you've had no say in story-wise is like being handed a baton in a relay race. Marvel Style encourages collaboration of a sort, where the artist ends up choosing pacing and panel breakdowns, but it's still an individual effort. That being said, I did an

Art by Klaus Janson

X-Men/WildCATS crossover once, and writer James Robinson asked me in advance which mutants I wanted to draw, and which ones I didn't care to. I thought that was nice and sorta collaborate-y.

PICHELLI: Being a part of the creation of Miles Morales is the most special thing to happen in my career. In spite of the responsibility you have when you "handle" characters as important and beloved as Spider-Man, the idea that my creativity helped bring to life a character who's quickly becoming a new icon so loved by fans makes me really proud.

SIENKIEWICZ: I'm fortunate to have had many "best" experiences; good ones for sure. Every series was a collaboration that seemed, at the time, to perfectly encapsulate a specific kind of reading experience, one that felt like a very definite point of view, "take," or statement on a character or group of characters. I think the best series do this—they take a stand, or create a pronounced arc, for good or ill. Nothing is really watered down.

In my experience, no matter which writer I collaborated with, if our efforts succeeded, we tried to stay true to the goal we set out to accomplish, and if we failed, we tried to at least fail spectacularly and honestly, rather than toeing the line or playing it safe.

Art by Sara Pichelli

Art by Bill Sienkiewicz

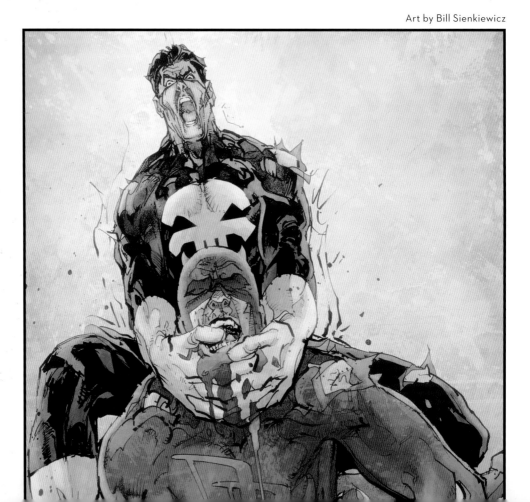

For example, *Moon Knight* with Doug Moench, was, at first, sort of the standard mainstream series, one that went more "indie" as we went along. This was in part because I began to get bored with the standard industry approach and arbitrary rules of what could and could not be done in the medium. I had always worked from scripts by Doug—even his plots were more scripted than not—and I wanted desperately to really contribute more to the stories, provide more of a personal POV (point of view). Around issue 26, I really started to get more involved in the plotting, which was very liberating to me. The issue was "Hit It!" and it dealt with things other than standard costumed characters. I wanted to see if I could convey a sense of musicality through words and pictures. After "Hit It!" I felt it was time to move on to new challenges.

Without naming names or projects, what was your worst collaborative experience?

ALLRED: It was actually my first—and only because it was never finished, so I don't mind naming names. It was a wonderful project with Steven T. Seagle, edited by Shelly Bond, for Comico called *Jaguar Stories*. We were a few issues in and then Comico went bankrupt. So there's a nice touch of reality for you. We often talk about revamping it and finishing it. Someday.

DEODATO JR.: Working on a bad, predictable script is the worst thing for me as an artist. You do your best to make it look better, but there is only so much you can do. Even the best, most compelling art won't completely rescue a tired, boring story.

Art by Michael Allred

Art by Mike Deodato Jr.

Art by Skottie Young

YOUNG: I had one where I didn't speak to the writer until a year after the project had come out. It's hard to even call it collaboration at that point. That was early in my career, and it taught me to be more in the loop at the beginning of projects. After that, I turned down projects if I couldn't be a part of the building process. Even the bad collaboration was a learning experience.

BAGLEY: I've had two really sour experiences in my career. The first was early on, and coincidentally was my first experience with a writer working Full Script. This arrogant guy would take *zero* input from me about the storytelling—even to the point of refusing to adjust his script when I added a much-needed transitional or "bridging" panel. The second was much more recently and due entirely to an editor who was about the most unprofessional jerk I've ever had to deal with (and I've been doing this job a *long* time).

Art by Mark Bagley

IRVING: Working on a boring franchise character where there was no emotional connection, no real relevance to anything, just months of my life spent drawing pages that would get sucked into a black hole. I got paid, and that was good, but ultimately it was an emotionally barren experience and I don't do this *just* for the money. I've dealt with crushing

Art by Frazer Irving

deadline dashes, poor rates, maddeningly confusing scripts, but the worst thing of all is always the "Boring Story."

THOMPSON: I worked on one project where the panel descriptions were so overly detailed and exacting about what was to be in them and how the writer saw things that it felt like I was wearing handcuffs. I felt as though I was a surrogate pair of hands for a frustrated artist. I would read the script and actually get a headache. And after reading this detailed story, I still would have zero pictures pop into my head. No layout, no page design, and no creative burst of enthusiasm about what I'd just read. It was awful! Luckily, that hasn't happened again.

MARQUEZ: My horror story came before I broke into comics professionally. I had hooked up with a writer at San Diego Comic-Con, coming on to finish the art for a self-published, creator-owned comic after the previous artist had left (red flag). We hashed out an agreement that suited both parties and moved forward. Over the next three years, the nature of the book changed time and time again. What was initially just a three-issue gig evolved into reworking the previous issues ("The publisher really wants the whole book to have a consistent look."). Guaranteed publishing deals fell apart ("But don't worry, the new prospects are actually a lot better."). When no inker could be found, what had been established as a pencilling gig became an inking gig as well (though this actually turned out to be a blessing in disguise, years later). Finally, with the project weeks from wrapping, Hollywood (I was told) came a-knocking. And, in order for things to move smoothly, the contract had to change ("But don't worry, I will still respect our original deal . . . until my lawyer says otherwise."). Long story short, three years of work and I had nothing—no money, no

Art by David Marquez

Art by Walter Simonson

ownership, no published work—to show for it. Still, I learned a valuable life lesson about counting chicks, trust, lawyers, and sticking to one's guns. And I got three years of terrible pages out of my system and learned to ink. Within a year, I'd be working on my first published comic and, within two, working for Marvel. I dunno whatever happened to the writer.

SIMONSON: The most difficult project I worked on was probably the Marvel Comics adaptation of the film, *Close Encounters of the Third Kind*. And that was because the movie company was extremely reluctant to release any information about the film, other than a script, to those of us working on the comic book. So we had virtually no visual reference from which to draw, and Marvel, who published the comic, didn't have likeness rights. In addition, because of the contract negotiations, we weren't able to start working on the comic until a few days before the movie opened in theaters. Under the circumstances, I thought we all did a pretty good job, but the comic wasn't all it might have been.

BACHALO: I've been pretty lucky and can't say that I've had a bad experience. On one project, I had a window of time to turn it around and the writer delivered the script slowly, one to two pages a week, and I had to leave and didn't finish. That didn't feel great. Every writer and every situation is different. A lot has to do with the nature of the project. Ideally, say in a creator-owned situation, or a project that is close ended, it's great to sit down with a writer and discuss plot, characters, pacing, etc. With Joe Kelly on *Steampunk*, we discussed the story up front and then he wrote and I drew. With Jeph Loeb on *Witching Hour*, we chatted several times a week. On monthlies at Marvel, in almost every instance, I've never had a conversation with the writer. I'm comfortable with him doing his thing and me doing my thing. Then, hopefully, we get it right. I can say that I'm perfectly comfortable with that relationship. In a way, I see myself as the first fan, the first person who gets to read the story who wasn't involved with its creation. There's nothing better than when a page-turner arrives. I really get into it.

JANSON: The worst thing that can happen to a project is to have the team lose its vision for the story. Once that happens, it's a pretty certain sign of deep trouble. And that loss of direction often happens because of interference from an outside source, like management or some distant

Art by Klaus Janson

Art by David LaFuente

senior editor. I think the most positive work usually emerges from choosing the right people, giving some editorial guidance, and trusting them to do their jobs. The notion that quality can emerge from top-down interference and constant tweaking and changing is something I have yet to see. 'Nuff said.

LAFUENTE: It was for one of those graphic novels with photo-traced faces. The writer was brilliant, and I had admired his work for years. But I'm not a photo-tracer or caricaturist, hardly the obvious choice for the project.

The publishing team turned out to be the absent kind, and the writer took on the role of editor/supervisor for the project. I also discovered quickly that he was a temperamental individual who would go into "Joe Pesci" mode without hesitation.

I began sending pages in, and, of course, the real people were recognizable by their clothing and hair styles, not their faces. The writer was not happy with this and requested changes. I redrew panels, moved lines here and there but nothing worked for the guy. This went on for about a year, and I accepted other gigs on the side to pay the bills.

After an especially abusive-sounding email from this writer, I felt I had enough, told the publishing house to keep their money, and walked away. It took two years and a few more artists for the project to come out and, I believe, tank.

HUGHES: The first time I worked Marvel Style. The final result was a pretty good comic, but I was frustrated that the final dialogue didn't always match the plot description I was given. For example, in the plot, character A is arguing with character B, and A is therefore yelling at B. So, I drew A yelling at B. By the time the writer scripted the dialogue, he/she had changed his/her mind, and gave character B downplayed, under-the-breath dialogue. My yelling face on character A suddenly looked *really* weird and awkward, as if I didn't know what I was doing. Again, the final product was fine, I was just a little put-off by the strange unexpected changes by the time the scripting was done. That's another reason I'm fonder of full scripts.

SIENKIEWICZ: The worst-case scenarios involve working with people who are convinced they know the right way, the only way, yet claim they're flexible collaborators. That's more a personality issue than a creative one. Some projects are more collaborative, while others are strictly division of labor gigs. I've worked on both and everything in between. I've worked with several writers—and editors—where pushing things was not only not

desired, but downright frowned upon. They wanted me and what I brought to the table, yet also wanted to control my input, which was ultimately unsatisfying to everyone. I've learned to steer clear of those scenarios. In some cases, the writer's personality was less about artistic expression than about doing a "production-line" comic book that didn't rock the corporate boat. There's nothing wrong with just doing the gig—that is a decent goal. This is a business after all. But for me, it's also fortunately—and unfortunately—an obsession, and I can't help but want to push against walls. But that said, the result is not necessarily negative. It's often relaxing to simply do a really good job and not always feel the need to swing for the fences.

My underlying point is about teamwork. This medium is one that, in its best iterations, demands a great blend of intelligence, artistry, technical facility, heart. And truth.

And besides, it's still just so much fun.

Art by Bill Sienkiewicz

THE ARTISTS' SIDE:
DAVID MACK AND ALEX MALEEV

Multimedia artist and children's book author **David Mack** is best known for his opus, his odyssey, *Kabuki*. He has also done acclaimed work on *Daredevil*, and was hand-picked by the Philip K. Dick estate to adapt the author's work into comics.

Born in Sofia, Bulgaria, **Alex Maleev** started his career in lithographic printmaking and moved on to storyboard work for acclaimed directors such as Alfonso Cuarón (*Children of Men*, *Gravity*) before breaking into comics. Alex and I have been working together since the '90s. We are best known for our Eisner Award–winning years on *Daredevil*, *Avengers*, *Halo*, *Spider-Woman*, and our ongoing, creator-owned endeavor *Scarlet*.

A CONVERSATION WITH MACK AND MALEEV

Comic book art is and can be so much more than just pen and ink and computer-generated colors. Many of our finest comic artists work in many different mediums, pulling from outside of the comic book field and bringing something new to the page. There is a quote by the musician Sting referring to the fact that rock 'n' roll is a bastard medium—that it only truly becomes elevated when people take something from outside of rock 'n' roll, like country, jazz, R&B, etc., and create something new. The same can be said for comic books. They are a very similar bastard medium. To truly elevate the art form, one must look outside of comics—pulling inspiration from classical or abstract painting, printmaking, cinematography, collage, etc.

Two unique visionaries of the last generation are David Mack and Alex Maleev.

David, you often write for yourself. How does that process work?

MACK: I often start by writing down everything I can think of for the character. For the first draft, I don't censor myself at all. The creative zone and the editorial zone are two different headspaces. You may be tempted to edit while you write, but you aren't objective about it at that

ABOVE
Art by David Mack

OPPOSITE
Art by Alex Maleev

ALL ART
David Mack

time. Write every idea you think about. If you think of three ways to tell the scene, write all three of them down. But when you come back a second time, *then* approach it with a critical eye, and think, *Of these three solutions to this scene, which gives the best sense of character? Which gives the best sense of pacing for the story?*

In the visual medium, the poignant visuals reduce the need for much of the written information. Or, often, it is a contrast, a dynamic between the written and visual. You can have an overstatement in visual elements, contrasted with an understatement in words.

I think of myself as a writer first, and I begin with the story. That gives me a liberty to create a visual style and pacing that best fits that particular story. After I've written it, I try to think of the best way to tell a particular story in visual terms. Maybe different scenes use different mediums, or color styles, or I will juxtapose a realistic scence against another one that feels conceptual or whimsical.

I've found that if you create a sense that the characters are real by drawing them realistically to begin with, and do a certain amount of close-ups and eye contact, then you don't have to do that every time. Once the reader gets to know the character, you can scale back on the information you put in and you can start to draw more expressively, in terms of the emotional content of the character. Anytime there is something that is rendered or realistic, I want to contrast that with something that is more whimsical or abstracted. You can gradually become more

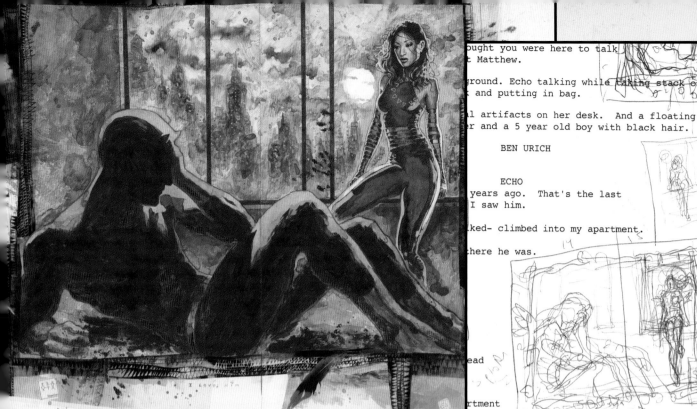

ought you were here to talk
t Matthew.

round. Echo talking while taking stack of
and putting in bag.

al artifacts on her desk. And a floating
r and a 5 year old boy with black hair.

 BEN URICH

 ECHO
years ago. That's the last
I saw him.

ked- climbed into my apartment.

here he was.

ead

rtment

Daredevil is in her house, sitting on the
. Resting. A mess.

her cluttered, culturally vibrant apartment.

Blood Splatter

and more abstracted to the point that what you're telling is an interesting abstracted visual metaphor for what is happening in the story itself.

Both of you have unique styles, and I'm curious what your major influences were or are.

MACK: My influence is the story. As a child, my introduction to comics was an issue of *Daredevil* by Frank Miller. Before that happened, I didn't really realize what comics were. I was ten years old and this *Daredevil* had a pretty terrifying crime story. I thought comic books were cartoons. Miller's *Daredevil* was beyond my comfort zone. I had a visceral reaction to it. I was almost frightened by it.

A couple years later, I stumbled on the next issue of that story. I was twelve years old and ready to understand it. I opened the book, and this creator was using shadows, panel size, double pages, weather, lighting, the beats of someone lighting a cigarette, etc. All these things were happening and I realized this creator was very consciously controlling every single element that the reader experiences—in order to give an atmosphere to the story. And from Frank Miller I learned about Will Eisner, got his book, and kept going from there.

Ultimately as a creator, there is no off switch. You are taking in things that you experience in your life, and your story and art becomes that laboratory for you to make sense of it. You are processing things that you are interested in and passionate about—childhood traumas,

Page 16- 17
Double page spread
Flashback!!
Int. Echo's apartment
David Mack art.

This is the first time on this quest that someone is actually cooperating with Ben and giving him a first-hand account of the last interaction they had with Daredevil.

Echo Close up with Daredevil. Nursing him. Close enough to kiss (Possibly even include a panel or sequence with them kissing. As if she isn't telling Ben the entire story, as if this night, or later, the last time she ever saw Daredevil, may have been the night her son was conceived).

 ECHO
I got him some ice. I begged him to
take a break. He snapped at me. And
he left.

About a year later I retired my
double life as Echo. I was doing
some field work... special ops. And
code breaking for the government...
Some globe trotting and deciphering
of archeological glyphs. Especially
when the Mayan Calendar thing went
down. Then the 616 revelation.

I think I quit that night actually,
seeing Matt like that- it shook me.
It sobered me right up.

But it took about a year to work it
out of my system.

Page 18
Flashback!!

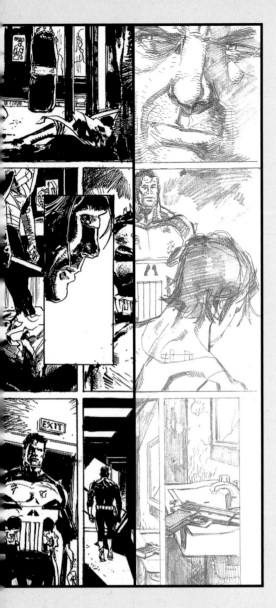

family ordeals, things that make you happy and give you joy, things that make you sad or hurt you. Those are your influences. You create a language, a vocabulary, through your work to give things an order and turn them into something useful or beautiful or powerful. Sometimes there are creators who come before you who have expanded the vocabulary of the form. It is up to you to add your own vocabulary to that language as well.

MALEEV: The question of influences is one we get asked the most at conventions, on panels, and in interviews. It is one of two questions I get asked the most.

MACK: The other one being, "Where do you get your ideas?"

MALEEV: Yes, and the second one is "What are your influences?" There are three ways of answering that question. One is to tell the truth. The second is to say what the asker wants to hear. And the third way consists of a lot of things you don't really understand.

I usually go for the second one because I'm trying to be polite and politically correct. I give away all the names and books, what I like and what I don't like, and the resources that I keep open next to my computer when I'm drawing. People like to hear that.

The true answer is—my inspiration is me. It is what is in my head, what I lay down on the page. Whether I like it or not. Whatever comes from my brain, through my arm, and onto the paper. That is the answer.

I am my own inspiration. Why is that? Do you know why this is? I don't know either. But I think inspiration is an extension of experience.

ALL ART
Alex Maleev

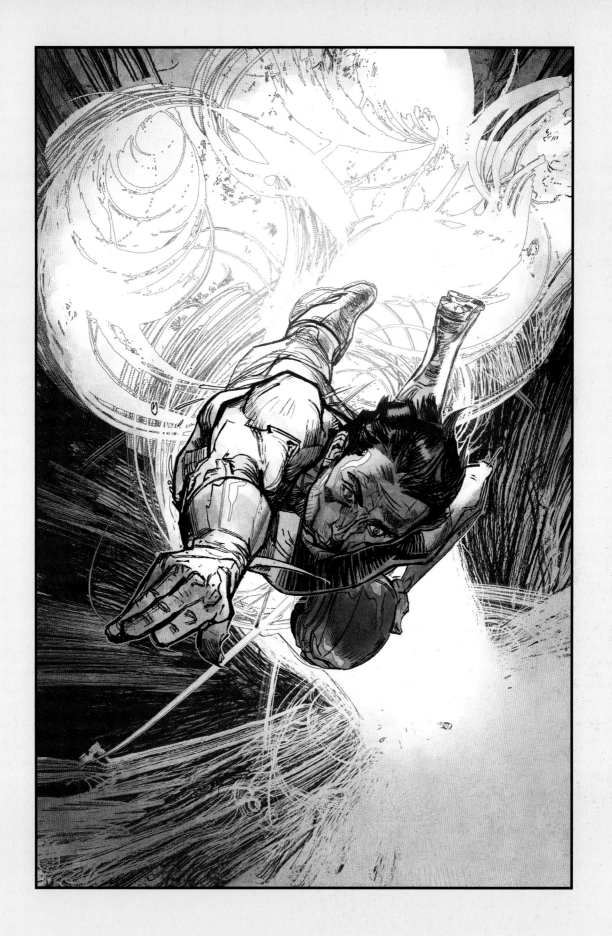

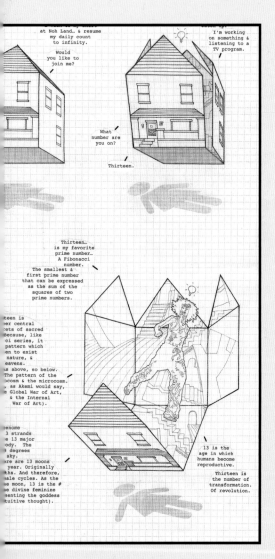

How many pages can you complete in a day?

MALEEV: I paint something and leave it on my computer overnight. When I go there in the morning and look at it again, I usually see a couple things that are wrong with it. And then the next day, it will be complete. It takes a little time.

MACK: I try to do a page a day. But there's a temptation to have a page completely, 100 percent finished before moving on. You want a sense of closure to the page before you start the next one. But sometimes I can only figure out 90 percent of the page. That is okay. You move on. Because you're not objective enough at that moment in the story to know how it all fits together. It's like editing film. Create the raw footage first, and then when it is whole, you finesse it.

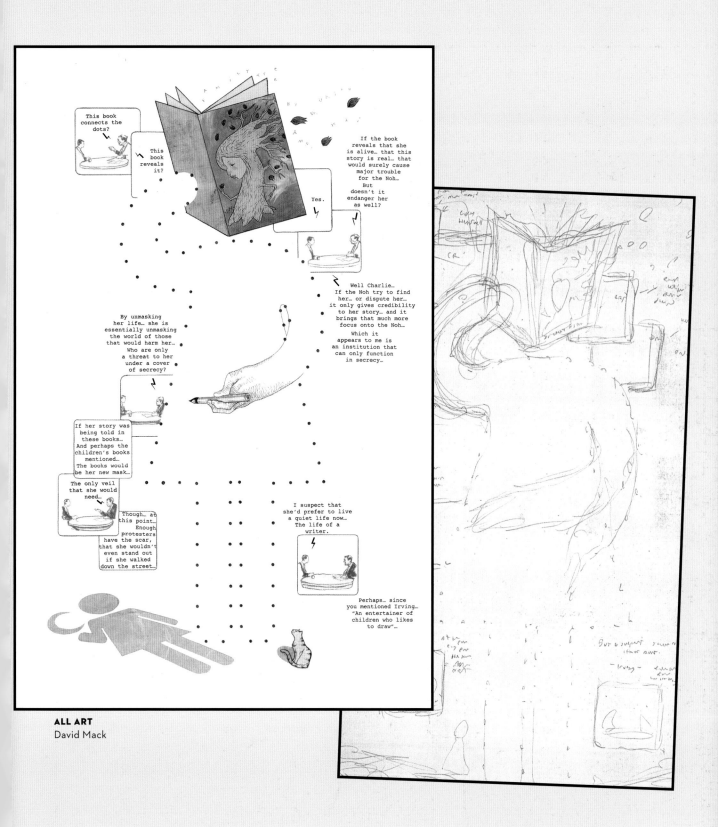

ALL ART
David Mack

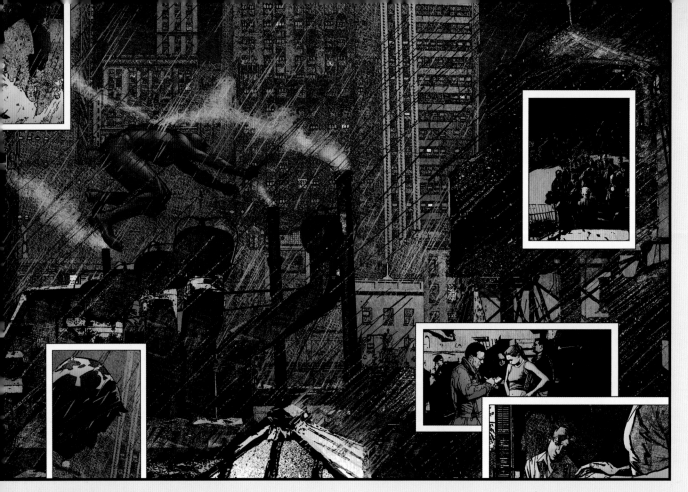

ABOVE AND BELOW
Art by Alex Maleev

David, you do most of your work on the canvas, and then you do a lot of Photoshop?

MACK: No. Not that I have anything against Photoshop.

I like working with my hands and figuring it out manually. Solutions will occur to me that I couldn't have worked out unless I was involved with the material, pushing the edges of the mediums. I've never used Photoshop. I don't know a thing about it. I see the things Alex does, and I think, *I should try it as he is doing amazing things.* So I imagine someday I'll experiment with that tool as well.

MALEEV: I use Photoshop for its speed and freedom. Speed—because I have deadlines and the work pays my rent and mortgage. And freedom—because you can do anything you want at any point. That's so liberating.

My background is in printmaking. I have a degree in it and could teach it in schools if I wanted to. My true love is printing press ink. If you give me that, I'll be happy. But I cannot pay my mortgage that way—so my family would be miserable.

Photoshop? Yes. I love it. It is a great thing. I bought the program ten years ago. I'm openly saying Photoshop saved my life and career.

In Photoshop, all the comic panels are created much, much bigger than on the printed page. I then shrink them down and make them fit.

What do you really like to see from a script? When a writer hands you a script, what are the things that get you really excited?

MALEEV: I like to draw people speaking in a bar. I don't like to draw hundreds of aliens descending from a spaceship.

That is the most direct answer I can give you. I love the really dark, noir way of telling a story. When there is a huge fight, it's the last thing I want to illustrate. It is usually the last page I'll draw—because I have to, the deadline is tomorrow, and I *have* to do it.

I like to have a European, indie sort of style to what I do. These are the stories I love. *Daredevil* was exactly that.

How do you rate doing stories that have a deeper meaning versus stories that just have entertainment value?

MACK: For me to be entertained—the story has to have a certain meaning to it.

ABOVE AND BELOW
Art by David Mack

Art by Alex Maleev

Art by David Mack

Generally, when I select a project, I like to choose one where I go to a place that I haven't gone before or explore something that I haven't done before. I try to find a personal connection to it on some level. That said, I try to make it entertaining for myself and hope that it is entertaining for other people, too.

You can never guess what is going to be entertaining for the lowest common denominator or largest amount of people. If it holds your interest and keeps you excited, that is the only compass you can go with. Sometimes people like it, and other times it won't be their cup of tea. Other times the project will find its audience over time.

Do you have advice for starting a new long-form comic project, where you get paid on the back end?

MACK: Yes. Save money. And have humble living expenses.

If you have an opportunity to do what you want, do it first, and then show it to the people afterward. That worked with me on *Kabuki*. I was able to do it and then say, "This is what I've done, are you interested?"

So many people get offered jobs and then flake out and never complete them. Publishers realize if they are going invest their time and effort in in a project, it is nice to know it will be finished.

If you do something first and then show it to them, that is a major advantage. The first *Kabuki* volume came out twenty years ago. I keep it in print. It finds its audience over time. A project doesn't have to be a smash hit immediately.

What inspired you to make comic books with multimedia because it is not a common approach?

MACK: I did a lot of work in a variety of mediums before I did comics. My mother was a first grade teacher and if I was to cite my biggest artistic influence, it would be my mother. As a small child, I had access to her art supplies that she used for teaching. She would construct visual lesson

plans to help her students learn numbers, seasons, syllables, colors. She had paint, construction paper, tape, and scissors to create images so her students would remember everything. That idea of art as a tool for communication sunk in at an early age, and this use of mixed media and collaging things together probably stuck with me as well.

Why comics?

MACK: Comics is amazing because it is really one of the last pirate mediums—where one person can convey [his] complete artistic expression and get it out there to a wide range of people. On radio and TV, you need a license to do that. There is no government form you sign to make comics. You don't have to take a licensing test to make comics. You can have an idea and then make it real all on your own.

MALEEV: I am very good at them, so why not?

Art by Alex Maleev

Art by David Mack

SPOTLIGHT ON MICHAEL AVON OEMING

Michael Avon Oeming is an award-winning comic artist who started working professionally at age fourteen. As a true jack-of-all-trades he has worked for every comic company—big and small. He is most known for his creator-owned work on *Powers*, *Mice Templar*, *Victories*, *Takio*, **and** *The United States of Murder, Inc.*

OEMING: I got interested in comics when was in sixth or seventh grade. I lived in New Jersey pretty much my whole life and I had to move to Texas and I couldn't adjust. It was like living in another world. Until one day my family went to a flea market, and I found some Spider-Man comics and I really liked them. I then went back to get more comics. I went back and found *X-Men* and *New Mutants* drawn by Art Adams and his work blew my mind.

After just having started drawing, my skills were not that great, but my inking was pretty good, and I was sending out sample work to different companies not knowing if I was going to get any work. I was just trying to get feedback. Steve Rude, one of my heroes, who created *Nexus*, would write back to me. He would just write all over my stuff and he would tell me, "This sucks and go back and fix this or that," you know? Every writer has a million bad words they have to get out. Well, every artist has that many lines.

Did you save any of that correspondence?

OEMING: Yeah, I saved all my rejection letters. They are good memories in a way. You learn from that kind of stuff.

Somehow I got a job from sending out work and trying to get feedback. It was for a company called Innovation for a series called *Newstralia*.

I think I was like fourteen or something. I was too dumb to know I could have continued and gotten more gigs and stuff, but I was like "Oh wow, I got published in a comic," and it never occurred to me that I would ever not be. I just didn't know. But from that point on, I just kept working.

Professional comic artist at fourteen. Wow. So *Powers*?

OEMING: Before *Powers*, my early stuff was all pretty line-heavy stuff. I wanted to be like Michael Golden. I tried getting a gig on the *Batman Adventures* books and that didn't work out. But in trying to do so, I realized all those things I loved about Alex Toth-style art. That is how the *Powers* style developed and where things led from there.

So how would you describe your artistic process on *Powers*?

OEMING: I usually do my breakdowns and layouts in a sketchbook that I have with me at all times. I sketch back there really loosely, and when you scan it in, you can put it in Photoshop. And you can move characters around. Then you print the art out in non-reproducible blue pencil. (Note: Regular pencil, even unlinked, can reproduce when scanned in black and white. A light blue "non-reproducible" pencil can't. This popular technique helps a graphic artist create a cleaner finished page.)

I used to use the high-end brushes and quills that they tell to you to get. The $17 brushes that split almost immediately, that most stores damage before they are on the shelf. It became a hassle, and so I went as simple as possible. If I can't buy it at Staples or another office supply store, I don't want it.

There are only a couple things that I order off-line. Like Pitt brushes and things like that. That is everything I draw with, minus a cheap watercolor brush. Everything else is ballpoint pens and things like that.

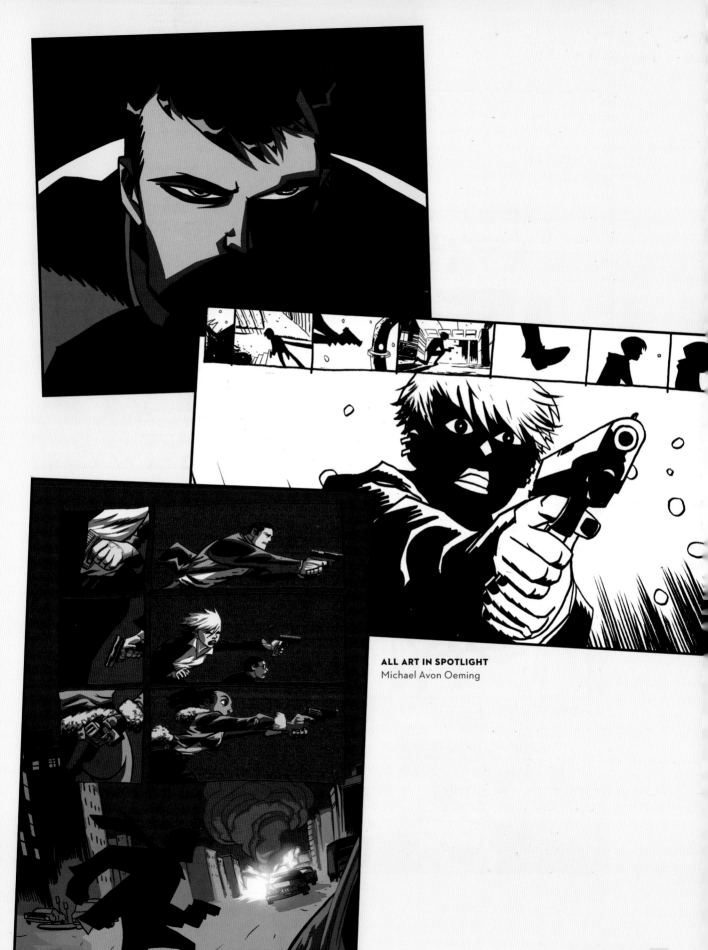

ALL ART IN SPOTLIGHT
Michael Avon Oeming

Those tools are on you all the time?

OEMING: Constantly. I say this as a joke, but one thing that drives most of us as artists is a sense of compulsion. I have anxiety disorders and stuff, and if I'm not drawing or don't have my art with me at some point, I literally freak out. We've been in between projects and I call you and say, I need a script now.

You finished our graphic novel *Takio*, which was a 93-page graphic novel, in the span of six weeks. It was insane. I figured you were going to take the week off and chill. The next day you called and said, "What are we doing? Come on."

OEMING: I carry my sketchbook everywhere. And when people tell you to bring it with you everywhere, just always do it. There is no reason to ever not sketch. And if you're with people who don't like it, then they shouldn't be around you.

What's the biggest mistake writers make in their scripts?

OEMING: Don't forget to mention that your character has a sword until page twelve because that really messes up the artist. It is not a good thing. Sometimes we draw it as we get the script pages in. We don't read the script all at once. When you have a limited amount of time to meet deadlines, sometimes you just have to start drawing.

Sometimes your brain can only handle so much information, so you take three pages for the week and that is what you're reading.

What do you see for comics in the future?

OEMING: There is such a huge gap between where we are and where things will eventually be. For a while, I was convinced that print was dead. I no longer believe that. I've done a lot of research and you

look at the amount of people reading comics. It is not about the numbers that comic books are selling; it's the fact that we lead popular culture right now. All movies are comic book movies. Millions of people are playing comic book games.

People look at comics whether it is in digital or physical formats.

When people tell you comics are dying, it's complete nonsense.

What are your personal goals now? Where do you see yourself headed?

OEMING: I do not need to be a famous comic book artist, I need to be a comic book artist. It took just getting to a really low place to be able to say, *I need to be a comic book artist.* I can put out a couple comics a year and if that is what I can do, that's what I'll do.

I love comics. I hate when people refer to it as a fall back gig. If you are here, you are here because you want to do comics. Find a field of work that you can be employed at but be happy. I chose a security gig so I could have time to draw.

If you want to be a writer, write.

OEMING: It's especially true for writers. Writers have it way worse. Most writers don't seem to hit their strides until their late thirties or forties—because you just become a better writer by living and learning.

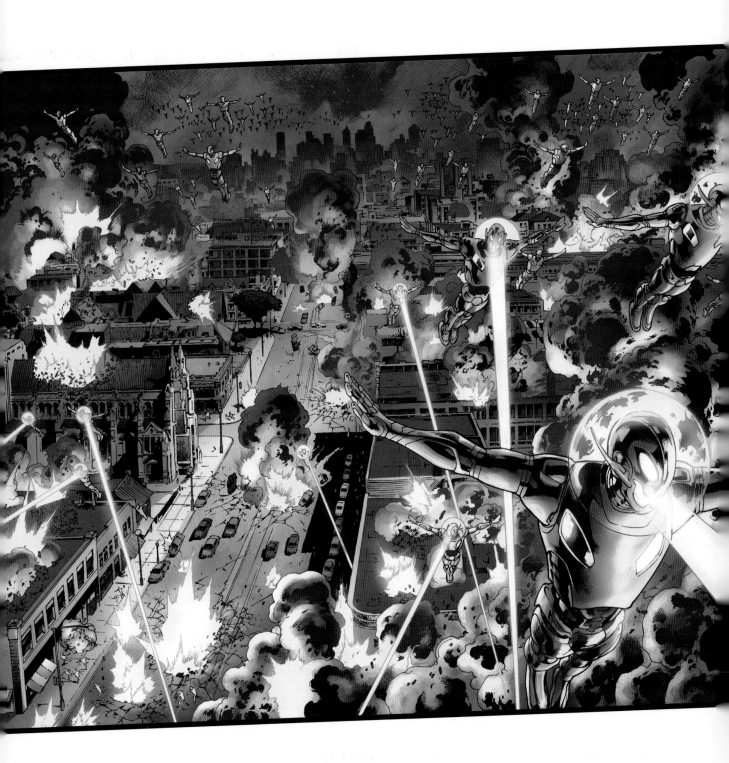

CHAPTER 4

THE EDITORS' ROUNDTABLE

ONE OF THE BIG MYSTERIES FOR ALL WRITERS IS THE relationship with an editor: How can I get an editor to hire me? What exactly do editors expect from me? How do I network? How do I behave? How can I impress?

What better way to demystify the mystery than to go right to the source. The following questions were presented to what I consider to be some of the best editors in comics. You will see answers from Scott Allie, editor-in-chief for Dark Horse Comics; Sana Amanat, editor for Marvel Comics; Tom Brevoort, vice president of publishing and executive editor for Marvel Comics; Nick Lowe, senior editor for Marvel Comics; Bill Rosemann, creative director and editor for Marvel Comics; Lauren Sankovitch, former editor for Marvel Comics; and Steve Wacker, former senior editor for Marvel Comics.

Those looking to break in to the business, to climb that magical wall dividing amateur from professional, read carefully and take these words very seriously. This is right from the source. This is honest and true . . .

What is the mistake most new talents make when submitting?

BREVOORT: I think the biggest, most typical mistake is oversubmitting. It's human nature to want to impress with the tremendous volume of your output, but I hire writers on the basis of the quality of their work, not the quantity. And all of those comics and manuscripts and novels

OPPOSITE
Art by Bryan Hitch

Art by Jamie McKelvie

and screenplays that you're sending me need to be read—and so does the script for the comic I'm actually putting out today. So your best work, the work you're proudest of and that represents you the best, the work that's actually the most likely to get your foot in the door, gets lost in the stack of everything else you've sent in.

LOWE: Being too aggressive. It's a lot like approaching someone in a bar. Most people come off as desperate or supernervous, which is never what you're looking for.

ALLIE: Submitting teasers instead of pitches. With the volume of work I have to handle, it's unlikely that a teaser will suck me in enough to make me follow up—unless I already know you can pull it off. If I'm unfamiliar with your work, I need to know that you can tell a story, not set one up.

WACKER: Mistake #1—Assuming that you don't need any writing credits to land a job in comics. That was probably true at one point, but not in this day and age when even the writer on the lowest selling comic has proven [himself] somewhere.

Mistake #2—Pitching stories with [Marvel's] characters. We can't legally look at these, but the bigger problem is that just having an idea about our characters isn't the same as showing you can execute a comic book.

Art by Filipe Andrade

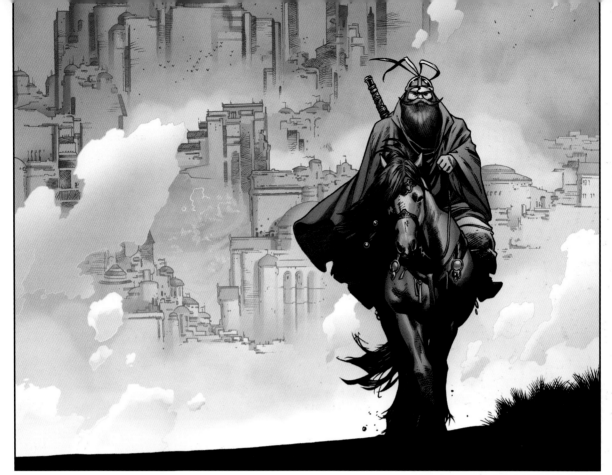

Art by Olivier Coipel

Mistake #3—That goes in hand in hand with the biggest mistake (#3 in a series!), which is people not submitting an actual comic. I think in almost any artistic endeavor today, you need to show people who have money that you don't need them to do what you do. If you can do all this without them and be successful at it, that makes you an opportunity, someone they need. So in a nutshell . . . waiting around to be discovered is the biggest mistake.

AMANAT: For writers, it's when they're not aware of recent Marvel continuity or big events that could affect the stories they tell. Granted, it's our job as editors to catch these things, but they might not realize how it could positively affect their stories and make the whole process a lot easier.

Also, a lot of writers send in a stack of books that they've had published. Because of our limited time, we won't read them all, so send in one or two samples of your best work—even if it's a self-published online story. If we like it, we'll ask for more.

Artists often email large files that clog our inbox. Make sure the file you submit is a small PDF no larger than 4 megs. I usually prefer links, as long as the website is easily navigable, with prominent links to samples. In terms of the actual samples, artists should not just send cover and splash images. A cool splash of Wolverine is pretty easy to do if you're a

Art by Leinil Francis Yu

Art by Ryan Stegman

decent artist, but it doesn't tell me anything about your actual skill set. For all I know, you could have traced the image. If you're submitting for interior work, lead with the sequentials (art that tells a story), show us your storytelling capabilities.

ROSEMANN: With writers, it's very difficult to judge their skills based on a pitch document. In fact, we're not legally allowed to look at unsolicited pitches. So, rather than submit their grandiose pitch for *Power Pack*, they need to show us a few issues of their independently published comic—in either print or digital form—so we can see if they have the chops to write several installments of an entertaining story.

Many new artists don't deliver a portfolio containing the elements we need to see to understand if they are—or aren't—ready to be a professional and publishable artist. Pinups and cover art are nice—they give us an idea if they can design an exciting and commercial image—but have they included interior pages with multiple panels that show they understand and have mastered the basic rules of clear storytelling? And can they draw the not-so-fun elements that often appear in our stories such as buildings, cars, offices and, yes, the dreaded horse?

SANKOVITCH: Personalize your communication to a potential employer. Most editors receive a large volume of mail and interact with numerous creators each day. You want your approach to be both professional and well thought out. Research what that editor is working on currently and

make sure it's a body of work that dovetails with your own professional interests. If you want to write and draw children's comics, a horror editor might not be the best fit.

What is the mistake most new talents make when they get their first assignment?

BREVOORT: I want to say simply not getting it done in time, choking, but that's not really very helpful. It's probably the other side, overworrying the script to the point where you as a writer are paralyzed. It's your first at-bat in the major leagues, and you feel like you've just got to hit one over the fences. That's definitely a goal to aim for, but it's also fine, and expected, that you simply get on base. Your first comic book script is likely not going to be *Watchmen*, so while you should take the work seriously, you needn't polish it ad infinitum. Also, watch out for overwriting, that's also a trap that newcomers will fall into.

LOWE: Unreasonable resistance to notes from their editor. No matter who your editor is or if you agree with his or her sensibility, when you're breaking into the industry, your primary audience isn't the people reading the comics, but the editors you're working with, because they are the people *who hire you*. The audience cannot hire you (unless it's creator owned, I suppose). That's why it's really important to try and find an editor who understands and appreciates your sensibilities so it's as good

Art by Mike Mignola

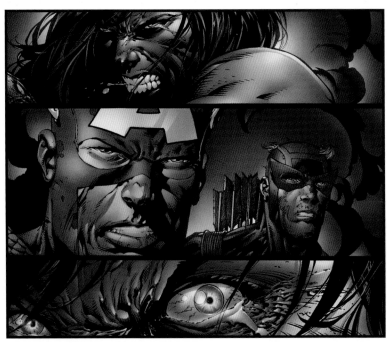

Art by David Finch

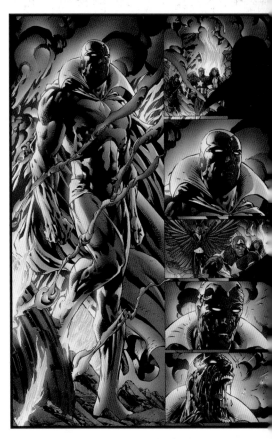

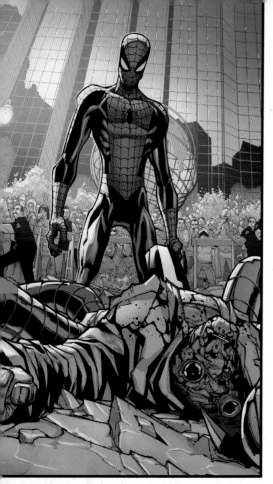

Art by Humberto Ramos

Art by Patrick Zircher

an experience as possible. Know you aren't perfect and trust that the note that is being given speaks to some problem in the work. The worst thing that can happen is to alienate the person who can hire you and works with a bunch of other people who also hired you. And word travels fast . . .

ALLIE: The worst is overcommitting and missing deadlines. If you miss the deadline, that's the first real impression. No matter how good the work is, I already know I can't count on you. But the most common mistake is posting stuff online before asking or announcing the project before we can have a plan in place to do it.

WACKER: Pitching the story that instantly fixes a piece of continuity that has always bugged the writer or a story that follows up a story from twenty-five years ago.

The way I see it is that with any assignment you have twenty pages to give someone a capital-E "Experience." Every assignment is an opportunity to grab some readers and make them remember a comic, and you, forever. To throw that away because of some obscure continuity nugget is a waste.

AMANAT: [Creators] get overexcited and accept too much work without taking into account what they're capable of. And as soon as they start getting some attention, they start going to conventions [that] suck up the time they need to work on their project. Devote all your energy to your new gig, both from a creative and professional standpoint. The *Creative* and the *Schedule* should be the masters you serve.

ROSEMANN: Biting off more than they can chew, especially if they do it deliberately. Listen, I understand the desire to please a boss—and I understand newcomers not yet knowing how much they can or can't do in a given amount of time. But if you definitely know you can't deliver something by a specific time, don't say you can. We are always happy to work with someone to make sure the assignment fits their capabilities and situation, but you can really sabotage your own career by not delivering on time right out of the gate.

SANKOVITCH: Don't overestimate your abilities because you want to impress. Be brutally honest with yourself and make sure you have the time and the materials to do your work well and on time. Comics is a relatively small and interconnected community, so keep this in mind: you don't get a second chance to make a first impression.

Art by Leinil Francis Yu

What is the thing that a new writer or other aspiring creator can do to get your attention in a positive way?

BREVOORT: Nothing succeeds like the work itself. I know a lot of people in and around the industry, and a lot of people who are struggling to break in, or to stay in. And there are some terrific people among that group. But none of that matters once it's time for me to hire somebody to do a job. At that point, it all comes down to how good you are on the page, right now—not how good you were years ago or how good you might one day be. There are other factors, too, of course—reliability being the very first one. But the most reliable guy in the world won't get called up if the work he's producing doesn't have that spark.

LOWE: Graciousness and published work. The second is obvious, but the first is missed *really often*. Don't be pushy, or act entitled, or nag. The last thing you want to happen is for the editor to rue your emails or calls.

ALLIE: Present yourself at shows as a professional grownup, and hand me or direct me online to completed work that I can read and judge. Don't spend a lot of time buying me drinks or meals, there are other people I'm looking to do that with. Get me excited about your work, and show me you'd be okay to work with.

Art by Ryan Stegman

WACKER: Give me a story that says something about the human condition, that has some kernel of emotional truth that shows me the characters in a different light or explores more deeply something I know about them. And somewhere, give me some dialogue that makes me smile, laugh, or cry.

AMANAT: Research the books I've worked on and angle samples accordingly. Editors tend to develop a style themselves as they grow, so if you think you'd be a good fit for the writers or artists we tend to work with, say so and show examples that prove it. Further, editors generally have certain books (Spidey books versus X-Men books, etc.), so send samples that might work for a particular title we work on. We're constantly on the lookout for new talent, but when you target our books or styles specifically that actually helps us do our job.

ROSEMANN: We don't need fireworks or an elaborate cover letter or a FedExed package. Just get your work in front of us in a simple and helpful way. Sending us links to your online portfolio or a PDF of your comic, even sending us your comic by snail mail—that's all we need to judge your work. I've hired many creators just because they shared their work with me and my gut told me to take a chance on them. A huge splash isn't needed—the cream will rise to the top.

Art by Giuseppe Camuncoli

Art by Joe Quesada

SANKOVITCH: Strike that tricky balance between being friendly and being professional. No one likes a cold fish, but it can be equally off-putting if you are overly familiar. And freshen up. A clean and well put together appearance is always in your favor.

What is the one thing a new talent did that impressed you the most?

BREVOORT: Apart from all of the obvious answers about being prompt with the work and being communicative and working hard and so forth, the thing that impresses me the most from a new talent tends to be the work itself. Evidencing a command of the craft. Knowing, either by instinct or by training, how much information will fit in a panel or will fit on a page. Not overwriting the panel descriptions. Having a story flow that feels effortless, that just glides, with everything in its proper place. And, most of all, having something to say that stirs an emotional reaction of some kind. That's at the heart of why we read stories in the first place, so I'll forgive somebody who can do that on a regular basis a lot.

LOWE: Writer Sam Humphries put together two beautiful and well-written comics and mailed them to specific editors he thought would react well to them. They were well drawn by professional artists (that I think he paid), well designed, and (*most importantly*) well written. They not only

Art by David Finch

Art by John Romita Jr.

Art by Francesco Francavilla

Art by Chris Bachalo

showed he could write, but also that he had the perseverance to finish a project and see it through.

ALLIE: [They] took advice. Whether it's changing something in a script or crafting appropriate samples or rethinking a plan for a project, an ability to take advice while really throwing effort into something is a rare and admirable talent in someone starting out.

WACKER: The thing that is always an admirable trait in new writers is the ability to accept what you don't know yet. Being open not only to editorial notes (which admittedly aren't often great), but also to what the artist brings. An impressive young writer will remember that—for you—comics are always going to be a collaboration, since you can't draw. Remembering and respecting that the real magic [that] is done in the panels can take years to learn, so the sooner you get that into your head, the better you'll be.

AMANAT: They turned in pages before their deadline. Gave a vision to a story that wasn't there during the script stage, made the story have a voice we didn't [or] couldn't imagine before. Was amenable and patient with notes and any of our script delays. That goes a long way, especially

Uncanny X-Men discussion document

By Brian Michael Bendis

Debuting in October, in the pages of uncanny X-Men-

DAYS OF FUTURE NOW

 After the punishing results of Avengers versus X-Men, mutant confusion is at an all-time high. Cyclops, and what is left of the Phoenix 5, have gone full on mutant revolutionaries which is illustrated by a huge set piece where Cyclops makes his 'take no prisoners' attitude very clear.

Hank McCoy, Storm, Wolverine, Ice man, Kitty and the others watch the chaos in disgust. What can they do? If they confront Scott head on then the next step is MUTANT CIVIL WAR.

And if that happens... no one wins.

> Storm
> If young Scott Summers saw what he has
> turned into... he would be sick to his stomach.

> Ice man
> When we were young we were always worried
> about a mutant apocalyptic nightmare... if the
> young us saw what was going on today it
> would feel worse than an apocalyptic
> nightmare!!

What the X-men don't know is that the 'Phoenix 5's's' powers set have been severely altered by their time with the phoenix power.

Scott has to completely re-train himself, Emma is a living Cerebro, Magneto had his powers leveled by the final conflict in AvX.

The X-Men revolutionaries dark secret is that they are as untrained and unprepared for war as they were the 1st day they got their powers.

Hank McCoy, secretly, hits another secondary mutation. A mutation so severe that he fears for his life. On top of this, Hank is tortured by what has become of their youthful dream of humans and mutants living together and fears that there

is no hope.

Storm's words about young Scott haunt him.

He cannot get the idea out of his head that there was no one who can peacefully stop Scott Summers other than the Scott Summers that used to be his friend.

Hank McCoy travels back to the earliest days of the Uncanny X-Men (Uncanny X-Men number 9 for those of you playing at home) and offers them a chance to save the world from themselves.

The original uncanny X-Men take the offer and travel to the present.

End of 1st issue

Rest of the story-

Throughout the 1st arc the original uncanny X-Men will see everything that has happened to them. They will see that the Xavier school is now the Jean Grey school.

Young Jean will be rattled to her core as she hears how she sacrificed herself for the greater good of mankind.

Young Scott will come face-to-face with the future self that in many way represents everything he's sworn to fight against.

Older Scott is PARTNERED with Magneto?

Everyone is shocked to find out that Bobby Drake ended up turning out the best. Bobby, humorously, is a little disappointed.

And young Hank McCoy is eventually able to figure out how to turn The Beast back into the fun-loving, blue, furry friend to everyone.

The original Uncanny X-Men and the X-Men of today will go head-to-head in a very large set piece.

At the end of it the original X-Men will decide to stay.

> Jean Grey
> This is where we are needed most.

Uncanny X-Men pitch document

Then...

5 to 6 months later this project will split into 2 monthly books.

UNCANNY X-MEN will retain its original numbering and will star the original Uncanny X-Men coming to terms with the world as it is today and fighting to make it better.

The book will star the original uncanny X-Men and members of the X-Men today. New friendships, new relationships, new drama, new dedication towards an ideal as fresh as it was originally stated.

Plus we have a book full of fish out of water Capt. America types dealing with the new.

The other book will be called, tentatively, X-MEN NOW and will star, primarily, the Phoenix 5 as they deal with their uphill battles, their new powers and their new struggles.

Because this is what the X-men are NOW.

The uncanny X-Men will be youthful and exuberant. Think of it as a cross between the original idea of the X-Men and the best version of the runaways.

Ideal artists- Pachelli, David Marquez, Churchill, Bachalo etc.

X-MEN NOW will be, in many ways, similar in function to the DARK AVENGERS. While nowhere near as twisted, because of the nature of the characters, it will be a more mature look at a revolutionary's dedication to making the world a better place at all costs.

What is the world like when the people decide they have to rise up against their oppressors?

Ideal artists- Immomen, Mcniven, Deodato, Etc.

The original uncanny X-Men can stay here in present-day for as long as the

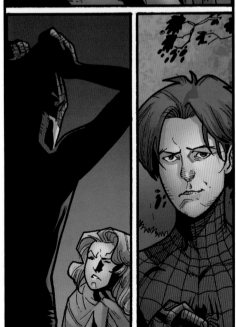

Art by Sara Pichelli

since the process can be very stressful on our end, as we're dealing with multiple books, and at times don't have control over the delays. Having a creator who is cool and collected makes our job a lot easier—and then we'll tend to want to work with him/her again.

ROSEMANN: A writer, who I eventually hired and happily work with to this day, mailed me a simple package showing a decent body of his work—a trade paperback and a few individual comics. It wasn't anything fancy, but it did show me his skills as a writer, and, more importantly, it proved to me that he could deliver excellent work again and again. Never forget that in comics, hitting multiple deadlines—and doing so with your very best effort—is often the key element of success from the editorial point of view.

SANKOVITCH: I had a newer creator turn down an assignment. They knew the circumstances wouldn't allow them to do their best work so they graciously declined. We stayed in communication until another viable assignment came up—and the rest is history.

Without naming names, what is the most unprofessional thing you have had a freelancer pull on you?

LOWE: This isn't one instance, but disappearing in the middle of a project happens way too often. Whether it's just dodging editors as the deadline approaches or literally disappearing.

WACKER: Missing deadlines because of conventions has gotten too common. And it happens with writers AND artists.

Also, I've had a freelancer who seems to have a very close relative "die" every time we work together and they're running late. They forget they've used that excuse more than once already.

AMANAT: Going out of town around the time a deadline was occurring and not notifying anyone. Becoming hostile and disrespectful in correspondence if they don't like the way I've done something.

SANKOVITCH: Not the most scandalous of stories, but a recurring unprofessional behavior is irresponsibility. This can be a creator not being realistic with his own abilities and/or in his communication/relationship with his larger team, including the editor. Comics is a collaborative experience and when one player will not take responsibility for his own actions, it has a ripple effect on everyone else involved. Don't lie. Don't hide. Be brutally honest. The relationships you build now, especially if you are newer, will last longer than your first assignment, so make that first impression a good one!

In my opinion, this section was worth the cover price alone. It was a laundry list of the most frequently, desperately asked questions any of us professional comics creators get about how we do what we do, how to break in, and how to get the genius from your screen into the hands of editors.

And now you have the answers—direct from the source. Honestly, if I was trying to break into comics, into any creative field, I would reread this section and memorize it as if I had to perform it on stage. *THAT* is how important this information should be to you.

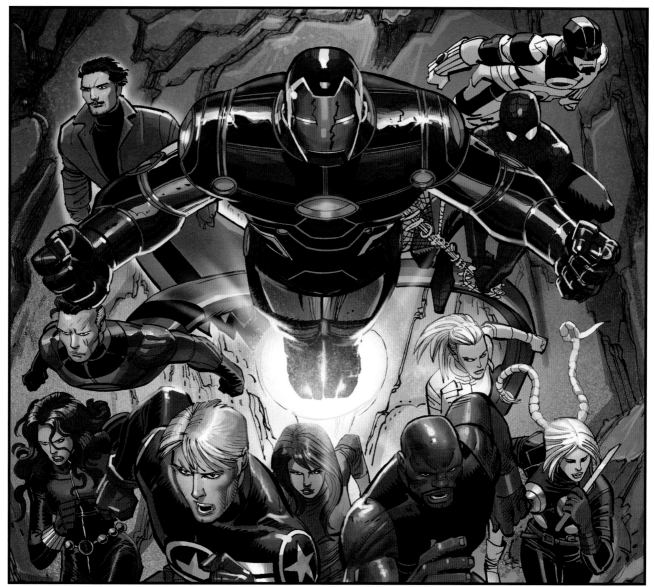

Art by John Romita Jr.

Concrete art by Paul Chadwick

THE EDITOR'S SIDE:
DIANA SCHUTZ

Diana Schutz has at one time or another, in her thirty-year career, held the title of editor, senior editor, and editor-in-chief of Dark Horse Comics (publisher of *Hellboy*, the *Will Eisner Library*, *Sin City*, *Buffy*, tons of manga titles, and so much more). She has personally shepherded some of the greatest books in the history of comics like *Sin City*, *300*, *Grendel*, *Mage*, *Cerebus*, and comics legend Will Eisner's *Library*. It's an amazing array of classics and near-classics.

She is also an educator, the reason I am a teacher, and the reason I ended up writing this book. She is frank, blunt, and to the point. And she's about to share some hard truths.

A WRITER'S GUIDE TO EDITORS

There is a designated editor at Dark Horse who looks at submissions. But for someone in my position, reading submissions is something that I have to do in my *free* time. There is no actual time in my editorial workday allotted for reading submissions.

Each publishing company has its own set of submission guidelines; it's worth your while to go online to the company's site, find out what its guidelines are for submitting projects, and follow those guidelines.

But this is far and away the worst, *worst* way to try to break into writing comics. There are much better ways of getting in.

If you're going to submit to a publisher, here's what you really need to do:

Know what titles that publisher is producing. Don't send a Batman story to Marvel Comics. It's not gonna happen! You would be surprised, but people do that sort of thing all the time.

If you're sending a submission to a specific editor, take a look at what that editor actually edits. For instance, I don't edit any superhero comics. And I really have almost no interest in them at all. But even though you won't find my name listed as editor in *any* superhero comics, people still send me their superhero submissions all the time.

Caricature of Diana Schutz, art by Matt Wagner, letters by Dave Sim

Usagi Yojimbo art by Stan Sakai

So, if you're going to try to break into the industry via a specific editor, take a look at what she is editing, and try to gauge that editor's tastes. Why kill your chances right off the bat by sending a proposal for a comic in a genre that doesn't interest the editor? You need to do a little bit of *homework*.

Beyond that, I recommend going to local conventions or establishing an online presence. A *lot* of people are doing comics online. In comics, as in any other field, getting your name out there is important: *networking*.

Next, for those writers who don't draw, remember that the comics medium is primarily *visual*.

Hook up with an artist you know. Writing comics is not just about *words*. It's about pictures, writing with pictures. And there are lots of artists out there also looking for work. Even if the art itself is not quite publishable yet, the truth is that your submission has a better chance of getting looked at if there's artwork accompanying it. Some beleaguered assistant editor, or even a beleaguered senior editor, will be more inclined to look at a proposal with artwork rather than just reams of typewritten prose.

Also, when you're submitting to someone, don't think more is better, because it ain't! If I'm having trouble slogging through the first page of a submission, I'm certainly not going to bother reading the other two hundred pages after it.

So keep your proposal short and concise. As an editor reading submissions, I can tell within the first page or two whether a proposal is

worth pursuing or not. And your writing another ten, or a hundred, pages is not going to convince me otherwise. You need to put your maximum punch right at the beginning and sell me on the project by page 1!

When looking for an artist to work with, I recommend you *not* be as harsh as an editor might be when choosing an artist to publish. Sure, you're probably not going to find someone at a super skill level yet, but evaluate: Does this person have the potential to go the whole way? Because the editor will see that potential as well. But if you can already see that the artist is *never* going to be up to snuff, then you should probably keep looking. Because if an editor opens up a package and thinks, "That is the worst artwork I've ever seen," why would she bother to read what's in the word balloons?

Another tip: It's always a good idea to meet an editor before trying to pitch her on your work. Conventions are a good place for this. But remember that editors *travel* to most conventions, usually by plane, and there's only so much room in any person's luggage. When I go to a convention and people approach me with big thick manila envelopes full of stacks of paper, I'm very unlikely to take that home with me to read.

But if someone makes a minicomic and hands it to me as a bid to get work, I will *always* read that. And I don't *care* what the artwork looks like.

If you tell me you're a writer, but you got someone to draw your minicomic just so you could show it and present it, then if I know that going in, I'll ignore the art and read the comic. A mini is typically only eight small pages; that's a relatively painless submission, no matter how bad the art might be.

Or you could try drawing it yourself. Stick figures are okay. Just explain to me that you're not an artist, and you're not trying to sell me on the art. By doing a minicomic, you show an editor how well you can handle many aspects of comics writing, and I guarantee you learn a lot in the process. In the Comics Art & Literature course I teach at Portland Community College, all my students have to make one eight-page minicomic; that is one of three major assignments for the term. When I look at a minicomic, I can tell if the writer is taking into account things like right-hand versus lefthand pages, pacing, reproduction, space. Space, the final frontier—the *first* frontier in comics, really. Writing for comics is about writing within finite spaces, and a minicomic is a very finite space—finite enough to come home from a convention in my luggage!

But working with an artist on a minicomic can teach neophyte writers an important lesson: comics scripts are *not* written for the reader! That sounds strange, but it's true. A comics script is written for the *artist*, and the writer has to give the artist all the important story information,

Concrete art by Paul Chadwick

Concrete art by Paul Chadwick

information that may be withheld from the reader until, say, the last page of the printed story or even a later issue. Your script is not the place to write something like "What mysterious character is that, lurking in panel 2?" No. Your artist needs to know everything about the "mysterious character" in order to *draw* that character! Especially if that character is going to have an important role later in the story.

Writers who come to comics from television and film often make mistakes having to do with the static nature of comics and the limitations that puts on portraying motion—the fact that comics panels are static images, images that don't move. Cramming ten thousand actions into one panel, or anything more than one action in one panel, just doesn't work in a comic book!

At the submissions stage, the editor really just doesn't have the time to point out these kinds of mistakes. People who submit proposals often expect a written review in response. Don't! "Here's my story submission. Could you send me a critique?" Hell no. If I had time for that, man, you know . . . No.

If it's going to get done at all, the work of reading submissions is something I have to do on my weekends or in the evenings when I'm at home—you know, when the rest of the world is kicking back and watching the tube, that is the time I have to read someone's submission. And my *only* job is to decide *do I want to pursue this or not?* My job as an editor is not to teach you how to be a publishable writer. That is what writing courses are for.

But don't be afraid of rejection! Your pitches *are* going to get rejected. Brian was an "overnight success" after ten years of hard work and his own share of rejections.

Dave Sim, creator of [independent comic series] *Cerebus*, puts it this way: "If you're an artist, first you have to draw two thousand pages of comics, and when you finally get to page 2001, then you might be publishable."

If you're a writer, you have to write a *lot* before you're ready for prime time—and you have to be compelled to write, so that even if some editor slaps you down and says, "No, you're not ready yet," you have to keep on going until you *are* ready.

There are a lot of people out there trying to break into comics, and everyone has the "best idea" for a story. But ideas, frankly, are a dime a dozen. It's all about the execution. And about that single-minded direction and focus and determination to continue working at your craft *despite* rejection . . . well, there's a much smaller number of people who have all of that.

As for the editor-creator relationship, I would say it's multifaceted: As an editor, I am different things to different people. Because I work primarily on creator-owned books rather than on corporate-owned characters, my job has a lot *less* to do with stuff like making sure the writer has the character toe the company line. My job, as I see it, is about helping creators realize their personal vision, about making things as easy for them as possible within the basic parameters of the publishing house.

With someone like [cartoonist] Stan Sakai, his *Usagi Yojimbo* pages come in with everything already done—story, art, and lettering—so the job becomes more about quality control of the art: overseeing the scans and final printer files (along with the nonstory materials). Easy-peasy. Stan rarely calls me to say, "I don't know what Usagi should do." Maybe once or twice in fifteen years.

Working with [comics creator] Paul Chadwick on *Concrete*, I'm more involved at all stages of production. Paul sends an initial plot. He then writes a full script by way of thumbnail breakdowns: small rough sketches with the words penciled in the captions and balloons. And at each of these stages, I provide feedback.

So when it comes to creator-owned work, my job really depends on the individual creators themselves, and what those creators want from me as their editor, and what kind of relationship we have. As much involvement as they want, it's my job to give it to them.

Cover of 300 collection by
Frank Miller and Lynn Varley

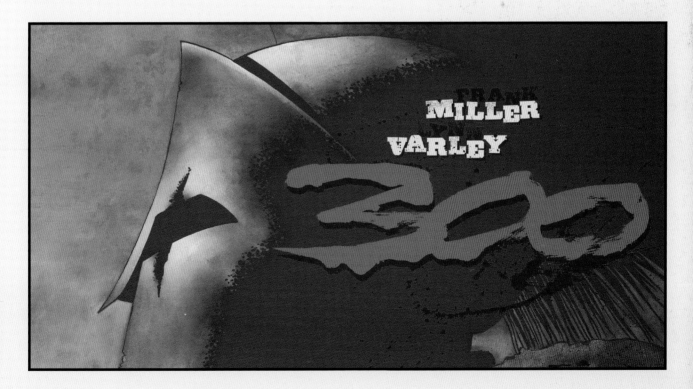

C. B. Cebulski is currently vice president in charge of talent and international relations for Marvel Comics. He is the man who is looking to hire you. That is his job. CB travels the world looking for talent of all shapes and sizes.

CEBULSKI: A little bit about what I do first. I coordinate talent. I find the talent. Once they're in, we very closely monitor their careers and guide them—the people who work for us. If you, the talent, make an investment with your time into the books, then we want to make the same investment back into you. By helping you build your name, we're helping your career and you're helping us. It's a beneficial relationship. Part of my job is starting people out on eight-page stories, moving them to whatever is next, and then guiding them through to bigger books.

What I do is I keep track—across the industry as a whole—of everyone from writers to letterers. At the Big Two, Marvel and DC, the editors are focused on one thing: getting their books out. They have very large workloads. Each editor can manage maybe five to twenty-five books a month on his or her own. And that's script through to the final flat plan that goes off to the printer.

The editors don't have a lot of time to go out there and keep track of the names of all available talent. That's my job. I keep track of things and make informed decisions and recommendations. As the face of the creative department, I go out and meet with people, look at portfolios, talk to writers, and read comics. Then I come back with opinions and educate the editors at Marvel.

As you break into the industry and get to know people on a more personal level, you will find that 95 percent of the people who work in comics are cool.

The other 5 percent of the people in the industry are jerks but they're so talented that we have to tolerate them. Fortunately, most of them stay locked in their studios and don't come out much for air or food.

As for getting your work out there: The good news is that now there's never been an easier time to break into comics in one way or another. Yes, I'm referring to web comics and minicomics. I'm also talking about getting exposure and breaking via publishers like Boom, Dynamite, Image, or Dark Horse.

It's the exposure angle. With the Internet, it's easier for you to build a buzz about your own projects. Once you develop buzz, that word spreads even quicker. We're able to discover new talent much faster than ever before.

The Internet has modernized what I do, and it's become that much easier. From where you are now, you have an amazing shot of getting your comic out there.

The bad news is that once you get in, it's harder to stay in because competition has become so fierce. In 2012, Marvel hired 144 new creators. That's almost three people per week. That's the amount of people who signed work-for-hire contracts to write, draw, ink, color, etc. Those are new people who have never worked for Marvel before.

There were 24 new writers, 81 pencillers, 13 digital painters, 8 inkers, 15 colorists who just color art, and 3 letterers.

For any industry to hire three people a week is pretty incredible. The reality of those numbers is, a lot of those people got one gig or two gigs and haven't gotten anything since. The work has been sporadic. I might have hired one person in January, and then someone else came in with maybe a similar style or tone in the writing who was able to deliver faster or whom the editor liked for a different reason or whose personality matched with different editors more. So the competition comes in quicker. Just because you've broken in, doesn't mean you have to stay in. People are working a lot harder to stay in after they break in.

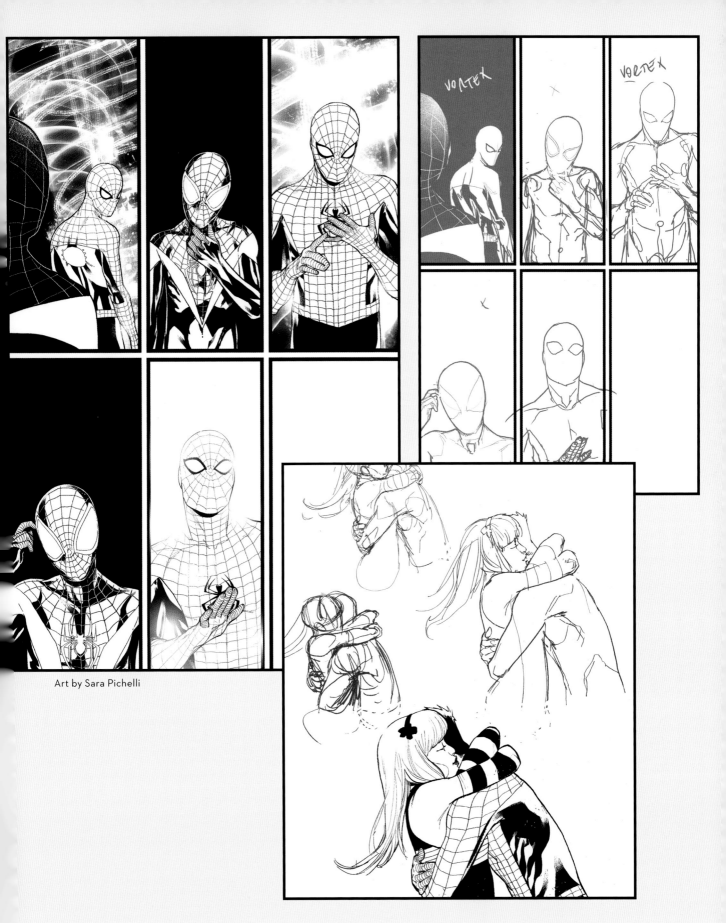

Art by Sara Pichelli

There are a lot of different ways to do that. A lot of it comes down to relationships: Be cool and have good relationships. Also have realistic expectations of what you're getting into.

One of the biggest problems a lot of new writers have is that once they get in, they expect they're going to stay in. They get clingy or suddenly think they're entitled—which are things you should never be.

The one thing you have to remember is that in comics no one deserves anything. It's all about your ability. What you do on the page is all that matters. What you turn in as script and art is what gets you your next job. It's not about your legacy. You're only as good as your last job, page, or script. That's something you really have to remember. Just because you're in doesn't mean you get to stay in. You have to have a good attitude and be realistic about it.

What's your preferred method for getting somebody's sample materials? Most people say that they'd like to see submissions from writers that have art with them, correct?

CEBULSKI: That's true. There are a number of different reasons for this preference. The simple reason is "time." When I review an artist's portfolio, I get a first impression from that initial page, and I can tell after three or four pages if the person is good enough to work at Marvel. I'm able to tell if that person has the chops. With writers, it's harder because you can submit a pitch for a script or a graphic novel, anything you want. But for me to sit down and read it to the extent that I'm going to have an understanding of whether the person submitting has a good sense of description, of the beats in comics, of how to use the right words to get his point across to an artist, that all takes a long time.

If you already have a comic produced—from art to lettering-it's so much easier to sit down and read that and understand what you'd be like as a writer. Plus, editors are busy and manage huge workloads. For them to sit down and read a novel or screenplay or comics script takes longer. If they can pick up the comic on the way to john for five minutes, they're more apt to do so.

As a writer, you can submit anything you want to Marvel. We accept everything. If you want to send it in, it will get on the desk of the person you want it to go to. Depending on how long it is, it might not get read though. If you have comics or graphic novels, those are probably the best things to send. Editors are comics fans, and that's what they're going to hire people for.

When you open a submission, what do you see that makes you say, "This guy can't write"?

CEBULSKI: As a writer, the main "don't" for submissions is *Don't submit anything with Marvel characters.* We can't read them. We live in a society where the Internet has changed the way that products are handled. Everyone is starting to protect his or her flanks. There have been lawsuits over stolen ideas. We can't read original ideas with Marvel characters for legal reasons.

If we like your work and we want you to pitch ideas, we will send you a one-page document called a Marvel Ideas Submission Form. By signing it, you acknowledge that you understand you're about to send original ideas based on Marvel characters, and Marvel understands these are your ideas. We're all under the mutual understanding that ideas are ideas and someone else could have had the same idea.

How important is the technical quality of a submitted piece? If two stories are submitted, but one was done on a piece of software that you could tell was total garbage software, how much does that really effect . . .

CEBULSKI: It doesn't matter. We don't care how you create your comic sample. It's about what the final project looks like when it's turned in.

There is one thing I do heavily recommend to writers: if you hear about an anthology being developed, that is the best place for writers to break into Marvel.

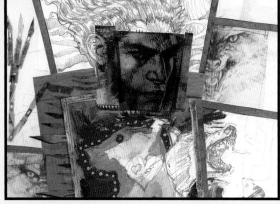

Art by David Mack

What about editorial positions? How does one audition for one of those?

CEBULSKI: There's no easy answer to that. There's only one quality that I know of—a love of comics. If you go to every editor on a con floor, the only thing that unites everyone is a love of comic books. We've had people who were professors, people who came up through our intern program. Some people came from other publishers. There's no set course for becoming an editor. It's about understanding comics and storytelling. A lot of it also comes down to personality. At Marvel, we're a close, tight-knit group. Marvel really is a family. We go to work, we stay at work, and we go out after work. We hang out with our families on the weekend. A lot of getting hired at Marvel in an editorial capacity comes down to personality.

When you're reviewing submissions, are you drawn to superhero stories because those are what Marvel is putting out, or do you look at the caliber of the writing, no matter the genre?

CEBULSKI: Caliber of the writing. While I also write for Marvel, my personal taste in comics tends to run toward "slice of life" stories. I don't just judge based on superhero work. That's a part of my job, but good writing is good writing. Some of the best superhero stories are the stories about the characters and their interactions rather than their battles with villains.

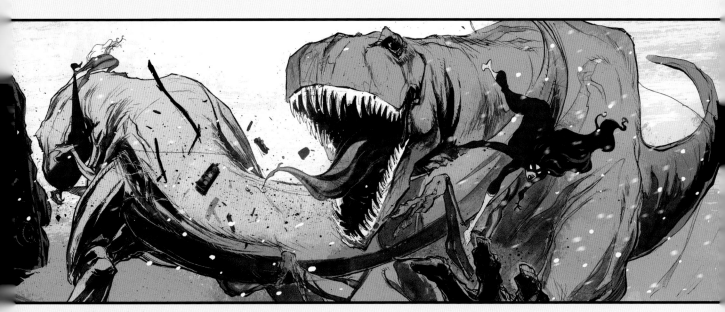

Art by Filipe Andrade

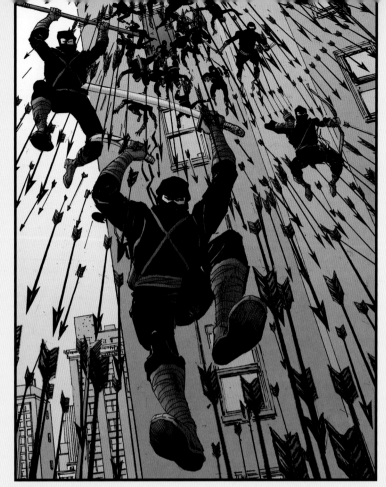

Art by Klaus Janson

What's the best way to approach an editor in person?

CEBULSKI: If you're a writer and have the opportunity to meet an editor, just meeting the editor and shaking his hand or giving him a card should be considered a success.

The truth of the matter is that editors meet hundreds of people at these conventions, and there's no way it's possible for them to remember everyone's names. Just going there and putting the bug in their ears and getting their cards and remembering where it was that you met them and being able to describe where you met them in specific detail are all important victories.

Do you need things to make you more memorable? Like a pink wig?

CEBULSKI: Don't be the guy who pummels the Marvel offices with books or who makes a point of going on the Internet and finding personal information about the editor and then goes to the con with "How's your son Gary? Next time you're down here, how about we play baseball? I know you're a really big fan of tacos," etc. That's taking it a little too far.

Be polite, pleasant, professional, and persistent, but don't be pestering and don't be a jerk. The polite and pleasant parts are the most important.

We'll open every package. We create stacks. We're going to read *this* and *that* and not read *that*. The stuff that gets moved to the "This person might be good" stack will typically have a cover letter formatted properly.

Don't do "Dear Editor" as your only greeting—personalize it. I get so many blanket emails and pitches, the mail guy comes with the cart, and you can see stacks of the same envelope. "Dear Editor, Here's my work." Those get tossed. You shouldn't submit to every editor.

In summary, submit your samples with a cover letter, personalized to the specific editor, with an explanation in two or three paragraphs of who you are, what you've done, and what you'd like to submit.

The illustrated manila envelopes with pictures on them get opened first. Whatever you're submitting: a screenplay, a novel, a comic—it should look professional. It shouldn't be just pages that are stapled together or handwritten script on blue-line notebook paper.

Your submission should be typed and look professional. You might even consider including a case or cover that looks good. The presentation is important. You kind of get a glimpse of the person's personality through the presentation of his or her submission.

Once writers have open communication with editors, what are the "do's" and "don'ts" then?

CEBULSKI: There's a fine line between persistence and pestering. If you meet an editor at a convention, wait a week until you follow up. The editors are busy and need time to catch up. They'll have their heads on better once you give them a week.

If you don't hear back, standard follow-up time is two weeks. It's nice to send a polite follow-up email. Something like this: "I know you're busy, and I just wanted to touch base. If you don't have an interest, I understand, or if you'd like samples, please let me know."

After that, you should wait a month to six weeks before following up again. If you already had a story submitted, I'd say the standard follow-up would be about once a month. Always submit new work. "I do this series for Image, I wrote this project for Dark Horse. I self-published this story. I'm working on this with an artist in Europe." One huge mistake I see comes from people who hand in the same submission over and over again. All you're saying is that's all you have in you.

In submissions, do you prefer to see something that's a self-contained story, or do you like to see stuff that kind of shows the potential for a story that may go further?

CEBULSKI: For writers, I always like to see a beginning, middle, and end. That's why I like looking at short stories. Short stories are very hard to write because it's hard to get a lot of information in a short amount of space. I want to see what you can do!

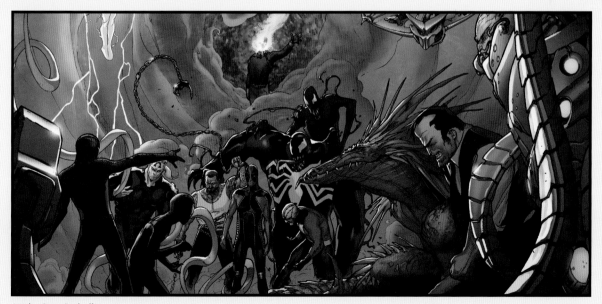

Art by Sara Pichelli

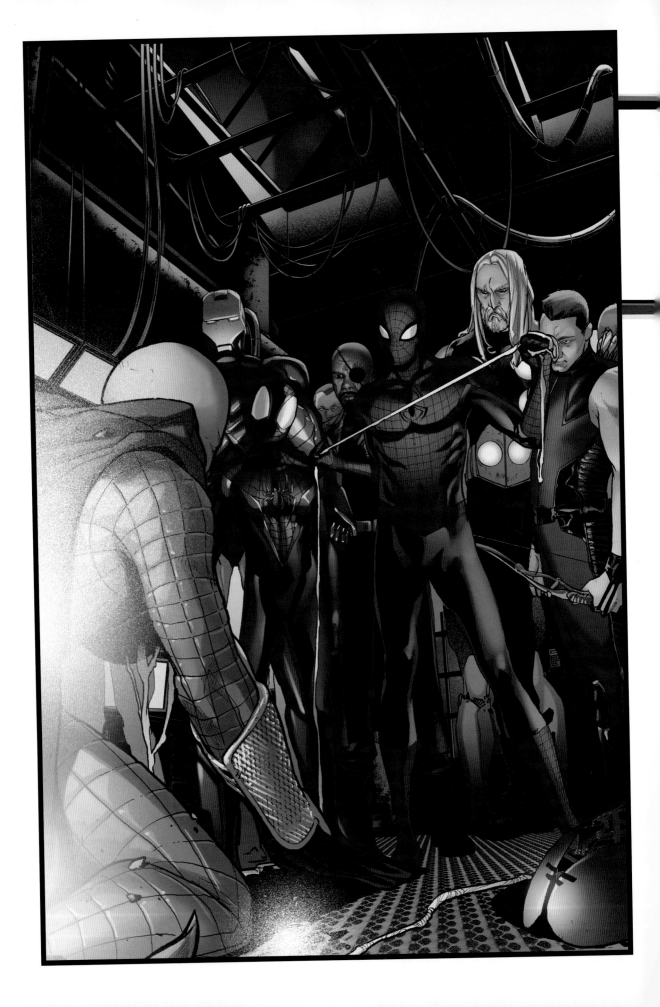

CHAPTER 5

THE WRITERS' FAQS

STARTING IN 2012, MY TUMBLR HAS BEEN FILLED WITH questions from frustrated writers and other aspiring creative people looking for some semblance of truth. Over and over again, the same questions kept coming up, which told me this was information a lot of you were seeking. Here's a look at some of the most popular and frequent questions I have received.

Q: What advice would you give to an aspiring comic book writer? Where does one start?

A: Write.

Write every day.

Write honestly.

Write something that doesn't exist, and you wish it did.

Read.

Learn.

Study.

Watch people.

Listen to what they say, listen to how they say it, and listen to what they do not say.

Surprise yourself.

Scare yourself.

OPPOSITE
Art by Sara Pichelli

Q: What made you so passionate about and focused on dialogue?

A: I LOVE the sound of dialogue. I love the mystery of conversation. They say every plot has been done, and maybe that's true, but not every conversation has been had. That's where the amazing stuff happens.

Think of how many times you have been in an actual fistfight. Probably not that many. At least I hope not. Now, think of how many times someone has said something to you that really hurt you to your core or made you feel amazing. Think of how many times words have completely changed your life. On some level it may have happened every day of your life.

Q: How long would you say it takes you to write a typical comic book script?

A: Writing is art, and you can't put a time limit on art—it takes as long as it takes. But I try to get one script done and handed in every week. All that time, I am plotting, planning, researching, and sculpting other books. One script a week makes me feel like I did something of value. Not lazy, but also not hacky.

I write a lot, but I sit on my work and hand it in when I think it is ready.

Q: What's a common mistake you see with inexperienced writers? And how do you suggest someone fix or avoid the problem?

A: I see this with experienced writers, too: They worry so much about the plot that they lose sight of the characters. They lose sight of WHY they are telling the story. They don't let the characters actually speak. Characters will start to dictate the story in sometimes surprising, emotional, and funny ways. If the writers are not open to those surprises, they're going to strangle the life, spark, or spirit out of their work.

That's why you sometimes see writers with a consistent listless tone to their work. Because they strangle the life out of it.

Let the characters surprise you. Let them take you somewhere you're not prepared to go. Even if it means tearing up tracks—who cares? Let the characters make you cry or laugh, or let them scare you.

Q: How do you go from Point A (having a thought-out world, character, or story) to Point B (transferring your ideas to a script for a comic)?

A: You have to set personal goals. It isn't just about writing every day. It's about knowing WHAT you're going to write every day. A lot of the time, if you know WHY you're writing what you're writing, finding your way from Point A to Point B will come more easily as a result.

The frustration for some people is they think there's some magic formula that will bring their work to life—but there isn't. I know writers from every walk of life who use every kind of program, outline, or trick they can think of. And all of us know that it comes down to just *getting the work done.*

Sometimes you will fail and sometimes you will succeed. But if you don't write the pages . . .

Q: What goal should young writers set to help themselves improve?

A: Finish what you start!! I can't express this enough. Take a project from beginning to end. Repeat. Make writing part of your everyday routine—even if you have two jobs and other responsibilities. Find the time to write every day. If it's really important to you, you will. And for those of you who say to yourselves *Easy for you to say . . .* , I did it. Every day. No matter what was happening.

Q: If you do research, how do you get any work done? How do you not end up spending years just researching, only to use small bits of that information in your writing, or even have time to produce?

A: First of all, I love doing research. It lets me know whether I'm on the right path.

So much of my research doesn't make it to the page, but it makes me feel more confident about my pseudoscience silliness. If the research is boring me, then I know the subject bores me and I should probably move on to something else.

Also, I love talking to experts in the field. I absolutely love it. I haven't run across anybody who hasn't been willing to share, and they always give good stuff I would've never thought of myself.

Q: What is the difference between "good" writing and "great" writing?

A: Honesty.

You can be the master of your craft and know story structure like the back of your hand, but if you are not honest with yourself, with the world around you, with your place in it, with your emotions, then you are just a craftsperson and not an artist. And that goes double for genre writers.

But there are plenty of very successful craftspeople in the world.

Q: When you're writing a story, how do you decide which events to show and which not to show? Do you only include what's integral to the plot?

A: I am a staunch believer in the David Mamet philosophy of getting into the scene late and leaving early.

That is a rule that is even more important to comic book writers because most of the time you just don't have the pages for anything else.

Also, I'm usually only interested in the kinds of scenes that reveal plot, but also reveal something about characters. So if I'm not getting both, I usually take a long, hard look at the scene and decide whether I really need it.

I'm a great fan of taking big scenes out of a story and seeing if it's more interesting without them. Sometimes this element you think you desperately need ends up not being needed at all.

Especially with a thriller or mystery—less is so much more.

Q: How does your writing process break down? Do you just dive into a full script or are there other steps?

A: There are a lot of other steps. There are outlines, story breakdowns, story beat sheets, character developments, theme development, collaboration meetings, research . . .

And sometimes, even practice drafts—where I start writing just to see what happens. Those are rarely ever for publication; it's mostly me just trying to figure out what the characters are like.

I will say, what I pride myself on is not having a set way. Having a set way usually means creative death. Or worse, creative boredom.

I know some writers who do have a very strict way of doing things, and I am always like, "Well, that's why your work is so lifeless and boring."

I like to surprise myself in the process, and if I can surprise myself, I am probably going to surprise you, too.

Q: Do you believe a story has to have some deep, philosophical meaning behind it? Or do you believe that's it's more important to create a story that's interesting and capable of making the reader experience different emotions?

A: "The writing begins when you've finished. Only then do you know what you're trying to say." –Mark Twain

"Quoting Mark Twain instantly makes you lame."
—Brian Michael Bendis

Q: A lot of your stuff has twinges of political or social commentary without making it one-sided. How do you toe the line and make both sides of the argument without devolving into stereotypes? Is there anything in particular that you do or use that helps you get into the head space of an opposing viewpoint?

A: I hate preachy writing. I hate it like Indiana Jones hates snakes. Hate it! So I just do not do it. I also have a genuine, deep curiosity about mindsets different than my own—political and religious beliefs included. So I read about and talk to people who feel these different things, and I try to write about them in my work—if only to help me figure them out. I like well-rounded stories. I like knowing what makes the "bad guy" tick, to the point of no longer being sure who the bad guy is. With any character, it's about choices and actions. Avoiding stereotypes means having your characters do or say things that surprise even you.

Q: When creating a comic book series, have you ever second-guessed how things were revealed or how certain characters impacted the way events unraveled?

A: Oh, yes, yes, a thousand times yes. Every day—from the biggest reveal to the tiniest character interaction. Trust your instincts and find the choice that most surprises or delights YOU! If you were buying the comic, which story choices would YOU be delighted by?

Q: Where do you draw the line on something being too unrealistic?

A: I think as long as the lead character or characters are on a quest that is very relatable and there is a consistent logic to the story's fantastic elements, then those elements can be as crazy as you want. A mistake I see a lot of people make when imitating creators who do all of the druggie, crazy image work is that they don't do any of the relatable character work to go with it. (Which I think is much harder.)

Why are *Star Wars*, *The Matrix*, and *Harry Potter* so successful? Because the lead characters' quests, journeys, and motivations are very relatable. When they enter their worlds of craziness, we can relate to their reactions because we can relate to *them*.

Q: **What's the difference between what is in your submitted scripts and what we see in the published books? How involved are editors in the storytelling?**

A: Everybody has a different relationship with editors. Some people use editors as sounding boards for ideas. Some editors hand out very specific assignments, meaning they already know what they want the writer to write. It all really depends on the editor and the writer.

On most occasions, I tend to forgo the sounding board element, unless I really need it. Instead, I use my editors as the first line of entertainment defense. I show them the script already completed to see if they like it, to see if it excites them or makes them laugh. My feeling is that if it does excite them or make them laugh, it will excite the reader or make the reader laugh. From there, we come up with ways to make it better or fix areas that might not work because of continuity issues with other titles.

Q: **Have you ever had a bad collaborative experience—either with an artist or editor? If so, how did you handle it?**

A: Oh my God, yes!

Mostly in my earlier years. I won't go into names because that's not cool. I am happy to say that I have learned from every experience, good or bad. I have learned that no matter how talented people are, if they start with the crazy, just bail. It's not going to get better. The worst thing that can happen is finding yourself on a successful project with a crazy person. Success often amplifies people's personality traits . . . good or bad. You can do everything right, but it does take two to tango. You can be completely ready to collaborate only to have no one on the other end who's interested in behaving like a normal human being.

And there are some people I work with who just want to draw and aren't that interested in any kind of collaboration. Everyone just does their job. Which is fine. Especially if the work is crazy good.

Q: Why can't I land a real, big-time pro comics gig?

A: In my opinion, the goal should not be to work for the Big Two companies (Marvel or DC). The goal should be to make a comic book that you feel passionate about. If, for some reason, that comic book is your calling card toward other things, like working for the Big Two, that is fantastic (if that is your goal).

But don't wait around for those companies to discover you—just make your comics. If you want to be in comics, make a comic and you are in. It's a sheer act of will. Almost everybody whose work you read today lived by that philosophy. With digital technology, there is nothing standing in the way of you creating art and distributing it. GO!

Q: You do so much, but you seem to be on top of it all. How do you manage your workload?

A: It's part of my job to make it look like I'm on top of everything, but, believe me, there is a lot of hair pulling and manic hysteria that goes on behind the scenes.

At the end of the day, I have chosen a profession I would do for free and I married very well, so my life is full of things that I really want to do. It's not hard to stay on top of things when it's a bunch of things I really love.

Q: Since Marvel no longer takes unsolicited submissions from writers, is there an alternate way to have editors see the work of aspiring creators, outside of going to cons?

A: Almost everyone you know in mainstream comics was discovered from their work in independent or self-published comics or other creative work in another medium. Don't wait for Marvel or DC to discover you—just start making comics for yourself. They will be your calling cards to editors.

Q: Do you have any advice for people going the self-publishing or web-publishing routes?

A: It's really difficult to do, but you have to become two different people: the artist who creates the work and the advertising agent or marketer who sells it. You have to take a good hard look at what you

really have, and then get out there and sell it smart. Especially with self-publishing, you have to get attention beyond what all the corporations and their bigger comics and creators get.

It's really hard, but you have to get out there and sell it, or no one will know it exists. Don't be afraid to show what you have. Tell people what the story of your comic is, and why they should buy it or read it.

But do not market yourself by saying, "My comic is better than someone else's comic." That never works. All you're doing is insulting the reader who may like that other comic.

Q: **Since you write so many titles, how do you know which plot or story arc will be best for which title?**

A: A lot of my story development comes out of characters and character themes, so rarely do I find myself in the position of not knowing where a story idea should go. The characters let you know what they should and should not do. Would the X-Men versus Venom be as exciting as Spider-Man versus Venom? Sure. Would it mean as much personally? (Not unless Charles Xavier was secretly Venom . . .)

Q: **How long did it take you to break into the industry after you left college?**

A: I was taking an independent study at the Institute of Art's Illustration Department to focus completely on my graphic novel work. My goal was to create a comic book that would get me the grade I wanted and that would also be my calling card to publishers.

Once my comic book was completed, I mailed it out to anyone I could think of. Seven months to the day, I heard from two publishers. One was willing to publish my comic book as is and another offered to publish the next one. So, even though I wasn't making a living, I was making comic books for the national comic book market while still in college. I was lucky. And by lucky, I mean working my butt off.

Q: How much background reading do you do before you write a well-established character? Will you read as much as you can before you sit down to write, or do you just read the recent stuff and the Cliff's Notes?

A: Cliff's Notes, or as we call it in the business, "Wikipedia," don't work. You have to do the research, just like a "real" writer.

But with a lot of these characters, I already have a pretty extensive knowledge and passion for them, so doing additional research is not a hardship. If it is, then that's my brain telling me I probably shouldn't be writing that character.

The worst part is that there are no characters in comics who haven't had some punishingly bad stories written about them. You start going through them, and it's sometimes a chore. But often these stories reveal some truth that makes my job that much easier.

Q: How many drafts do you write of an issue and how many serious revisions do you make on average?

A: An embarrassing amount. Things just don't fly out of me like they do some writers. Everything seems to be a struggle. But it's my job to make it look like it isn't . . .

It doesn't matter how many drafts it takes or how long it takes . . . it is done when it is done. And even then, it's probably not done. Just finished.

Q: How did you get your comic seen? Did you have a webcomic? Minicomics? Did you finance your own small run? Where did you put them (local comic shops, conventions, street corners)?

A: Things are very different now. I broke in when I was still in college. I created a self-contained anthology one-shot as my final thesis in Illustration. It was six stories using different styles of writing and drawing. A show-off piece.

I'm going to sound like old man Groucho Marx, but "back in my day," there was no webcomic situation available for me. You either

printed your comic or you didn't. I went to Kinko's, I printed a few hundred copies, and I sold them at the comic book store I was working at. Then I mailed them off to any publisher I thought might be interested in them.

Amazingly, seven months later, two publishers were interested. Fantagraphics offered to publish my next project, while Caliber Press (RIP) offered to publish the anthology nationally.

I ended up rewriting and redrawing the anthology before it went to "grown-up" print. And by the time I was done, I decided to stick with Caliber. It was a better fit for me.

My point is . . . hustle.

If I were breaking into the business today, my web presence would be insane. I would be everywhere to an annoying degree. I would use whatever money I could scrounge together and print however many copies of my comic I could, and I'd get them into the hands of whoever would be in a position to help me. As I said before, if you want to be in comics, just make one comic and you are in comics. There is no magic trick. Be smart and make sure that the comic you are making is something you really believe in. People can tell if you are full of it.

Q: **Would you want your kids to grow up to be writers?**

A: I want them to grow up to do whatever they want that makes them as happy and crazy as writing makes me.

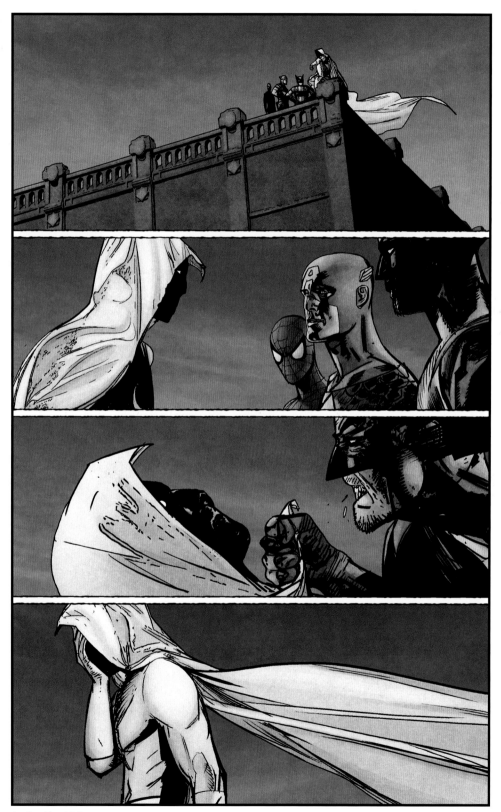

Art by Alex Maleev

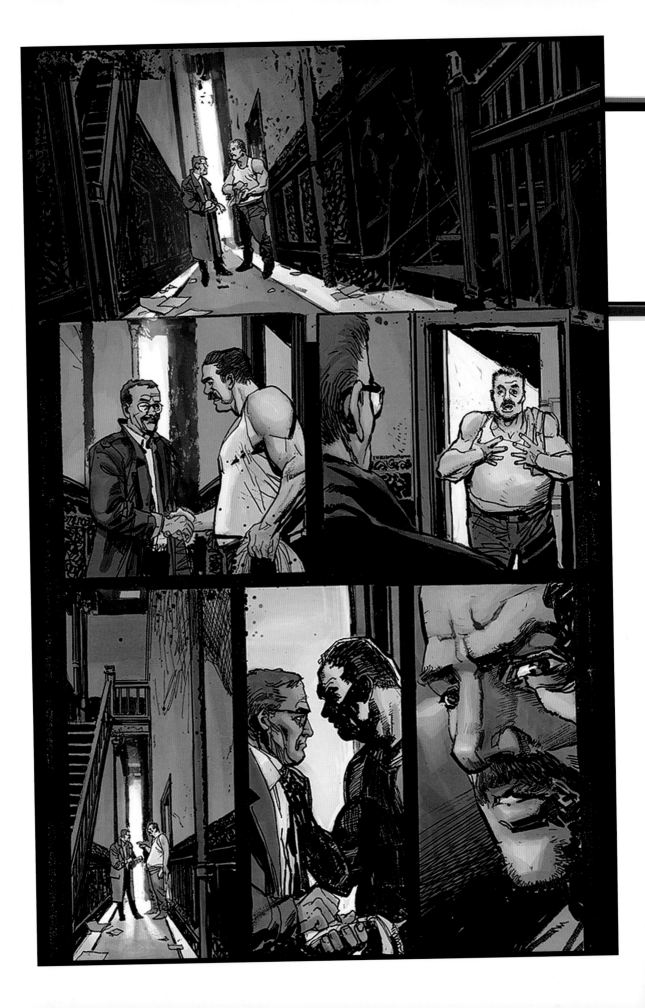

CHAPTER 6

THE BUSINESS OF COMICS WRITING

THE BUSINESS OF COMICS IS TWO FOLD. I HAVE already covered the business of "how to break in" and "how to present yourself to an editor." Now it's time to get down to how to run your business. If you are a writer, you are going to be a business. Now before you skip this chapter because you cannot believe it is an interview with my wife, I am going to tell you that this is probably the most important chapter in this book. This is the subject that most writers need major help with, whether they are up and coming or established.

Now I don't know how to run my business, I really don't, but my wife, who has a master's in education and a degree in business, is exceptional at it. She has run our company very successfully for eighteen years. I'm not just saying that because she's my wife. We've been married and business partners for a long time. She is immune to my charms (kind of).

I am not exaggerating when I tell you that comic book professionals from all over the world have come to my house specifically so my wife could sit down with them and tell them what they are doing wrong and what they need to do build their business.

For most creative people, it's fun to create, but it's really hard to run a company. It's doubly hard to run a company when the company's main export is the writer's imagination. But you have to learn how to do it. You have to. Go online and Google the phrase "comic book creator

OPPOSITE
Art by Klaus Janson

Note: All art in this chapter by Klaus Janson

legal problems," and see how many horror stories starring very talented people come up. Do you want to be one of those people? You don't. I don't.

This is the part of being a writer that a lot of writers don't want to talk about, because most know they *don't know* what they're talking about. So take a deep breath, and listen to someone who knows what she is talking about.

AN INTERVIEW WITH ALISA BENDIS

How do you describe who you are and what you do?

A. BENDIS: I am president of Jinxworld, Inc., the company my husband and I founded. Jinxworld, Inc. is the business side of Brian's career at Marvel Comics, as well as the financial and production side of his cocreations and self-published works such as *Powers*, *Brilliant*, *Jinx*, *Scarlet*, and *Fortune and Glory*.

How did you and Brian meet?

A. BENDIS: Brian and I met because the organization that I worked for in Cleveland hired him to do promotional art and a coworker recommended him to me for a project.

When I married Brian, he was the dictionary definition of a "starving artist." He spent 80 percent of his time writing, drawing, and creating comic books and 20 percent of his time doing caricatures at bar mitzvahs, weddings, and business events.

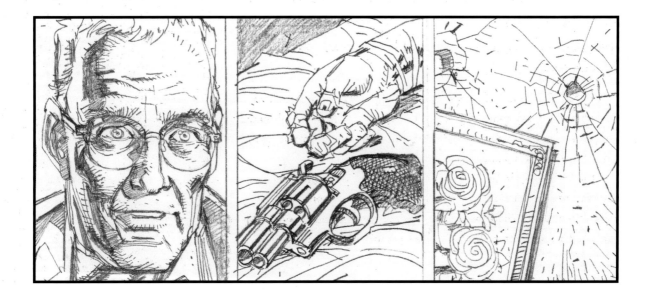

He lived off the money he made as a caricature artist because, at the time, he made next to nothing from his comics. In fact, at the time, my vision of our future was me earning the income and Brian being a stay-at-home dad and comics creator.

The old saying about loving what you do and never having to work a day in your life—well, Brian was living it. I loved him dearly, but I soon discovered he was a financial disaster waiting to happen. He had already messed up his taxes and was running his finances backward, which, sadly, is a common problem among many of his peers.

Needless to say, I quickly took over the household finances and have managed them ever since. In fact, I took away Brian's checkbook and started paying his bills even before we were married.

Brian is amazing at so very many things, but he is not a bookkeeper or accountant. I shudder to think how long he would have continued not filing or paying taxes if I hadn't come along.

What's the biggest mistake you see comic creators making businesswise?

A. BENDIS: Just not being bothered with it. They don't read their contracts because the contracts bore them. Or they don't even make contracts. They take the first offer a company makes, as they are so excited to be making comics that they forget to negotiate. They don't know it's okay to say no.

These contracts and page rates you agree to are life- and career-defining choices. You have to take them seriously. I have discovered that some of these companies are counting on some of the creators setting themselves up to be taken advantage of. It's almost like an unwritten rule in comics. Creators don't care about the money, and the companies are happy to oblige them.

What's the biggest mistake that you and Brian have ever made in this business?

A. BENDIS: Early on, I should've done research and asked publishers about standard payment rates. But I foolishly trusted one collaborator working on our book when he told me the usual rate for people doing the type of work he was going to do.

The lesson we learned is to *never* be afraid to ask about usual, standard business practices. If I had read a book like this one, I would've known to call established comic book publishers or ask anyone with a self-published book how they did it—to have something unbiased to go on.

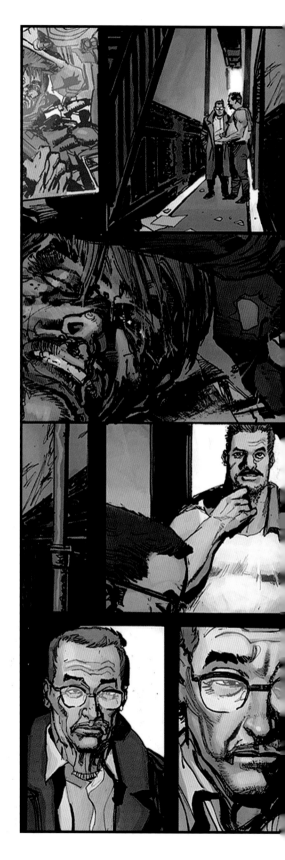

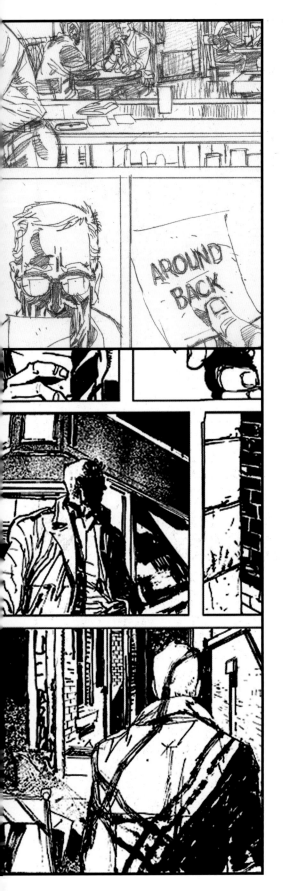

What is the best business advice you have ever received?

A. BENDIS: That all contracts should be written like the book you are creating is going to be the Next Big Thing. Write contracts as though you are splitting up a million-dollar pie, and ensure you cover all possible income streams and all scenarios.

Sure, most things fail. If there's nothing to split up, everyone involved just goes their separate ways. The trouble starts when the money comes in; so be prepared.

What are the going page rates for comic book talent?

A. BENDIS: In every profession, many variables go into calculating salaries, such as location, experience, and budget, to name a few. There are no set page rates.

You, the creator, have to decide if you can live on what is being offered to you in relation to the time it takes you to do the work. And by *live*, I mean paying all of your bills and your insurance.

For independent or self-published projects, creators tend to make less money than they would by working for one of the bigger publishers. Plus, for self-published works, the page rate could be zero and replaced by a percentage of ownership or profits. The writer and artists, the co-creators of a new project, have to sit down and agree, in writing, to what percentage each of them will receive of the publishing advance and any other money the creation might bring them.

What are the general items or sections that one would expect in a well-written self-publishing contract?

A. BENDIS: I am not a lawyer, but we have a lawyer. The money you spend on a copyright or entertainment lawyer is worth ten times what you pay,

because you must protect your own self-interest no matter how big or small the project.

I cannot stress enough that you must plan for all contingencies, including and especially success. I believe the following are the basic and broad terms that every self-publishing contract should include. Feel free to give this list to your lawyer as a guide for creating a legally binding contract with the exact legal terminology required by your state or region:

- Alternative media rights
- Approvals
- Audit rights
- Complimentary copies
- Confidentiality
- Content and form of work
- Credit
- Decision-making ability
- Definition of property
- Dispute resolution
- Division of royalties
- Due dates and timelines
- Identification of the project as work-for-hire (if appropriate)
- Ownership
- Page rates and/or salaries

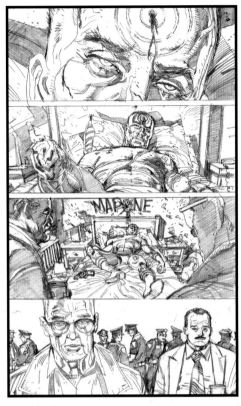

- Payment and reporting

- Promotional responsibilities

- Remedies for lateness

- Responsibilities

- Sales and service fees

- Scope of job

- Term and termination

- Territory

- Warranties and indemnities

[Note: Definitions for these terms are found on pages 182–185.]

What if you are working with friends and family? Do you need or should you have a contract then?

A. BENDIS: This is probably my favorite question! I think it is extremely important for everyone to have terms and conditions in writing, and it is equally essential if you are doing business with family or friends because everything boils down to human nature and fallibility.

Every project includes some kind of negotiation, including projects you do with family or friends. Without having terms written down and signed by both parties, you might honestly remember different terms. It's not necessarily that you're lying to or manipulating each other. It's just that people's memories are extremely fallible, and parties could remember different points from the same negotiation.

In addition, there are many aspects of a deal that come up only in contract negotiations, and an omission of these discussions can be just as dangerous as having no contract.

Also, if someone passes away without having correct paperwork for a project, how are his or her heirs supposed to know what the deal was?

For these reasons, I absolutely insist on having contracts with close friends and family. The bottom line is that it really helps everyone involved to have a contract.

What is the difference between an employee and an independent contractor?

A. BENDIS: An employee is someone who solely works for one business or company and an independent contractor works for several businesses or companies at the same time.

How do you write the perfect contract?

A. BENDIS: I'm really glad that you asked this question. It is close to impossible to write the perfect contract. The best lawyers in the world can't account for every single contingency and nuance—it's just impossible. However, your goal should be to come close and to make sure that you hire the best lawyer possible. At the end of the day, all sides should be happy with the final agreement. By all sides I mean, all interested parties of the work or creation.

But the bottom line is that, at some point, everyone involved is going to have to take a leap of faith. You have to trust that deadlines will be met, that both parties will do their best work, and that the spirit of the contract will be upheld under every circumstance. My advice is to look at the overall track record of those you are going into business with. Look online, ask other professionals who have done business with them, and then decide whether or not to take that leap of faith.

Do you have any final thoughts?

A. BENDIS: Brian and I have grown together and created this amazing family and business together. We did it by listening to those smarter than us, by getting a lawyer and an accountant and making sure we run our business like a business—like our family's well-being depends on it.

When we started this company, the idea of having movie and television deals seemed insane, but we planned for them. Now they are happening and we are ready. We have watched many of our friends and peers struggle to survive because of huge mistakes they have made in this department. They just wanted to write or draw and couldn't be bothered with the "boring" stuff.

So, my advice? Get a lawyer. Get an accountant. Listen to what they say. Don't just hope for the best. Brace for the worst and be pleasantly surprised by anything else.

Don't be afraid to say no if there's something in the contract that you don't like.

Some of this might seem cliché to some of you, but the bigger cliché is how many creative people let themselves be screwed over by not following these simple guidelines.

PUBLISHING CONTRACT DEFINITIONS

Alternative media rights: This defines the contractor's (the writer's/artist's) rights regarding the project's use in television, movie, video game, Internet, and other alternative media formats.

Approvals: This section defines who has the final say regarding advertising and promotional material and regarding content of the source materials.

Audit rights: This defines the contractor's permission to review financial information and make sure he or she has been paid appropriately.

Complimentary copies: This specifies how many copies (for both individual comic book issues and collections) the contractor gets and how he or she would go about getting additional copies if desired.

Confidentiality: This defines that not only should the terms of the contract be kept confidential, but also the content and storyline of the project.

Content and form of work: This section states whether the contractor will have to turn in actual artwork or can use film or another digital format. (This doesn't affect writers as must as it does artists.)

Credit: The exact size, placement, and wording of the contractor's credit in the project are specified here. For example, the contract might say something like "all creators names will be the same size and font and appear on the cover, binding, and credits page of the book."

Decision-making ability: This section in non-work-for-hire contracts, for works concerning new creator-owned properties, defines who has the final say in all publishing, movie, video game, TV, merchandising, and other contracts.

Definition of property: This would include the working title of the project.

Dispute resolution: This section defines that, if there is a problem requiring the payment of lawyers' fees, in what state disputes can be filed and who pays for lawyers' or arbitrators' fees.

Division of royalties: This section describes how royalties will be split among all parties in the project.

Due dates and timelines: This section defines all due dates and timelines for project work as well as the consequences for late work.

Identification of the property as work-for-hire (if appropriate): This defines whether or not the project is a work-for-hire project. This means one party will be paid a salary or page rate and not have any ownership in the project or intellectual rights.

Ownership: This section says which company, corporation, or person will hold the intellectual property rights to the project, including but not limited to the copyright and license for the characters, trademarks, and design.

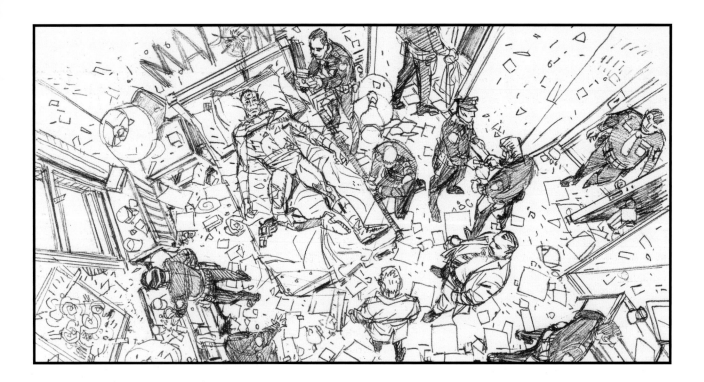

Page rate and/or salaries: This section specifies the exact amount that is going to be paid to the contractor (that is, the artist, writer, colorist, etc.).

Payment and reporting: This section specifies how long after the contractor turns in his or her work that payment can be expected (for example, within 30 days, within 15 days) and what kind of backup paperwork is expected. If this is a work-for-hire contract, you are determining the turn-around time from you receiving a payment on behalf of the book to you sending the percentage due the subcontractors—people working on the book who are not credited creators of the property.

Promotional responsibilities: This section outlines each party's responsibilities in terms of promoting the book via social media, advertising in other published works, and at conventions.

Remedies for lateness: This section defines what would be considered "lateness," what the consequences of lateness would be, and what form and timeline termination would take.

Responsibilities: This section defines the role(s) of the parties covered under the contract—that is, it describes what a letterer is, what a publisher is, what a writer is.

Sales and service fees: In contracts with publishers, this section defines a specific flat fee or percentage, or a combination of the two, that the publisher will keep for its participation in the distribution of the project or property.

Scope of job: This defines the projected time to completion of the project plus the amount of issues or trades and/or the exact issues and trades covered under the contract.

Term and termination: This section defines for how long items in the contract will be enforceable (some may need to be enforceable forever, or "in perpetuity") and the circumstances and form that would result in the termination of the agreement and/or employment.

Territory: This section identifies the countries and languages covered in the contract and states whether the parties will retain international rights in hopes of making a separate publishing deal with international publishers.

Warranties and indemnities: This section basically guarantees that the content and creation is not only original but also was produced by the parties included in the contract and not by a third party.

So there you have it. The business of comics and it is *JUST AS IMPORTANT* as the art of comics. Follow up with a lawyer. Your comic creations are a part of who you are. Protect them like you would your own family. Do not be a cautionary tale.

CHAPTER 7

WRITING EXERCISES

SO HERE YOU ARE! YOU'RE THIS FAR INTO THE BOOK and your head is just filled with great advice from writers, artists, and editors from all over the world. You have a much better sense of what is expected of you if you ever become a professional writer. But still . . . you are plagued with doubt.

Do you have what it takes? Will you ever be good enough? Will you ever have a story inside you that people will actually want to read?

Don't worry about it.

Seriously.

That feeling will never go away. I have written hundreds of comic books, I have won awards, I have worked with some of the greatest artists on the planet, and I still feel all of these doubts all of the time. In fact, all of my accomplishments only exacerbate a lot of my self-doubts as a craftsman and an artist.

We all feel it. All my peers do. It's basically all we talk about.

We also do something about it. We work through the doubts. We work on our craft. We find ways to better ourselves. We take assignments that make us face our weaknesses head-on. We purposely write stories and characters that defy our own and other people's expectations.

That's not to say everybody does this. There are definitely two schools here. There are those who constantly work at their craft and

OPPOSITE
Art by Michael Avon Oeming

those who, consciously or unconsciously, do everything in their power to cover up their own inadequacies.

It can be hard to detect with writers, but you may have seen this behavior with certain comic artists. You will see an artist who doesn't know to draw, let's say, feet. One type of artist will cover up that fact by filling pages with billowing ankle level smoke or long capes. Yet another type of artist realizes that he can't draw feet so he draws nothing but feet. He might spend a year drawing nothing but feet. He will draw feet until it's the thing he does best.

Although it's not as visually obvious, writers do the same thing.

If you bought this book, I'm guessing you are the kind of writer who wants to conquer all of your doubts through hard work. No one can help you do this—no one, that is, but *you*. You know you better than anyone. You know where you need work. Maybe you're not confident about your skills with dialogue. Maybe you think you write amazing dialogue, but you can't script a decent action-set piece to save your life. Maybe you think you have a good plot, but you have a hard time understanding your characters. Maybe certain genres baffle you. Maybe you just don't feel confident about how to make all this work on the comic book page. That's all okay.

The only thing that isn't okay is if you think you don't need any work. That means you're insane. If you think you read this book and now you have it all covered, you DO NOT! And, to go back to my earlier point, YOU NEVER WILL. This is a lifelong quest, journey, and commitment.

No matter who you are, where you live, or what kind of writer you think you are, you NEED TO WORK ON YOUR CRAFT. I don't care if your creative writing teacher gave you an A+ and three gold stars on all your assignments, you are on a creative journey that has no final destination. Every day you need to do things to better yourself. It's just like working out. You have to do it every day or it all goes to hell. (At least, that's what I hear about working out.) Some of you bought this book because you think I know it all and have it all worked out . . . no! I wrote this book to *try to work it all out!*

A lot of the journey, as many have said before me, is just simply reading and writing. If you are a writer, the best way to learn is to read and write EVERY DAY.

"If you want to be a writer, you must do two things above all others: read a lot and write a lot. There's no way around these two things that I'm aware of, no shortcut."

—Stephen King, *On Writing*

As I writer you *read* with a writer's mind. Your brain works differently. You not only read for content, but for craft. In fact, you might have a hard time reading just for fun. As soon as a writer sees something great, she immediately starts to pick it apart. She dissects it. Why does this work? Let me tell you, you can learn just as much from someone's failure as you can someone's masterpiece.

BETTER CHARACTERS THROUGH LIVING LIFE!

When in doubt, use your life. Use your relationships. Use your friends. Use your parents. It's your job as a writer to write the world around you. Your perspective on that world is unique.

From a personal example, in *Ultimate Spider-Man*, I was riddled with doubt about how to portray Peter Parker's Aunt May. This is a character that historically had been underwritten to the point of caricature. She was a walking heart attack.

I tried to think about a very good maternal figure I knew. But I also wanted someone who had a lot of sass and character. I racked my brain until it occurred to me that it was the one person in my life who I had never written one thing about . . . my mother. (Some would argue that everything I've ever written is about my mother, but that's a different topic for a different type of book.)

My interpretation of Aunt May is a dead-on impression of my mother . . . if my mother had unknowingly raised Spider-Man, instead of a half-crazy child who was obsessed with writing Spider-Man. The only person in the world who knows how dead-on an impression it is is my brother. Hopefully, to everyone else in the world, Aunt May is a realized character. You don't have to know my mom to appreciate that May Parker is real to me.

You can do that with your characters. You can use the people in your life. You can have them color your world and characters. You're probably already doing it subconsciously. But I think it's better when you do it head-on, with purpose.

But do not mistake character for characterization. If you say a character wears a blue scarf and goggles is that character or characterization? It's characterization. It's "character color." Character is the choices they make. The actions they take. When I think of Aunt May I think *What would my mother do?* Not *What would my mother wear?*

You can also step outside your comfort zone and take in the world around you. Like how an artist learns to draw by drawing from life, a writer learns to write by *writing* from life. Back in my glory days when I took public transportation to work, I used to take a sketchpad and sketch people on the bus. I would zoom in on colorful characters, not only drawing them but also listing fantasy backstory elements. I would write about these people. I would look them over and decide where they came from, where they grew up, and the story behind where they got that coat. I would make up elaborate stories about them, never knowing if they were true or not. It took me out of my wheelhouse. It made me empathetic to people living different lifestyles, living in different worlds than my own.

I know it sounds creepy to tell you to stare at strangers and take them apart. It is. All I can say is this: try not to be obvious. And sure, there might come a time when you find yourself wanting the person to notice what you're doing . . . because he or she is cute. Well, go ahead. See what happens. I'm telling you that 90 percent of the time you are going to creep that person out. He or she may even engage you, and maybe that's okay because whatever he or she says or does to you is going to be good material. And if by chance he or she is charmed by you and gives you their number, that will probably be good material, too.

The world is there for you to listen to, observe, and take in. You have to train your brain to not only listen to the conversations in your life, but to recognize how those conversations sound. You need to listen to the music of the world all around you.

Most importantly, you need to dig through it all and pull out the good stuff. Go to the mall. The park. Go where people are and . . . listen. Take it all in. And spit out ONLY the good stuff back onto your pages.

Because not everything in the world is a story worth repeating.

The magic comes from finding the stuff that is interesting. The magic comes from discovering that "realistic dialogue" isn't actually that realistic. Most real-world dialogue is quite annoying. Some people

don't know that their stories aren't all that interesting to others. Some people don't know when they have gone on too long.

"You had to be there." You ever hear someone say that after they told a story that didn't "land" quite the way the storyteller may have hoped? That is someone who didn't quite know how to tell a story.

That's why readers turn to you, the writer. They want you to tell them a story. They want a story far better crafted than the ones surrounding them in real life. People would rather tune out the "realistic dialogue" and listen to yours.

Train your brain. Train your ears.

THE ART OF THE COMIC BOOK PAGE

There are truths about writing that apply to just about every medium. And then there are the ideas specific to the comic book medium. One of these is knowing your comic page real estate. How much stuff can you fit on the page without overloading it or underwhelming it? How much is too much and how little is too little? How many panels is too many panels? How many word balloons is too many word balloons? How many character can fit in a panel without crowding?

The answer is: there is no answer. You have to get a feel for how a page comes together. You have to study them. Study the masters and study the hacks. Break all the examples down. Reverse engineer them.

THE SCRIPT

Take a page of a published comic book and reverse engineer it. Any page. Any book. A page that rocked you to your core. Now break down the page. How many panels is it? How many figures or story elements are on the page? What "camera" angles did the artist use? Write what you imagine the script looks like. Train yourself to write a script for a good story. Get used to writing a successful page. Get used to the feeling. If you can find the script online to compare your version against, great. But it's not necessary.

Take the following pages as an example. Write your own version of a comic book script for these pages. Go!

Now, do the same thing to a comic page that you consider bad. Find a comic that completely annoys you and do the same thing—break down the page. How many panels? How many figures or story elements are on the page? See if you don't find a way you could have told the story better.

Art by Olivier Coipel

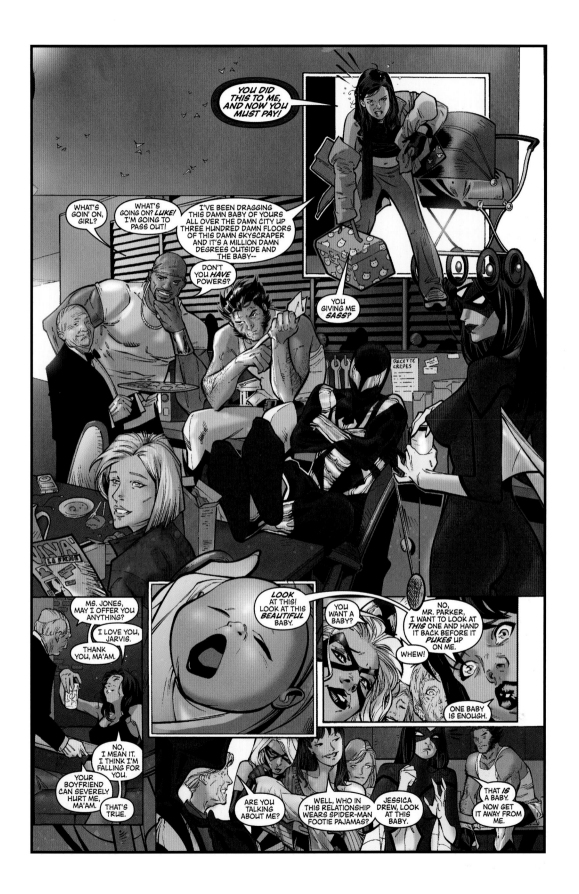

THE STORY

So you want to open yourself up to different kinds of comic writing and stories? Another trick is to find a comic page with lettering included. Hundreds of samples are available online. Comic book company preview lettered art all the time.

Imagine an editor calls you up and says, "The writer of this project has disappeared and I need someone to finish this. But I don't have any of the original writer's notes. Take these pages and give me five more. Finish this scene. Finish the story."

Take this challenge: Write the next page. The next *pages*. Go!

Art by Chris Bachalo

THE DIALOGUE

For this activity, you will need unlettered pages. You can find hundreds of them online or in comic art books.

Imagine an editor calls you up and says, "We have these pages, they are all drawn, but all the writer gave us was a plot. They left to do another project. We need someone to dialogue these pages."

First of all, situations like this do happen. Careers are made from them. And what a great way to get a feel for putting dialogue on a page. It helps get you used to how much or how little room the page has for you.

Find pages online from books you have never read. Or use the example below.

Go!

Art by Michael Allred

PAGE TURNS AND CLIFFHANGERS

One more specific element to the art of the comic page is the *page turn*. Stan Lee famously said, "Every comic is someone's first or last." If it's their last, it is the writer's and artist's fault. If it's their first and it hooks them, it is the writer's and artist's success. With that philosophy in hand, Stan amped up the idea of the end of the issue cliffhanger. Read the first hundred issues of *Spider-Man* or *Fantastic Four* . . . the story never ends. Cliffhanger after cliffhanger! Every 20–22 pages, the craziest thing is about to happen. I personally believe in this—the art of the cliffhanger.

In a documentary called *Countdown to Wednesday*, writer Mark Waid confessed that he would often write a cliffhanger without even knowing how he was going to get out of it in the next issue. One time he actually had a car going off a cliff. Bravo to him!

I have tried to take Stan's philosophy a couple steps further. I try to create a mini cliffhanger at the end of every page. *EVERY PAGE*. Twenty cliffhangers. Sometimes it's a big one—a mystery character revealed to the hero. The reader turns the page to find out who it is. A character asks a question, but the reader must turn the page to find out the answer.

I also noticed something the writers and producers on the show *24* tried. They had a physical cliffhanger and an emotional cliffhanger. *A DOUBLE CLIFFHANGER!!* I started applying this to my comics. Page 20 would be a physical "is he gonna die?" cliffhanger, and page 21 would be a "is she really going to leave him?" emotional cliffhanger. When I see someone online driven mad about my books but who keeps buying them regardless, I know it's the twenty little cliffhangers on top of that double cliffhanger. I gotcha!

The importance of real estate on the comic page and the art of hooking the reader are two very important mini-arts that you have to confront in your script. There's no right or wrong answer for how to do it. Just knowing these challenges are there will bring you into the correct mindset. The act of looking for answers to these and other comic page challenges will immediately make you a better comic book writer.

CONCLUSION

SO A FUNNY THING HAPPENED ON THE WAY TO THE END of this book.

As I was putting the finishing touches on these pages, a little controversy broke out. As I said on page 163, I host a mostly comics art Tumblr open to the occasional Q&A when I have a free moment. I have retired from comic conventions because my wife and I are raising four little kids (Yeah, four!! That's the next book!). If I have a minute, I like to answer any questions I can—big or small. I tend to pick process questions because between this book, teaching, and being an actual writer, that's where my head is at most of the time. About every tenth question is a version of "Help me get started, help me off the mat, help me get in the business." And about every other day I share some version of my "write every day/make your own comic" philosophy. A philosophy I live by, but one I hardly invented.

This day's version was: "What advice do you have for someone that has had writer's block for the past six or seven years?"

Seven years threw me. I won't lie. I responded: "This will sound harsh, but you're probably not a writer. Writers write every day. It's okay, not everyone is. But if you consider yourself one, get off your butt, and get back to work!! Write about why you haven't been writing. Anything. Just write."

My response was terse, yes, but still, I thought *This person wants me to tell them to get to writing.* Then I went about my day. When I came back to the magical land of the Internet, I discovered this controversy

OPPOSITE
Art by Bryan Hitch

had exploded. Three thousand-some comments or notes in a couple of hours. *Uh oh, what did I do?*

Some people were very upset with me for flatly deciding that someone who had not written in seven years was probably not a writer. Actually, I was wildly misquoted by some as saying he or she was *DEFINITELY* not a writer. I said and meant probably. Seven years? Yeah, *probably* not a writer. Some people came at me with pretty tragic circumstances and explanations as to why they themselves could not write. I was truly sad for them, but I wasn't talking about them and their tragic circumstances. I was answering one guy's question. Some believed just thinking about writing was enough for them to call themselves a writer. That's a line I read from more than a few people. They had great stories, but they just hadn't written them down yet. They think about writing so they are writers. And who the hell was I to say they are not!!?

Later that day, the original poster reached out to thank me for getting him off the mat. That is who I was talking to and that was what I was hoping to do. To be Walt Simonson.

The line was drawn all that week between the "writers write" and the "writers get to it when and if they feel like it" camps. At first the groups were split right down the middle, but it since seems to have leaned towards my original idea. I was terse, but I wasn't wrong. As of this writing, the thread has inspired articles in a bunch of local papers and blogs outside the comic industry. Mostly writers used it as an excuse to write about writing. Which is more than okay by me.

What fascinates me about the feedback/backlash from all of this is how many of the responders who did not write on a regular basis wrote so much about the issue. Such long answers! They were writing about not writing more than most writers actually write. And then I noticed many of them used the word *fear* in their discussions of why they did not write.

"I'm afraid I don't have it all figured out yet."

"I'm afraid to fail."

"The 'writers' block' thread scares me into thinking I might not be good enough or have the discipline to become a professional."

"I'm fearful that I am working on something too similar to something else someone else is doing."

"I'm afraid I won't be able to finish it."

Fear.

Fear seems to be the number one demotivating factor for people who don't write. Fear stops them from expressing themselves. If you

take anything away from this book, from all the creators and editors in these pages, it should be: *LET GO OF THAT FEAR*. If you can't let go of it, write into it. Scared? Write about it! Remind yourself that we all live with fear. The difference between the writers, the published authors, and the rest, is that they don't let that fear of failure, that fear of success, that fear of criticism paralyze them. Every one of your heroes in literature, comics or not, got to be who they are by not letting fear dictate their way.

I have failed. I have fallen down in front of thousands of readers. I have been dragged through the Internet for weeks and months on end because I killed off beloved characters. My pathological fear of printing errors has come horribly true. Anything you are afraid of happening to you as a writer has happened to me and I am here to tell you—it all passes. You know what happens when your worst writing-based fear is realized? You lay on the floor for an hour, get back up, and try again. If you're a real writer there is nothing ANYONE can say or do that will stop you. Especially no one on the interwebs.

There is literally nothing to be afraid of. Nothing. It's an illusion. Go write.

The other bit of business I took from this back and forth was that many readers- or writers-in-training liked to use authors with low publishing outputs as examples of why it's okay not to write with frequency. "Well, my favorite writer only put out one book every ten years!" "My favorite writer only wrote one book in their whole life."

I was surprised how many people thought that everything they read from an author was everything that writer had ever written. Oh no. No, no, no. For every page ever published there's one, ten, a hundred pages that will never be seen. A book that took ten years to write may have actually taken all ten years to write. Rewriting. Reworking. Massaging.

This book! This very book took dozens of revisions and rewrites. In fact, there was another epilogue here until the Tumblr nonsense inspired this one instead.

Yes, a writer can get writer's block. Yes, the blank screen or page is a living nightmare. Some writers think writer's block does not exist. That it is a myth. Of course it exists, but I don't think it has anything to do with writing. It is some other deep, personal pain that manifests itself as a block that doesn't allow your mind to create. And that is horrible, just horrible. I have never had it, and I hope I never do. If I do, I hope I take my own advice and write into it.

But I know for a fact that a writer writes much more than she will even let you read. Don't go by page count. Page count is the real myth.

It does not fly out of you. That is why it is so important for you to write every day. You need to purge those bad pages out of you. You need to put down a thousand pages to get to a good baker's dozen. I promise you, your favorite author have dozens of books in their drawers that they won't even show their closest friends. They know they suck.

John Lennon and Tupac have been dead for years and we STILL keep finding new demos and tracks of theirs. I am telling you, they didn't release them to the public because they hated them but couldn't toss them. (Reminder to self: Add to my will that my wife and kids can't release any of these deleted scenes or aborted projects I can't bring myself to throw out.)

Don't sit and ONLY think about your story. Think and then write. Write while you think. Even then the words might be a struggle. They might flow like butter, but you might be shocked by how many times you have to write a sentence. You won't believe how many times I had to write this sentence!! Don't be afraid of bad pages. Embrace them. For every one you write, you are that much closer to the gold. Think of it like a buried treasure. No one wants to dig through mud and dirt, but if you know there's a treasure at the end of it, you will.

That's why you should write every day.

Okay. That's enough.

Go write.

I'm dying for a good comic. Go make one so I can buy it.

BRIAN MICHAEL BENDIS

ACKNOWLEDGMENTS

THIS BOOK HAPPENED BECAUSE OF DIANA SCHUTZ. She is the one who put me on the road to become an educator. I truly believe no one would have thought of asking me to write a book like Words for Pictures without her putting me on that road.

When I started teaching my college class, I knew that I could ask just about anybody I knew in comics to come by and guest lecture or help some other way. Not because I'm a swell guy, but because I knew that almost everyone I knew in comics would jump at the chance to share what they know with people who wanted to know what they know. That's comics.

When we started putting this book together, I decided early on that it would not be a "how to write like me" book, but rather a showcase of all the different ways these things are done. I knew I could ask just about anybody in comics for help or contributions, and that they would give it. They would all jump at the chance to share what they know with people who want to know what they know. That's comics.

What I didn't know was how much help my friends and peers were going to be. When I showed Matt Fraction the edited version of an interview we had done together that I hoped to include in the book, he sent it back as brand new feature completely written by him. Some of that had to do with the fact he knew I had a brand new baby that my family was not expecting and he wanted to help out where he could, but the other part of it is that is just who he is. Someone who will drop everything to help a friend. That's comics. Actually, that's Matt. But Matt, to me, is comics.

Stan Lee, the godfather of comics, is someone I have a good, professional relationship with. He has been very nice to me both publicly and privately. When someone is that nice to me, my instinct is to not ask him for anything. I literally paced around my office for a day before deciding whether or not to include Stan in the list of people I was hoping would contribute to the book. I held my breath and sent an email to him. And before any of my good friends—people who actually might owe me one—were able to get back to me, Stan had instantly sent me things he thought I could use. One of the most important people to ever make comics, in his ninth decade on the planet, dropped everything to help me. Just 'cause. That's comics.

Every single artist, writer, and editor who took time to contribute to this book did so because they all just liked the idea of it. They didn't do it for any other reason. An astounding 98% of the people I asked to be in this book said "Yes." That's comics.

My extended family at the mighty Marvel Comics, in the form of the lovely Dan Buckley and David Bogart, allowed me access to all the things you see in this book. They also allowed Jen Grunwald, my long-time editor on all my creator-owned books, access to everything I would need to make this book look like an actual book. They didn't have to. Everyone over there is very busy. That's comics.

And let me tell you, Jen Grunwald is a saint.

My thanks to Joe Quesada, who saw my very meagerly selling independent comics, thought I had what it took, and put me on the world stage of mainstream comics. A lot of people like to take credit for "professional me," but only one person can. I have learned more about the world watching Joe be Joe, than from just about anything else.

My darling editor Patrick Barb came to me with the idea of doing this book because he had followed me online and saw my enthusiasm for comics studies and education. I don't know what he thought he was getting into with me, but I feel this was a much larger pain in the tuchas than he imagined. He knew that I am—miraculously—a very employed person who would work on this book between projects. He did not know that my wife would soon be accidentally pregnant or that the circus involving my television career would explode in both our faces. Even though very good things came out of both situations, Patrick showed an amazing amount of patience. Not once did he bring up the irony that I was writing a book about how to be a professional, while I was kind of, sort of, acting anything but.

To everyone who dedicated time and energy to this book, I thank you.

To the godfathers of comics education Will Eisner and Scott McCloud, thank you for raising the bar for books like this one so high that I literally had to throw the entirety of the modern comic book industry at this project to even attempt to earn my place on the shelf next to you.

And most importantly, this book is for you—the writers of the next generation who find my peers and me, and who ask us questions about craft everyday, online or at signings and conventions. (Even though they are the same questions we ask each other.) Hopefully, you will take the information in this book on your own journey and put it right into projects you're working on now.

And when it doesn't work, you will try again. And again. And again.

Because as you know, there are no shortcuts or magic tricks. The only way to make comics is to sit down and make comics.

Art by Bryan Hitch

INDEX

OPPOSITE
Art by Sara Pichelli

Script and art by Brian Michael Bendis, circa 1981